8/82

A New and Noble School

By the same author

1947 On Human Finery
1951 (With Helmut Gernsheim) The Impossible English
1961 Roger Montané
1963 The Schools of Design
1963 Ruskin
1967 Victorian Artists
1968 Bloomsbury
1972 Virginia Woolf – a biography in 2 volumes

A New and Noble School

The Pre-Raphælites

Quentin Bell

MACDONALD

General Editor Catherine Carver
Editor Bridget Daly
Designed by Grub Street, London
© Macdonald and Co. (Publishers) Ltd.
First published 1982
Macdonald and Co. (Publishers) Ltd.,
Maxwell House
74 Worship Street
London EC2A 2EN

Filmset, printed and bound in Great Britain by
Hazell Watson & Viney Ltd.
ISBN 0 356 085 46 5

Contents

Acknowledgements

I have been helped in writing this book by many persons, institutions and publications, perhaps by some whose names I have forgotten and whose forgiveness I must beg. Like many others I have benefited by the erudite civility of officials in the London Library, the Tate Gallery and the National Gallery. I owe much to Mrs Julian Bell, to Miss Mary Bennett and to Lord Norwich, nor should I forget those long-suffering people my publishers and their gifted representatives: Mrs Rosemary Cheetham, Miss Susan M Rea and Miss Catherine Carver, patient midwives in the mountainous parturition of this mouse.

Anyone who writes about the Pre-Raphaelites must make extensive use of those eminent Victorians, Ruskin, Holman Hunt and the Rossettis. The works of these and many other authorities will be found accurately listed in Professor W E Fredeman's *Pre-Raphaelitism: a Bibliocritical Study* (Cambridge, Mass. and London, 1965), and to him I refer my readers. My other debts are acknowledged in the Notes and Sources and in the Select Bibliography.
March 1982 QB

for Virginia Bell

Introduction

The Pre-Raphaelites imitate no pictures: they paint from
nature only. But they have opposed themselves as a body,
to that kind of teaching . . . which only began after
Raphael's time, and they have opposed themselves as
sternly to the entire feeling of the Renaissance schools; a
feeling composed of indolence, infidelity, sensuality and
shallow pride. Therefore they have called themselves Pre-
Raphaelite. If they adhere to their principles, and paint
nature as it is around them, with the help of modern
science, with the earnestness of the men of the thirteenth
and fourteenth centuries, they will, as I said, found a
new and noble school in England.

Ruskin, *Pre-Raphaelitism* (1851)

The movement in British painting John Ruskin was to herald in his
1851 pamphlet, began in 1848, when three young men, John
Everett Millais, William Holman Hunt and Dante Gabriel Rossetti,
were joined by four others – William Michael Rossetti, James
Collinson, Thomas Woolner and Frederic George Stephens – to form
the Pre-Raphaelite Brotherhood. This was a semi-secret society
whose aim was to regenerate art. I imagine that, for the time being
at all events, they would have been content to regenerate the art of
painting in England. The term 'Pre-Raphaelite' (it is spelt in a
number of ways) was already current both at home and abroad.
There was a general notion – and it was by no means new – that the
painters of the age before Raphael had been particularly earnest,
excellent and religious. Technically they were primitive, but the
piety and sincerity of their motives was, in the view of many people,
worthy of imitation.

Millais, Hunt and Dante Gabriel Rossetti were by far the most
important members of the group formed in 1848; as painters the
lesser men are not important. Of the seven, all but William Michael
Rossetti, younger brother of Dante Gabriel, were students at the
Royal Academy Schools. Ford Madox Brown, who was rather older
and much more experienced than any of them, was very closely
associated with the movement although not actually a Brother.

At this stage the Pre-Raphaelites seem to have been chiefly
interested in what was called 'history' painting, that is to say the
painting of historical, poetical or religious subjects. 'Modern'
subjects, which were felt to be something rather different from
'histories' and are sometimes described as 'genre' were also attempted;

but the Brethren in their earlier years were indifferent to, perhaps averse to, anything like pagan mythology, nor did they ever paint nude figures; they seldom painted landscape for its own sake and I do not think that they ever painted still-life except as a student's exercise. In the earlier years there were a few, but only a few, Pre-Raphaelite portraits. This meant that they were aiming at what were then considered the highest forms of pictorial art.

Millais was by far the most gifted of the young men, Rossetti the most imaginative and the most engaging. Probably it was Rossetti who, more than anyone else, created the Brotherhood as an organization; Holman Hunt, by his own account — and it would seem to be largely true — was the theoretician. He it was who invented the technique of the Brotherhood, a technique adapted to the exact and unselective examination of nature. It would be wrong to describe the Pre-Raphaelites of the Brotherhood simply as 'realist' or even 'naturalist', but there was a very strong realist element. Figures were not to be idealized; the model was to be imitated with all its natural imperfections, the ugliness of the world was to be accepted. A large number of rules and conventions still felt to be important in the painting of a 'history', and which derived from the sixteenth- and seventeenth-century masters, were to be abandoned. The Pre-Raphaelite picture was to be painted with the highest exactitude of detail in pure bright colours and without strong contrasts of light and shade.

The Brethren exhibited in the Academy exhibitions of 1848 and 1849 and were not ill received. In 1850 they attempted to launch a magazine, *The Germ*; this brought in some other young men who were not members of the Brotherhood. After two numbers it was renamed *Art and Poetry* and, after a further two numbers, it folded (May 1850). In that year the meaning of the initials PRB, with which the Brethren signed their pictures, became known, and this may have contributed to the tremendous wave of hostile feeling which became evident at the Academy Exhibitions of 1850 and 1851. At this time, when the Brethren were producing some of their most interesting work, they were denounced in the press for wilful archaism, that is to say for imitating the faulty technique of earlier masters, for choosing ugly subjects and ugly models, for something very near to blasphemy in their treatment of sacred themes, and indeed for much else. This virulent criticism continued for many years, notably in the art criticism of *The Times*, but it was in *The Times* that it received its first check when Ruskin intervened with two letters. Thereafter there was a slow improvement in the critical reception of the movement; at the same time the painters themselves attempted in their work to conciliate public opinion.

WILLIAM HOLMAN HUNT
Frontispiece to *The Germ*
1850.

The decade 1850–60 saw a great efflorescence of what I have called 'hard-edge' Pre-Raphaelite painting. A great number of painters adopted the technique of the Brotherhood and many of the pictures which we think of as being typically Pre-Raphaelite were painted by artists who were not, strictly speaking, Pre-Raphaelites.

This first epoch of Pre-Raphaelite art ends about 1860. The Brotherhood itself, which existed as a sort of club, a pleasant society of young artists united it seems by the strong and charming personality of Dante Gabriel Rossetti, with William Michael Rossetti as its secretary and chronicler, went into a decline in the early 1850s and by 1855 had vanished altogether. By that time Frederic Stephens and William Rossetti had given up painting and become art critics, in which capacity they could be of greater use to the Brotherhood as a whole; Woolner who was a sculptor was following a line of his own; Collinson was gone and so was his successor, Walter Deverell; Holman Hunt was in the Holy Land; Millais was in the Academy.

When in 1855 two new recruits, William Morris and Edward Burne-Jones, came from Oxford looking for a Pre-Raphaelite leader they found Dante Gabriel Rossetti almost, as one may say, in sole command. Dante Gabriel's situation in the Brotherhood is in many ways anomalous. He was at once the leader and the chief dissident, and it is not easy to say how much of Holman Hunt's realism he could accept. But by the mid-1850s, when he was beginning to exert a decisive influence upon Burne-Jones, he was, despite his continual efforts to complete at least one picture depicting modern life, pretty completely engaged in a kind of painting quite divorced from realism of any kind. Burne-Jones, who from the first was interested in decoration, found what he needed in Rossetti's second manner and so did William Morris. Other painters joined them or imitated them and the whole temper of the times seemed to have turned away from the moral earnestness and careful exactitude in which the movement had begun.

Because Rossetti was the leader and Ruskin the friend of the new movement, people spoke and continue to speak of Morris and Burne-Jones as Pre-Raphaelites, although the soft-edge painting of this later generation is in almost every way opposed to the kind of thing Millais and Holman Hunt were doing between 1848 and 1858. The second generation took its inspiration not from Nature but from Art; the painters before Raphael were a source but so were the masters of the High Renaissance; the nude became very important and so did the antique; mythology was valued rather than Christianity. Above all this was a style which lent itself naturally and easily to decoration.

This second flowering of Pre-Raphaelitism centres upon the work of three men, Rossetti, Burne-Jones and William Morris who had a good many imitators. It is also closely connected with 'the Firm' of Morris, Marshall and Faulkner and the 'arts and crafts' movement. It is hard here to provide precise dates, but we may think of this second wave as coming into existence in the 1860s and remaining influential into the 1890s.

The original Brotherhood, although it may have looked abroad for some of its ideas, was essentially an English movement. It had very little commerce with Europe. The second generation gradually attained an international character. The arts and crafts movement became known in Belgium and Central Europe, the influence of Ruskin was felt, and late in his career Burne-Jones excited the attention of the French Symbolists. Thus the movement as a whole may be regarded first as a withdrawal from, and then as a gradual *rapprochement* with, the art of the Continent.

Art history would hardly exist were it not for the fact that in our kind of society there is a continual shift of opinion, so that new forms are created and new tastes acquired. In the study of the Pre-Raphaelite movement we can observe this process in every stage of development. I have met older people for whom the later developments of the movement were still 'modern art', who disliked everything that had followed it and who felt that with the death of the movement beauty had also died. I have also met students who regarded the Pre-Raphaelites and in particular Rossetti with unqualified enthusiasm and who found it as natural to enjoy such work as it is to enjoy the Impressionists or the Fauves. This is an attitude which would have seemed strange to my parents and to many of their generation who could find nothing to say for any of the Pre-Raphaelites. People of my age (b. 1910) tend to be in a more complex and a more contradictory position. In our youth we laughed at the Pre-Raphaelites and when we became conscious of recent art history it seemed that everything of importance in the second half of the nineteenth century had happened in France. England, after the death of Constable and even more after the death of Turner (1852), had turned away from the mainstream of European art and gone whoring after strange insular gods. The Pre-Raphaelites had got into a stagnant backwater, they had been misled by Ruskin and had produced little except morally improving photographs in paint. The true heirs of the great European traditions had been the Realists, the Impressionists, the Post-Impressionists and the rebels of our own century. I still hold that we were not altogether wrong in thinking that the really great events in the history of art between say

1850 and 1912 took place in Paris; but I have found myself getting more and more pleasure from the earlier work of Millais, from Rossetti and from Burne-Jones and by examining my own feelings I can come nearer to the process of action and reaction which makes art history what it is.

In the years between 1900 and 1940 the Pre-Raphaelites were sufficiently distant in time to be utterly unfashionable, and perhaps we may be excused for having been unable to see any beauty in their work. What is far less excusable is the virtual absence during those years – years when so much of the living evidence must still have been available – of any serious historical studies. Because so much Pre-Raphaelite work was condemned, it was taken for granted that the Pre-Raphaelites were unworthy of attention. But what should we think of someone who made no mention of the works of Rubens in a history of Baroque painting because he happened to dislike those works?

In the case of the Pre-Raphaelites this view was carried to a point where, even in works of reference or general histories of art, these painters were not mentioned, or were dismissed with a few inaccurate remarks. The result was, of course, that other areas of art history were misrepresented, for the Pre-Raphaelites influenced other movements, and because of our wilful ignorance, movements of which the historians *do* approve were not fully understood. For, whether the practice of the Brethren was or was not to be admired, or whether the influence of the second generation upon European art in general was or was not to be deplored, the Pre-Raphaelites are a subject of the highest historical interest.

In the mythology of art history there are 'goodies' and 'baddies'; all avant-garde painters are considered 'goodies', all academicians are *ex officio* 'baddies'. This may sound ludicrous but I can assure you that it is true. Forty years ago all Pre-Raphaelites, despite the fact that theirs had been an avant-garde movement, were 'baddies', and even fifteen years ago I found it difficult to explain my interest in them to students and to colleagues. But during the past decade they have come into their own. A Millais or a Holman Hunt now fetches a large price in the sale room and Victorian art, as distinct from the art of the nineteenth-century rebels, is again in favour.

The Pre-Raphaelites may now be considered a growth industry, and I should like to suppose that the enormous increase of scholarly activity in the field, on both sides of the Atlantic, results from a clearer understanding of the duties of the historian; but probably it is simply that the movement has come back into fashion. Since 1965, when Professor Fredeman's *Pre-Raphaelitism: a Bibliocritical Study* arose pharos-tall to light the way, an ever more numerous

flotilla of lesser craft has been launched. Much has been written about Rossetti, and although some other masters have received less attention, indeed far too little attention, it cannot be long before they too become the subject of monographs. The learned journals meanwhile are full of information, and eventually someone with an efficient filing system will gather all the scraps of information together and combine them in one vast, comprehensive *General History of the Pre-Raphaelite Movement* — in, say, five volumes.

It will not be I. Even if I had the time, the scholarship and the strength for such an undertaking I do not think we are yet ready for it. For myself I propose a humbler task. This essay is but a collection, and a fairly unsystematic collection, of things that seem to me worth saying about the Pre-Raphaelites, and an attempt to answer some questions concerning the movement which I think will one day have to be answered: How and why did the Pre-Raphaelite movement come into existence and what characterized it at the outset? What was the reason for its sudden vast success and its equally sudden extinction? Finally, why was it that, having perished, it was reborn — but reborn with such a completely new personality?

Of course I shall not be able to provide perfectly satisfactory replies to all these questions; indeed I shall have work enough in trying to formulate them properly. But I feel that at this stage of Pre-Raphaelite scholarship such an endeavour may be useful; I hope, also that it may be entertaining.

Chapter 1

Origins

I have said that the Pre-Raphaelite Brotherhood was a group of young men whose aim was to regenerate the art of painting. There have been other such groups with aims which were not dissimilar, but something which makes the Pre-Raphaelites unlike any other such group is the fact that they were so very literary. It was not simply that their paintings insisted on telling 'stories' so that if we want to see them as their contemporaries saw them we must never lose sight of the narrative which lay behind their pictures, but also that they were painters themselves with peculiar literary tastes. It is not easy to say which artists interested them most and, as we shall discover, they could not and did not know much about the Italian painters before Raphael to whom in theory they owed allegiance. But they did have a particular interest in Tennyson and, much more, in Keats.

Nor is this all. In both the first and the second phases of its existence the movement produced a painter who was also a poet; and in addition to the versatile figures of Dante Gabriel Rossetti and William Morris there were others, Christina Rossetti, Elizabeth Siddal, James Collinson, William Bell Scott who expressed themselves in verse and painting or in verse alone. This is so much the case that some writers, particularly American, freely describe Swinburne and many other poets as Pre-Raphaelites. I adhere to the older practice which deals with Pre-Raphaelitism primarily as an art-historical subject. The chief figures in the original Brotherhood were after all painters and the movement in its early years was almost entirely concerned with painting, though when the group published the ill-fated magazine *The Germ* it seems to have been taken for granted that the members would be able to contribute

articles, stories and even poems. One supposes that this was Rossetti's idea and he, it would appear, was able to persuade almost anyone that he or she could do almost anything in the different arts. But it would be hard to find any other group of young artists embarking upon so purely literary a scheme; in this respect there has been nothing like the Pre-Raphaelites before or since.

This concern with literature explains in part the reluctance of the Brethren to paint still-life or landscape. History painting was the only vehicle that could serve such literary painters, and it may also explain their distaste for so much of contemporary art. At that time many painters were content with the anecdote, and although their anecdotes were taken from Goldsmith and Lesage, anyone who looks at the many anecdotal trivialities that found their way onto the walls of the Academy, and in particular the numerous 'keepsake' figures — young ladies with fine eyes, white shoulders, raven locks, etc — will agree that the Brethren did bring a new feeling of seriousness to the literary content of their work. In the same way, I think, as Millais's talent declines, he turns more and more to sentimental banalities of a kind which pleased a large public but which do not remind us of the serious literature of the age.

Perhaps then we may use a preliminary definition: The Pre-Raphaelites were literary painters attempting to use painting for the expression of serious literary ideas, as a starting point in our attempt to answer the question: 'Why did the Pre-Raphaelite movement come into existence?'

Arguments

When the Pre-Raphaelites were growing up the literary scene in England was in many ways more interesting than the artistic scene. Dickens, soon to be followed by Thackeray, the Brontës and Bulwer Lytton, had soared to fame. It was also a great age — a discernibly great age, I think — of poetry. *Sordello, Paracelsus, Locksley Hall* and *In Memoriam* were all written during those years. Looking for a poet who expresses the aspirations and anxieties of the period I find none better than Tennyson; no one voices the feelings of his age with more eloquence:

> Behold, we know not anything;
> > I can but trust that good shall fall
> > At last — far off — at last, to all,
> And every winter change to spring.
>
> So runs my dream: but what am I?
> > An infant crying in the night:
> > An infant crying for the light:
> And with no language but a cry.

The wish, that of the living whole
　　No life may fail beyond the grave,
　　Derives it not from what we have
The likest God within the soul?

Are God and Nature then at strife,
　　That Nature lends such evil dreams?
　　So careful of the type she seems,
So careless of the single life;
　　　　　　(*In Memoriam*, Cantos LIV, LV)

These surely are the sentiments of an optimist whose optimism has
almost failed him, who looks to Heaven and finds it void and who
is immensely and terribly perplexed. They remind us that Keble's
National Apostasy was published in 1833 and that this was an age of
prophets. Even the young prophets were alarming. In 1833 Carlyle
published *Sartor Resartus* and in 1837 *The French Revolution*. In 1843
Ruskin published his first volume of *Modern Painters* and in 1846 his
second. *Sybil*, by the young Disraeli, was published in 1845.

　　It was an age of deep anxiety, an age very much concerned
with religion. Even in art criticism we find a strong religious tone;
the critics; like the novelists, seemed to travel with a portable pulpit
which could be set up whenever the occasion offered, the reader was
constantly reminded that 'we have done those things which we
ought not to have done and there is no health in us'. In other
situations the writers displayed violent sectarian feeling. Nothing
disturbed the guardians of the status quo more than the desperate
spiritual adventures of those young men at Oxford who, in their
struggle against what Newman called 'Liberalism', that is to say a
spirit of doubt and toleration, found themselves forced by the passion
of their own beliefs into the arms of Rome. And yet this was, in a
way, but a skirmish upon the surface of belief; for now, and
increasingly as the century passed its meridian, religion had to
encounter a new form of infidelity: not the old bantering scepticism
of the Encyclopaedists but something even more frightening, the
sad and sober doubts voiced by an adversary who, though reluctant
in his persistence, would not go away — the scientist.

　　These philosophical agonies were reflected in the history of the
Pre-Raphaelites. Their ideas stemmed in large measure from an
enthusiasm for religious art and a dislike for that which was pagan
or worldly. They too were afflicted by doubts and they too seemed
to maintain a religious attitude in their art; it was one of their
troubles that they were identified, wrongly it would seem, with the
sectarian warfare of the age.

　　Beyond these anxieties lay a fear of another kind. Carlyle,

believing in neither the doctrines of the Church nor the pretensions of the old regime, deplores the decrepitude of the one and the frivolity of the other. In *Past and Present* he looks back nostalgically to the age of faith and of chivalry, and Disraeli agrees with him as do many others. Not without reason for, by the middle of the nineteenth century, people were beginning to wonder how, unless Christianity could hold society together, any system was to survive. In the French Revolution the Church had been the only institution which did not founder under the shock of violence and new ideas; but if faith were to be undone by a new form of doubt the Church herself might perish and then what? As a continental writer had put it: 'a spectre is haunting Europe, the spectre of communism.'

I am not suggesting that all these perplexities were present in the minds of the young men who formed the Pre-Raphaelite Brotherhood; nor, if they had been, is it likely that they would have formulated them as I have done. But I do think that the ideas, hopes and fears to which I have alluded were very much in men's minds and found their way into the literature of the period — though not the painting.

The example of architecture must have been instructive and suggestive. For nearly a century architecture had been affected by innovations which looked outside the main traditions deriving from the teachings of the Renaissance and the seventeenth century; it had in a way become 'Pre-Raphaelite', and although by the middle of the nineteenth century there was a kind of anarchy in which many different methods of architectural treatment had become acceptable, there was also a 'serious school' of revived Gothic and this, significantly, was very much involved with the sectarian divisions of the time. From the playful surface 'gothick' of the eighteenth century, which had used battlements, pointed arches and crockets for purely decorative purposes, there had developed a style altogether more serious and more earnest, an architecture which derived from the study of Gothic structure. The fact that the leading architect and theorist of the revived Gothic, A W Pugin, was a Catholic convert and that the movement did represent a turning away from the comfortable Anglican mundanity of the previous century, was enough to frighten many good Protestants. Nevertheless, by the middle of the century it had become almost impossible to build a church in any other style, and this did represent the current preoccupation with religion which had a whole body of architectural and ecclesiastical doctrine behind it.

But the strength of the revived Gothic in its architectural form derived from the fact that there was a rich native tradition on which to draw. The architects of the period could look back confidently to

the example of English Decorated, seeing in it the best form of English architecture and cheerfully destroying anything but English Decorated when it came to 'restoring' a church.

The young Pre-Raphaelites, to whom it appeared that our painting had become trivial, sensual and falsely sentimental, and who wished to make it moral, poetical and in a broad sense, religious, had no national tradition to which they could turn. The scraps of religious art which had been spared by the Reformation were not such as would inspire great excitement in a young painter of that age; they looked very crude and inept and did not have the power that might compensate for these deficiencies in another manner. Painting in England seemed to them almost to have died out or fallen into the hands of foreign portraitists in the two hundred years which had succeeded the advent of Protestantism.

The English School, as a prosperous, vital and important element in European painting, had its beginnings in the eighteenth century and the eighteenth century, to eyes which had first opened in the 1830s, seemed a barren period, an age of elegant futility, of irreligion and immorality ending in disaster; also it stood at a sufficient distance in time to have gone out of fashion and not yet to have become picturesque.

I think that the only eighteenth-century painter for whom the Pre-Raphaelites felt any enthusiasm was Hogarth. He was a moralist and a very English moralist: there was something solid and unpretentious about him, he derided the artificiality of his age. And although his loose technique was not to their taste, and although he was at times regrettably coarse, still he was made endearing by his dislike of Sir Joshua Reynolds. Reynolds the Pre-Raphaelites found objectionable for many reasons, but here I am concerned only with his content. His essays in the sublime and the antique they may very reasonably have deplored; but for the rest his talents were at the command of a not very admirable aristocracy, he taught no great moral lesson, and even Ruskin, who *did* admire him, had to concede that the portrait of Lord Heathfield — his masterpiece according to this critic — 'is but an obstinate old English gentleman after all'. I assume, although I do not know whether it is a fact, that the objections to Reynolds would have applied to Gainsborough and *a fortiori* to the lesser masters of portraiture.

There is some reason to think that the young Pre-Raphaelites had not read Ruskin, and therefore would not have read the first volume of *Modern Painters*, with its tremendous defence of Turner. But even if they had, it would have been difficult for men of a younger generation to embark upon landscape painting when that genre had been so very thoroughly exploited by their seniors; by the

time they came upon the scene that great efflorescence was pretty well over, and anyway I think they wanted to do something more clearly didactic and indeed Christian. The only thoroughly religious English artist whom they might have discovered among their English forerunners was William Blake. Little was known about Blake at that period, but the Pre-Raphaelites were better placed, at least to have heard about him, than were most of his coevals. Dante Gabriel Rossetti did indeed know Blake's poetry and even managed to borrow ten pounds from his brother William in order to purchase a Blake manuscript. William Bell Scott, who was a friend of the other Pre-Raphaelites, would surely have been familiar with Blake's work, for his brother David Scott had admired and felt its influence. Rossetti did later feel the same influence, but one will find no trace of it in the art of Millais or of Holman Hunt.

It is interesting that both Blake and the other great critic of the Academy, Benjamin Robert Haydon, were, like the Pre-Raphaelites, critical not of its ostensible purpose but rather of its neglect of that purpose. When it was founded in 1776 its first President, Reynolds, had expressed the hope that the Royal Academy would revive history painting in England: 'that this present age may vie in Arts with that of Leo X'[1]. Instead it had become a market-place where the gentry placed their orders for portraits or the masters of landscape sold their wares. To the young Pre-Raphaelites the Academy was of course something worse. It was the black beast, the perpetual monster, the enemy.

I say 'of course' because by the middle of the nineteenth century every young painter worth his salt took this view of the Royal and all other academies. They were the forcing houses of mediocrity, the strongholds of privileged incompetence, the enemies of young genius and all kinds of originality, and to these views the young painter clung — unless he were himself elected to an academic body.

Since one of the few things which seems definitely to be established about the Pre-Raphaelites is that they were opposed to the Academy, it seems useful to say a few words about what the Academy was, what it was supposed to stand for, and — for this is what the Pre-Raphaelites knew best — what it taught.

The Academy then was a collegiate body consisting of forty painters who, in the usual way of business, could only be removed by death; there was also a body of Associate Academicians from which the forty were elected. It represented painting in national affairs and it had most of the important public commissions in its hands. It held an annual Exhibition to which outsiders could send work and which was by far the most important exhibition in the

country. It maintained schools at which promising young men were educated free of charge.

The Academy stood, in principle, for a certain hierarchy of the visual arts. Just as tragedy was felt to be something finer and more philosophical than comedy, so history painting, because it dealt with transactions of great, sacred or noble persons, was felt to be grander then genre painting, in which the dealings of ordinary people, perhaps in undignified situations, perhaps exhibiting the passing fashions of the age, were represented. Genre might be preferred to portraiture, which is of necessity tied to a realistic account of things rather than idealized images, and portraiture was to be preferred to landscape, for man, a divinely made creature made in the image of divinity, is more worthy of respect than the facts of geography, botany and agriculture. But landscape again is to be preferred, in that nature can be poetic, to the humdrum statements of the still-life painter and he in his turn is preferable to the craftsman, the 'ornamentista'.

There was much in this that was absurd, and the notion that the craftsman must be kept on a very low rung of the academic ladder was to be profoundly shaken by the second generation of Pre-Raphaelites. But in their choice of subject matter the Pre-Raphaelites showed that they were largely in agreement with the academic theorists. Most of their paintings can be described as histories, and indeed Burne-Jones was in almost every way an academic painter. But the Brethren, although they usually chose 'historic' or at least poetical subjects, did not always treat them in an academic fashion and, as we shall see, one of the main points in which their practice differed from academic theory was in the general refusal to idealize their figures. The academies demanded that the painter, having found a great religious or mythological scene, should show events, not as they would probably have appeared if we had been spectators, but rather as they *ought* to have occurred; and this meant, not only that the scene should be presented in a graceful and dignified way, but that the protagonists should be made to look as beautiful as they ought to have looked. In their failure to do either of these things the Pre-Raphaelites incurred the wrath of a great many people — not simply people who understood and believed in academic theory, but people who had been brought up in a still-living tradition as to what was seemly and beautiful in art.

An extension of this part of academic teaching is the idea that the imitation of nature is no more than a means to an end. I am aware that a great many people think of academic painting as a kind of painting involving a 'photographic' imitation of nature; but in fact all academic theory and practice sees nature as something

imperfect, full of deformity and ugliness. Unless the painter be equipped to represent on a two-dimensional surface an exact equivalent of that which he sees in nature in three dimensions, he does not know his job. But unless he is ready to go further and to improve upon nature, showing us the ideal as did the Greeks and the painters of the High Renaissance, he has produced no more than a skilfully made toy for the amusement of the vulgar. The élite, says a seventeenth-century critic, is interested not in imitation but in abstraction. In the same way colour was considered a vulgar quality – an intellectual art must be based upon drawing. The Pre-Raphaelites, with what must have seemed extraordinary perversity, rejected both principles. Idealization implied falsehood; the artist must depict that which he sees howsoever imperfect a thing it might be. And yet they also believed that a painter might achieve a kind of purity which was better than genius even though, technically, he was imperfect.

It would be wrong to suppose that the Academicians of the year 1848 were regularly and conscientiously devoted to the principles of art as understood and enunciated by Sir Joshua Reynolds and his many French and Italian predecessors, that the idealized human figure, the pyramidal composition, the 'correct' disposition of light and shade, were the objects of every one of our forty immortals. As we have already observed, Sir Joshua himself, although hankering after the grand style and managing, not without some ingenuity to bring something of the academic 'history' into his portraits, painted very little in a truly academic manner.

Nor were there many amongst his successors who attempted more than a passing reference to the grand principles of the High Renaissance and the seventeenth century. Blake, in his determination to look away from nature and his ardent imitation of sixteenth-century models, might almost qualify as an academic artist; although one who was much closer to the Mannerists than to the Carracci, Haydon (one of the 'immortals' whose names were affectionately inscribed by the young Rossetti and Holman Hunt on the walls of their studio), was paradoxically enough, the author of a determined attempt not only to paint in the grand manner of the masters, but also to provide an efficient theory of idealization – something which Reynolds had sought in vain. But of the painters alive and working in the 1840s, William Etty was the only one who seemed to maintain traditional forms, and even in the work of Etty one may wonder whether the nymphs and goddesses are much more than an agreeable excuse, an occasion for the undressing of some very pretty models. For the rest, we may find the teachings of Raphael here and there in the work of Mulready, Eastlake and the young G F Watts

(but he would scarcely have been known to the Brethren), and elsewhere; but I doubt whether the annual Exhibitions of the Academy contained much that could be considered thoroughly academic. Academic principles were remembered and some quite unlikely people suddenly discovered an enormous enthusiasm for Raphael when the Pre-Raphaelites had become a menace; but when one gains one's living by painting civic dignitaries or 'sweet spots in the home counties' it is hard to bother a great deal about the Divine Urbinate.

Of what then did the Pre-Raphaelites complain, apart that is from the jealous and monopolistic tendencies of the corporation?

I think a large part of their hostility arose from the fact that they were or very recently had been Academy students. For it was in the Schools that the Academic principles found their last stronghold. Just as a young engineer was expected to begin life by learning to construe Caesar, so a young painter, even though he might already have decided to devote his life to plump cardinals or snowbound sheep, must begin by becoming familiar with the proportions of Graeco-Roman sculpture.

Academic training was perhaps fiercer in the nineteenth century than in earlier times. Until the end of the eighteenth century most artists began with some form of apprenticeship, and the academic school was a night school — hence the student might draw but did not use colour. Colours he ground, and sometimes used, in his master's studio by day. The Academy Schools and those schools which prepared for the Academy brought these night-school methods into daily education; thus there would have been no escape from the seemingly endless task of copying. The student copied eyes, mouths, noses, hands, feet and arms from the great masters, or rather from bad engravings of the work of the great masters. He drew from individual features and members, ending with entire bodies all made in plaster and all defiled with the accumulated filth of generations of students. Finally with an eye which in theory had been so blinkered by the Antique that it would actually perceive nature in terms of the Farnese *Hercules* or the Medicean *Venus*, he might work from a living model who was very unlike the ancient 'examples' which had for so long supplied all his studies. And still his work would all be in black chalk or charcoal upon white paper; when at last a brush was placed in his hands, he would be supplied with only two colours: black and white.

Needless to say, many students found a way of escaping the curriculum, working in colour from nature, and even of earning a little money on the side. But it is hardly surprising that the Academy, if it were judged by its curriculum, seemed a dead and

dreary place. For the young Millais it cannot have been too bad; he found the work so easy that he must soon have escaped from the tyranny of the classroom, and we know that from a very early age he was making small sums of money by his brush. But for Holman Hunt it must have been a terribly hard education. Unlike Millais, whose parents were delighted that their Jack should be an artist and who had no doubt about his genius, Holman Hunt's pursuit of art was sternly discouraged by his father, and his father's views were for a long time strongly supported by the Academic authorities. Hunt however was a stubborn fellow who seems almost to have enjoyed working under difficulties. By sheer dogged application he succeeded at last in gaining admission to the cast room, and he went on, with the same invincible determination, to finish the course and to become technically proficient, although he never acquired anything like Millais's magisterial ease. Throughout the course he must have become increasingly doubtful concerning the value of what he had so doggedly decided to do.

'Nature is finer than Raphael' — that was Hogarth's phrase, and if Hunt knew it he would surely have agreed: a Raphael came from the hand of genius, nature proceeded from the hand of God. To follow the masters of the High Renaissance was to turn away from nature and to fall into pedantry and mannerism, and this was all that the Schools had to offer; they bade the student look at nature through the eyes of other men — he was to falsify, to idealize, in a word to tell lies about what he saw.

Nor was this cultivation of decorous falsehoods to be confined simply to the life room. When Hunt set off on his own, attempted a landscape and brought it back to his master for criticism, he was told that he had got everything wrong. He had made the grass and leaves all green, the sky all blue. None, he was told, save a madman, an eccentric such as the late Mr Constable, would commit such absurdities. Trees must not be green, they must be brown; grass must not be green it must be harmonized, which in practice meant that it must be covered with a good thick coat of transparent golden ochre. Let everything be of more or less one tone, and let no colour be allowed to speak too stridently for itself; although the thing might not look very much like nature, it would look ever so much more like a picture.

Valuations

John Millais and Holman Hunt were devoted friends: Millais the academic prodigy, the boy most likely to succeed, and Hunt the hard-working, naturally religious, naturally Protestant intellectual.

Perhaps intellectual is the wrong word, if it conveys the idea of a well educated person, which probably Hunt was not; but of the two friends he was the thinker, and of the two he was the most literate. Both of them must have been depressed not only by the teaching of the schools but by the condition of British art, for which they would also have held the Academy responsible. Hunt was the leader in argument and very sensible to poetry and literature generally; Millais was more naturally and easily a painter, deeply influenced and seeking a new direction from his friend. Both of them were looking for something new.

And to them came a young man of a very different stamp, gifted neither with the facility of Millais nor the assiduity of Hunt, but amusing, captivating in his manners, his gaiety, his range of knowledge. He also was opposed to the Academy and marked his disdain for that institution by doing no work there; rather he sought the tuition of an older man whose work he had discovered — in such matters he was a great discoverer. But he was hardly more industrious when Ford Madox Brown set him to paint bottles than he was later when he became Hunt's student. Dante Gabriel Rossetti was indeed a most unsatisfactory pupil; he was lazy, wayward and inconstant, he borrowed money and did not return it, he left it to others to pay the rent for his studio. Indeed here was Hogarth's idle apprentice personified, and by all the rules he was from the first marked out for failure. Today we should perhaps say that it was he who attained the greatest success.

We rely on our notion of what happened in these early years of the Brotherhood upon the memoirs of Holman Hunt. *Pre-Raphaelitism and the Pre-Raphaelite Brotherhood* was written for the most part when Hunt was an old man; Mrs Holman Hunt was his amanuensis and perhaps his editor. Naturally enough, one aim of the book is to prove that Hunt was the theorist and only begetter of the Pre-Raphaelite movement, that he was always in the right and everyone else in the wrong. Old irritations seem to have been more clearly recollected than old friendships, and one certainly gets the impression in reading it that Dante Gabriel was simply a foreign cad.

Ford Madox Ford (1873–1939), the grandson of Ford Madox Brown, knew of the Brotherhood only by hearsay; nevertheless, he is not unfair, in commenting on Holman Hunt's book, to speak of Hunt's all too complete memory of conversations which back up almost too wonderfully well the patent contention that Mr Hunt and Millais deserve all the credit of Pre-Raphaelism[2]. Ford goes on to point out that really Hunt does himself an injustice, and Millais too, when he depicts them as being 'instinct with a want of generosity that it is hard to believe in'. In fact, says Ford, there was a much greater

degree of cameraderie, and much greater readiness to offer mutual help of all kinds, than the old Hunt would admit.

Certainly it is true that Rossetti, this idle apprentice who so often behaved in an unforgivable manner, was able to captivate the other two, so much so that it was he who created, first the triumvirate and then the seven-man Brotherhood, and who became virtually the leader of the band, even at a time when he was still learning from his seniors. It was he who brought them together to regenerate art.

Their motivation is not easy to understand. No doubt they were all bored by their teachers, but ennui hardly amounts to a definite programme. A programme demands some kind of theory and this they did not produce. The furthest they went, so far as we can tell, was to announce that artists should have genuine ideas to express and should study nature in order to express them.

What they did have, I think, was a vague but not unimportant concept of art history. It was not their own; it had been developing in England and even more on the Continent for a long time. This conception played an important part in the history of nineteenth-century art, though its tremendous implications only became apparent in our own century; but the Pre-Raphaelites, in their work and, even more, in their attitude to the history of art, helped to present it to men's minds.

The common attitude towards art history of most educated people of the time was that art had come to perfection in the ancient world. (I should say at the outset that this 'official' view was concerned only with the art of Egypt, the Hellenic world and Europe, and that this Eurocentric attitude was shared by the Pre-Raphaelites and by Ruskin.) An apologist for this view might have argued:

'With the fall of Rome and the onset of the barbarians art itself became barbarous, or, as they say, "gothic". Painting revives in Italy with Giotto in the twelfth century and then, after a long pause, is again revived by Masaccio. For nearly a century we see the Italians struggling to escape from the hard, dry, gothic techniques of the past. Suddenly, at the end of the fifteenth century, a glorious success is achieved by Leonardo, Correggio, Titian, Michelangelo and Raphael. These great men brought the art to perfection. It has been the business of the academies to carry on their great traditions. These traditions have been given their most perfect form by the great teachers and artists of the seventeenth century. Poussin, Guido Reni, Lebrun and the Carracci took and combined all that was noblest in the work of the High Renaissance. Although we may admire the technical virtuosity of the Dutch and the Flemish Schools

and find not inconsiderable charms in the work both of French and British landscape painters and portraitists, it is to the High Renaissance and the great eclectic masters of the seventeenth century that we turn for perfection. We live in degenerate times, but if we look for salvation then it is to that great mainstream of Italian art that we should turn.'

To this statement a Pre-Raphaelite would I think have replied: 'Your fundamental error lies in considering the High Renaissance as a glorious dawn of art. In truth it was at best a vivid sunset. The great moment of art was the fifteenth century when nature was being rediscovered, when the virtues of Greek art were alive again (for the Greeks were virtuous inasmuch as they looked at nature), but in which the vices of Greek art, pagan sensuality and the pride of virtuosity, were absent. At that time art was the handmaid of religion; she was chaste and devout and sincere, but when in the High Renaissance she accepted the adornments of the Hellenic past and became outwardly embellished she was in fact inwardly corrupted. For all their technical brilliance the artists of the High Renaissance lost their own souls while they gained the world. Art then became, what she has remained, a strumpet.'

'The change,' continues the Pre-Raphaelite, 'comes with Raphael, or at least with his later period.* What has followed has been degradation and disaster. Painters no longer serve God, they serve man. They imitate the masters of the High Renaissance and fall into mannerism. All the inventions of the seventeenth and even more of the eighteenth centuries do but take us further from religion and hence both from nature and morality. The great age of art was that immediately before Leonardo and Raphael, the age of Benozzo Gozzoli, of Fra Angelico and of all those other pious craftsmen, monks many of them, who worked for the love of God, who eschewed all carnal pride and the technical showmanship of later generations and who looked with love and respect at nature. At that time, in the age before Raphael, the artist was no mere face painter, no servile flatterer of wealth and fashion, no sycophant in pursuit of

* Raphael's short life is divisible into two halves. In the first half he was still under the influence of his master, Perugino. Then, in Florence, whither he went at the age of twenty-one (in 1504) or thereabouts, he began to study the 'modern art of' his day; this is the relatively early period of the *Sposalizio*, the *Mond Crucifixion* and many Madonnas, a period of sweet-tempered painting, simple and gentle in drawing and colour. His second period begins with his journey to Rome (1508). He had already seen Michelangelo but in Rome he is changed, he develops a new grandeur of design. This is the period of the Stanze and of the tapestry cartoons. At the time of his death he was at work on the *Transfiguration*, a highly theatrical work much disliked by Ruskin and the Pre-Raphaelites.

academic honours. He was a humble craftsman seeking only to bring honour to his guild; his art was pure, pure in line and colour, devoid of all dramatic bituminous shadowing, all tricks of foreshortening, all mannerisms borrowed from the past, all gesticulations, theatrical contrivances, and meretricious "brilliance". It was but a frank, honest and fair description of that which the artist had found in religion and seen in nature.'

The apologist of the Academy would have listened to all this with some impatience, and taking up the Pre-Raphaelite's last sentence would perhaps have replied: 'No doubt these early monkish craftsmen found a great deal in religion even though theirs was a religion which turned away from some of the most beautiful things in nature – I am thinking of the nude body. Still, even allowing that they did see something in nature, you must concede that they were not very good at describing that which they saw. Remember your early days as a student. Like all of us you began by trying to draw a face in profile and then discovered that somehow your drawing did not look right. You have been looking earnestly enough, I dare say, at nature but somehow your drawing is not like nature. Look then at an engraving of a profile by Raphael and he will inform you that the top of the ear is on a level with the eyebrow and the lobe of the ear is on a level with the nostril. Look then at your model again and you will discover that Raphael is right, that is where it is. You correct your drawing and bring it into harmony with Raphael *and with nature*. Raphael is not teaching you to copy, he is teaching you to look. It is true that nature was telling you the truth all the time; but for some reason you could not hear what she said. You needed the assistance of a master. Now, if you found your engraving in the great study of Raphael by Eugene Muntz* you will also have found a drawing by Giovanni Santi, Raphael's father, a Pre-Raphaelite if ever there was one. It represents the infant Raphael in the arms of his mother and he has drawn Signora Santi's ear much too high so that the lobe of the ear is on a level with the eyeball; just what *you* did, I dare say, when you had only nature to guide you and the effect is perfectly ridiculous.

'Raphael idealized, but his idealizations were based upon an average – an average sufficiently true for you to be able to use it when you want to look at nature (unless of course you should happen to be drawing a monstrosity). Thus, by looking at the idealized academic drawing you are in fact being taught to discover that which

* In point of fact this supposed conversation would have taken place a little too early for either disputant to have read Muntz.

is before your eyes. For, after all, most people do conform more or less to the ideal.

'Morally, the early schools had no doubt much to recommend them: they were honest, pious, workmanlike, unaffected and so on, but you must not, for that reason, forget that from our modern point of view they were inept. To imitate their religious zeal and single-hearted devotion is all very well; but to imitate their crude manner of representing reality would be folly and perversity. As well might a grown man totter across the room in imitation of a baby who has just learnt to walk.

'In saying this,' continues the apologist of the Academy, 'I do not think that I am presenting an essentially modern point of view; in fact I believe that those old painters whom you so much admire would have agreed with every word I have said. The last thing that a "primitive" would have wanted to see represented was his technical ineptitude; he knew it for what it was and, at his best, he struggled against it. Look at the two really great periods of art, or rather at the age which preceded and introduced the two great periods. Consider Greek sculpture before its greatest age, that is between the sixth and fourth centuries BC, or again your favourite century, the fifteenth, which culminates in the High Renaissance. Is it not evident that the greatest and noblest artists of those times were, above all things, dedicated to the pursuit of reality? If you compare the figures at Olympia with those on the Acropolis or compare Masaccio with Leonardo, the direction in which art was moving at once becomes clear. The men of those epochs, those whom you bid us admire for their moral qualities, were indeed moved by a divine discontent; they were aware of their imperfections and you can see how they struggled to render perspective or movement, how hard they were trying to arrive at the technical perfection which indeed their followers were finally to achieve. The centaurs upon the western pediment of the Temple of Zeus at Olympia are trying to exhibit the natural flow of limbs and drapery which the next generation will find in the horsemen of the Parthenon frieze, the *Ognissanti Madonna* of Giotto gropes splendidly but still half blindly for that solidity in space and that anatomical assurance which will be realized in the *Virgin of the Rocks*. In these great preludes there is no decay, no falling off, but rather an ever-increasing mastery of technique which culminates in the complete mastery of the apogee. How then can you discount that which was indeed the principal motive of the artists whom you profess to admire?'

'But,' answers our Pre-Raphaelite, 'you entirely mistake my meaning. I never for one moment suggested that the work of the early Christian artists was to be valued for its defects, any more than

you would claim that the pagan and lascivious qualities of the High Renaissance masters can be claimed as merits. No, our claim is that the religious purity of these older masters is so great an advantage that it cancels disadvantages which are real, even though you may exaggerate them. For admitting that in the work of the fifteenth-century painters, and even more in that of the fourteenth- and thirteenth-century artists there are certain crudities, certain awkwardnesses, is there not also a humble sincerity, an affectionate observation of nature which is worth all the braggart posturing of a Rubens or a Lebrun? So that in a spiritual way these masters do come close to nature and, to borrow a phrase, "have no awkwardnesses which are not as good as graces". If a man can learn from casts and from prints then we are ready enough to learn from Raphael. But after all it is not Raphael who teaches in the Academy Schools nor is he President. And what have Landseer and Frith, Redgrave and Eastlake to do with Raphael? These pictures of dogs and monkeys, débutantes and pork butchers, fluffy young things and fluffy old landscapes, recollections of portrait painters who were at least competent and landscape artists who have left no worthy successors – what have they to do with the High Renaissance? If you want to learn, first learn the craft of it, go to the Italians, yes and the Flemings of the fifteenth century, and see how honestly they drew and how they have used clear, bright, luminous, unequivocal pigments. They can teach us much for they can teach us to avoid the English malady which we call "slosh".

'And what is slosh? Slosh is the showy brushwork which conceals feeble drawing, slosh is the conscious brilliance of those who are clever because they cannot be great, above all slosh is bitumen. Bitumen gives you a lovely, glowing, golden darkness and if you paint into it with white you can achieve a splendid highlight, just the thing for a flashing eye or the reflected light on a fold of satin. Bitumen unites and harmonizes the brown gravy sort of painting which is now so fashionable and eventually it turns dull and dies. It cracks and flows out in great lumps all over the canvas, it never dries properly but simply goes on cracking. It brings out the worst in us for we are not a nation of draughtsmen and since mediaeval times we have only produced one important sculptor. We have always been too fond of Venetian colour, and we have a strong partiality for watercolour landscape: a form well adapted to those who seek beauty in mist and foliage rather than in precise forms.

'Loose painting, the kind of painting which makes use of accents of colour rather than of contour, may, in the right hand – those of Gainsborough or Constable – answer well enough, but when it runs to seed as it does with Etty or Sir Thomas Lawrence it

JOHN EVERETT MILLAIS
The Woodman's Daughter
1851

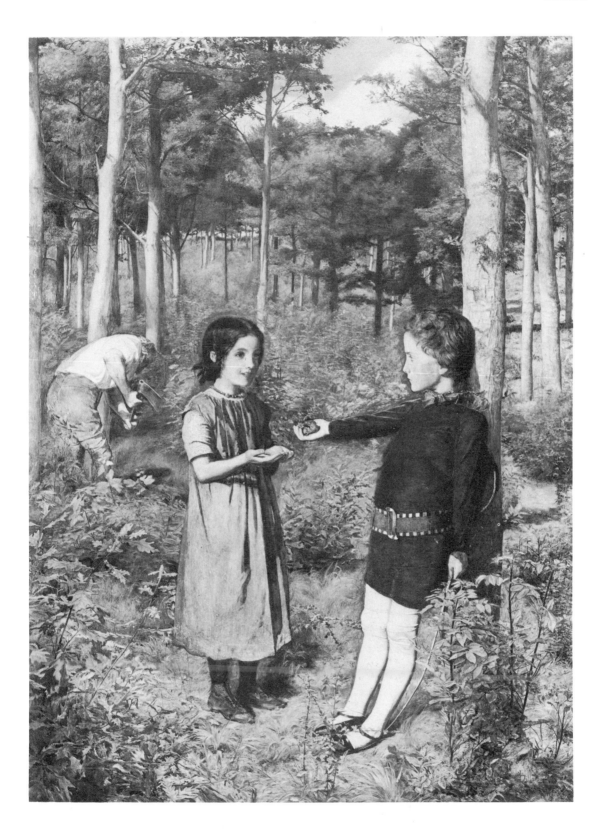

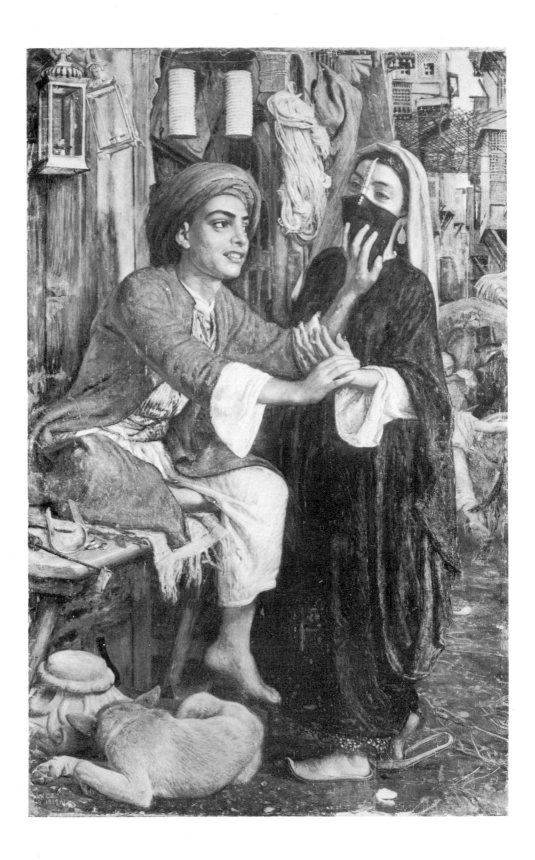

becomes vague, slovenly and meretricious. In fact, it becomes slosh.

'It is this, not the scientific drawing of the High Renaissance, to which we are opposed. It is only in their zeal, their quiet honesty of purpose, their honest respect for nature, that we wish to imitate the masters who painted in the age before Raphael.'

This last affirmation, which was often repeated by the Pre-Raphaelites, was not wholly sincere. At least it may have been what they intended, but it was not what they in fact achieved.

Look at *Ferdinand lured by Ariel*. Millais has here painted Ferdinand's trunks — every crease and wrinkle of them — so that they stand out sharp and definite against the adjacent foliage, like things cut out of cardboard and set against a tapestry. Or look at the little boy's stiff wooden arm in *The Woodman's Daughter*, by the same artist; or the boy in Hunt's *Street Scene in Cairo (The Lantern Maker's Courtship)*: in nearly all those early paintings there is a stiff, wooden quality, a mediaeval rigidity which does remind one of the fifteenth century. It reminds one even more, and this is strange, of the caricatures of mediaeval art which were at that time being produced by Dicky Doyle. As we shall see, if the Pre-Raphaelites did want to imitate something of the crudity of mediaeval work Doyle would have been their most accessible source; although it does seem strange that they should actually have gone to a parody of that which they affected seriously to admire.

Again it must be emphasized that in all their public pronouncements the Pre-Raphaelites denied that they had any intention of being archaistic.

> 1st Lady: They say that this picture was painted in the
> thirteenth century.
> 2nd Lady: Oh, earlier, surely?
> 1st Lady: Indeed, why do you think so?
> 2nd Lady: I should have thought that they could paint
> better than that in the thirteenth century.

The joke, or something very like it, appeared in *Punch* and is the work of Du Maurier. It dates from the 1880s and he returns to the same theme in *Trilby*. I quote it in order to give a notion of the strength and the persistence of this technological view of art during the last century. It was strongly held that the technical innovations of the sixteenth and seventeenth centuries represented a real advance, a real improvement in the art of painting, and that any artist who turned back to old methods was guilty of the most ridiculous affectation. For an artist to do such a thing was like a modern designer, impressed and of course rightly impressed by the work-

WILLIAM HOLMAN HUNT
*The Lanternmaker's
Courtship* 1854

manship of vintage cars, turning back to the ancient lubrication systems or the acetylene headlights of former decades. Even Ruskin, who did much to break down this idea of technological 'progress' in art, felt it necessary to apologize for the artist's crudity when he wrote in praise of Cimabue.

Today it is not easy to sympathize with a view of art which perforce allows us to suppose that any reasonably well educated art student is in the nature of things better equipped than the greatest of the Sienese masters; but this view was sincerely, nay passionately, held by painters and public alike. Until it faded and was replaced by what we now think of as more purely aesthetic considerations, the full value of the work of exotic cultures, of children and indeed of the sketch as opposed to the finished artefact, could hardly be appreciated. A vast, if silent, change of standards had to take place; and modern art, as we understand that term in our own century, could hardly have come into existence unless that change had occurred.

At the time when the Pre-Raphaelites formed their Brotherhood this 'technological' view of art was barely challenged. Nevertheless there had been a substantial change in taste throughout Europe. The Pre-Raphaelites found themselves in a situation in which a change in the traditional attitude towards art history was almost inevitable, but in which the implications of modern taste had yet to be considered.

The Sense of the Past

It may have been unwise of me to imagine a dialogue between an Academician and a Pre-Raphaelite, if in so doing I gave the impression that I was using the kind of language and the kind of examples that would have occurred to disputants in the year 1848. I have armed both parties with a knowledge of art which would have been available to very few people at that time, and which the members of the Brotherhood did not possess.

In fact — and it is a point of the utmost importance in considering the nature of their movement — the Pre-Raphaelite Brethren had seen very few works by Raphael and hardly anything by Raphael's predecessors. Where, indeed, were these young men to see them? They were young and they were poor; they could not go to Italy; it was some years before they were able to visit continental galleries. Living in London they might have been able to find a Bellini, a Perugino, two Francias, Van Eyck's *Arnolfini Marriage* and a Lorenzo Monaco in the National Gallery. At Hampton Court they would have seen the Raphael Cartoons and Mantegna's *Triumph of*

PLATE I
BENOZZO GOZZOLI *David
and Goliath* 1468–84.

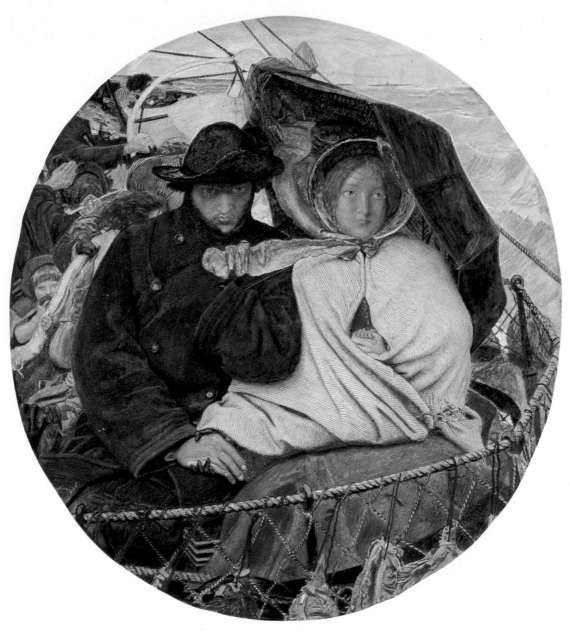

PLATE 2
FORD MADOX BROWN *The
Last of England* 1855.

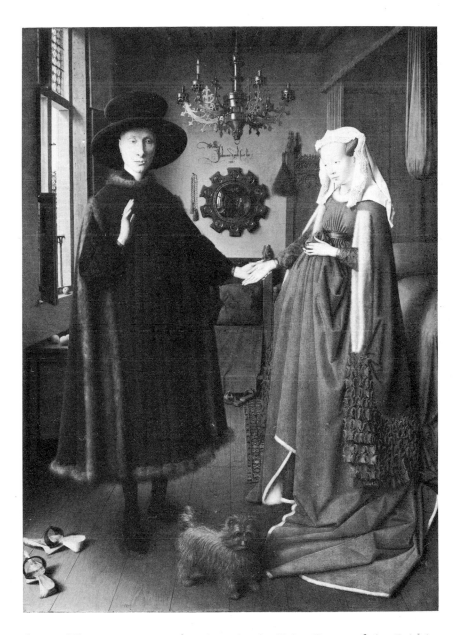

Caesar. There were some drawings in the Print Room of the British
Museum and some public exhibitions which they may or may not
have seen, but for the rest they had to rely upon casts and on
engravings — frequently very poor engravings — to give them some
idea of what they were supposed to be talking about[3].

It is not easy for us, living as we do in an age of cheap and
abundant images, to understand how hard it was for a young man
who could not find the money to take him abroad to divine through
the medium of the engraved place, the roughest of rough translations,

JAN VAN EYCK *The
Arnolfini Marriage* 1434

what the great frescoes of Italy might be like. We have to imagine discussions in which the motives of the artist, his subject matter and his use of symbolism were more important, because more accessible, than the design, the handling and above all the colour. The latter qualities had all to be taken on trust. At this time sculpture was the most accessible form of art, for a piece of sculpture could be cast. Hence the great educational importance of sculpture. Even given these reproductions, how many plaster casts are a real substitute for the original work?

The critic or the historian who wanted to show his public the beauties of a painting or a drawing had to rely either upon the dry half-truths of the engraver or upon his own descriptive powers. It was because he could write like an angel that Ruskin was so persuasive a critic; indeed from his point of view the lack of accurate or even tolerably convincing illustrations was not all pure loss. Ruskin's descriptive power is such that he can convince us that Turner is really much more like nature than is Poussin; even today his literary power is convincing, but at the time *Modern Painters* was published most of his readers had nothing save his words on which to rely.

It is worth noting, before we run away with the idea that we are in every respect better informed than our ancestors, that if you could get to Italy and see originals (better still if you went to Italy with a sketchbook, than which there is no better instrument for the understanding of pictures), you probably received an impression far deeper and far more valuable than that which the art lover of today gains from the enormous mass of mendacious rubbish, purporting to be faithful reproductions of oil paintings by the old masters, beneath which our coffee tables groan.

It remains true, however, that even in the field of academic art the student of the mid-nineteenth century was ill served, and the number of engravings that would give any idea of what painting before Raphael was like was small. It would appear that the Brethren decided to call themselves Pre-Raphaelites because they were greatly impressed by the Benozzo Gozzolis, or what people believed to be the Benozzo Gozzolis, in the Campo Santo at Pisa. Even so, Rossetti was inclined to laugh at the crudity of these old things; nor can one blame him when one looks at the engravings by Lasinio which were all that he had to go on. Ford Madox Brown set him right; but then Brown had seen the originals.

We must therefore imagine these young men discussing paintings the true character of which had to a very large extent to be imagined on the strength of other men's descriptions. But they were by no means the first to call attention to the value of the earlier

schools. A considerable body of opinion implicitly or openly challenged the orthodox view that art really began with Leonardo.

There is a certain pleasant irony in the fact that one of the first expressions of Pre-Raphaelite taste came from Sir Joshua Reynolds himself. Of the true Pre-Raphaelites not one was to speak with such perception and knowledge or in such moving terms as did the first president on the subject of Masaccio. And although Rossetti was greatly excited by Memling and Van Eyck when he visited the Low Countries in 1853, again Reynolds had been there before him. What Reynolds discovered in the early Italians and the Flemings, Flaxman discovered in the Gothic work on the façade of Exeter cathedral and J A D Ingres in the paintings of Botticelli; and during the next seventy years a great many artists and critics shared these and similar admirations.

We tend to think of Ingres and Flaxman as artists of the neo-Classical rather than the Gothic revival; but in fact the admiration for pre-Renaissance art was general: there was an almost universal interest in the older schools, and indeed in anything reminiscent of ancient and uncorrupted forms of art and society. The specific dislike of paganism was a nineteenth-century addition to a sentiment as old as, if not older than, Rousseau.

In that it drew a part of its inspiration from the Hellenic past, Italian art was always backward-looking; but the attitude to history which develops in the eighteenth century and culminates in the nineteenth century has a more radical character. It involves a new and much more acute understanding of previous ages and with it there grows a positive distaste for modernity, a very powerful and entirely novel sentiment.

This new sentiment encouraged artists to paint in a new way when they sought to represent history. In the fifteenth century it had been possible, indeed it was natural, for an artist to represent almost any scene whatever its supposed date as though it were happening at that moment outside the artist's front door. Biblical and Homeric characters would be clothed in the costumes of the painter's own time, so that today historians of costume do not hesitate to use pictures which purport to depict the rape of Helen or the death of Goliath as evidence of what was worn by ladies and gentlemen in the thirteenth or fourteenth centuries. This naïve use of contemporary material was to an increasing extent challenged during the eighteenth century, and in the nineteenth century it became impossible. In 1789, when Copley painted Charles I entering the House of Commons to arrest the seven Members, he did so with every person in the attitude and costume proper to his historic role on that occasion, and such exactitude was something of

a novelty. When, in 1851, Holman Hunt, taking a subject from Shakespeare, painted *Valentine rescuing Sylvia from Proteus* he committed the error – or so it was alleged – of painting the gentlemen's swords, or rather their sword hilts, in a style which separated them by at least fifty years from the fashions then being worn. Hunt was considerably nettled by this charge, and devotes a good three pages of his autobiographical work to a detailed refutation.

The incident provides a good example of the Pre-Raphaelite care for detail, but Hunt was by no means alone in his attempt to get his historical details 'right': by the middle of the century 'authenticity' was expected of any painter. In much the same way the architects, who indeed had led the way in this direction, were now scrupulously careful to make their pointed arches or their battlements historically convincing. Like the painters they were ready to clothe their buildings in almost any style, giving us Babylonian warehouses and Moorish banks – any style so long as it led the spectator to think of distant lands and remote ages, any style which did not smack of modernity. For this romantic attitude was two-sided: it expressed a deep affection for the past so long as the past was far enough away; but it also expressed a dyspeptic attitude towards the present.

The nineteenth century had indeed an architectural style of its own, the style that we find in the gasometer, the suspension bridge and the bottle oven. But the Pre-Raphaelites, and with them pretty well all artists and lovers of art in England, were agreed in finding these objects aesthetically detestable. Nature, it was generally agreed, was offended by anything new; but not by that which was old.

Consider the nineteenth-century landscape, with woods and fields, a running brook and mountains in the distance. The century loves them all but especially the mountains, which, as objects of delight, are still something of a novelty but in which, it is now felt, nature holds bastions inviolate. A lover of the picturesque might allow the inclusion within the landscape of peasantry, although *banditti* were to be preferred; ruined shrines were always welcome, and military architecture so long as it was clearly obsolete; cottages and mills (mills, that is, which were not powered by steam) were acceptable. But railways, factory chimneys, gasometers, iron bridges or neat modern villas were regarded as blots on the landscape and not to be tolerated. This feeling was expressed in a passionate way by Ruskin; but Ruskin voiced a sentiment already widely felt, and which made the willingness of the Impressionists to look at and to record the urban life of their time something very strange and reprehensible.

From a more positive point of view we may say that the nineteenth century, although it might bestow approval upon many cultures, had a particular affection for the Middle Ages. To most artists nothing was more acceptable and paintable than a *côte-hardi*, a hennin or a suit of armour, nothing more ungrateful to the eye than a top hat, a crinoline or a pair of trousers. And yet there is here a certain schism of opinion, and we shall find painters – and Pre-Raphaelite painters, too, who were ready to depict the horrors of modern costume – unpoetic though that might be. It was possible, although it might require courage, to paint the modern scene; and in the earlier stages of Pre-Raphaelitism the possibility of doing just this seems to have been one of the things that interested the Pre-Raphaelites, and, even more, those painters who were attracted by their method but were not members of the Brotherhood. I believe this interest in the actual world around us may have been of vital importance in determining the form that the movement took.

The Climate of Opinion

The climate of opinion in which the young Pre-Raphaelites grew up was composed of some such elements as these: there was a feeling that painting should achieve a new gravity, comparable to that of our best architecture and greatest poetry, a poetic seriousness to match the agonies of the time. It should express religious feelings and a love of nature, nature being opposed to the artificiality of the High Renaissance, and even more, of the seventeenth century. The artists were in many ways drawn to the mediaeval past, to the age of Christian art that preceded Raphael; but this feeling was in some degree checked, partly because 'young England', to borrow an expression used at the time, was distinctly vague in its notions of what art before Raphael was like, and partly because of the fear that an admiration for the sentiments of those early painters might develop into an imitation of long-discarded methods of painting – in fact of sheer incompetence. There was a strong feeling amongst the young that the modern English School lacked high principles, and that the very free methods of painting which for so long had been fashionable had now degenerated into a kind of braggart virtuosity, what the young men called 'slosh'.

The past was passionately loved; the Middle Ages, in particular, were felt to be exquisitely poetical; and yet another feeling, which may loosely be described as 'realist', informed a number of the young painters of that time, a feeling which enabled them to make a careful study of their own times. Nearly all the Pre-Raphaelites painted pictures of modern life, and those who were influenced by Pre-

Raphaelite art in its earlier manifestations seem to have painted very little else.

But where was young England to find a model, a serious religious form of art taking its inspirations from the era before Raphael? The answer is easily found: in Rome and in Germany.

For many years the Brotherhood of St Luke, usually called the Nazarenes, had been settled in Rome, in the monastery of S Isidoro on the Pincio. The brothers came from Austria and from Germany, and when they made their way back to their homelands they exerted a very strong influence both upon the art and the art teaching of the German states. They were pious and patriotic, noted for their private virtues and their religious zeal. They were convinced that painting should be the handmaid of religion.

At that time, when the British were enthusiastically discovering the greatness of German culture, when Munich rather than Paris was regarded as the artistic capital of Europe, the names of Julius Schnorr von Carolsfeld (1794–1872), Philipp Veit (1793–1877), Peter von Cornelius (1783–1867), Franz von Pforr (1788–1812) and others – names which do not loom very large in modern histories of art – were becoming famous in London. The term 'Pre-Raphaelite' was already being used in connection with their work, though not always very exactly, since for the most part these artists had a deep respect for, and were indeed obsessed by, Raphael (the earlier Raphael).

In later years the apologists of the Nazarenes claimed that although they admired the masters of the fifteenth century, they never imitated the technique of those ancient masters, never fell into the sin of wilful archaism: that had been the fault of their English followers, the Pre-Raphaelites. Holman Hunt makes the same charge: unlike the English these Germans, whose work he never had liked, fell to imitating the faults, not the virtues, of the early Italians. In fact there were faults, if faults they be, on both sides; but in the Nazarenes they were much greater. The work of Franz von Pforr did really carry mediaeval ideas and mediaeval techniques to their logical conclusion with a knowledge and a thoroughness never approached by the London Brotherhood.

The Nazarenes were also far more loquacious and far more explicit than those vague English. They followed theories which had been expressed in books, and they themselves made intelligible statements. They rejected the insincerity and the artifice of those schools which arose after the time of Raphael, greatly disliking the extravagant gestures and equivocal chiaroscuro of more recent art: they too rejected virtuoso brushwork and sensual depravity of all

kinds. They revived the use of true fresco, using pure bright colours gently modelled within severe and precise outlines, and they attempted to revive the old master/apprentice relationship in art education. Pious and benevolent in their communal life, the Nazarenes welcomed earnest-minded strangers, and made a convert of William Dyce, a young Scottish artist of high talent.

If the Pre-Raphaelites saw Dyce's *Joash Shooting the Arrow of Deliverance* or *Omnia Vanitas* or *The Dead Christ* — all Nazarene-inspired works painted before the Brotherhood was formed — they could hardly have failed to be impressed; indeed they did regard Dyce with a respect which they did not feel for other Academicians, and he for his part was their chief friend in the Academy. His interest in the German School was shared by John Rogers Herbert and in some measure by Daniel Maclise, a very popular and influential artist. Haydon, who regarded the whole business with dismay, considered it a 'return to the gilt ground inanity of the Middle Age'[4]. In London a German Prince was instructing his wife's subjects in all matters of taste, in Oxford the doctrines of Schnorr and Cornelius received the respectful attention accorded to those of Keble and Pusey. In fact the whole scene appeared to be set for an

WILLIAM DYCE *Joash Shooting the Arrow of Deliverance* 1844

entirely successful German invasion, and a conquest not altogether unlike that which France was to achieve in England sixty years later. Surely if the young wished to regenerate art here were the very men to teach them how to do it.

But the conquest never took place; the Pre-Raphaelites owed remarkably little to the Nazarenes. To be sure they cannot have seen much of their work, for there were only a few examples to be seen and those mostly in private collections – although engravings, somewhat in the manner of Dürer, were to be found in the *Art Journal*; but Holman Hunt had seen enough to know that he did not like the work of the Germans in the least. Ford Madox Brown, who had met the painters themselves, was perhaps a little influenced by them; but then this was one of the things Hunt did not like about the work of Brown. If Hunt disliked the Nazarenes it is probable that Millais would have been persuaded against them.

But the great adversary of German painting in this country was Ruskin: 'Of the German art I have no words to express the badness. I never before conceived the possibility of vanity so naïve and ludicrous existing in grown persons.'[5] This outburst, contained in a letter to Lady Waterford dated 22 August 1859, is a comparatively mild example of Ruskin's style when he approached this topic. With Keith Andrews, the learned historian of the Brotherhood of St Luke, we may wonder at the great man's violence – all the more so because, in their deep religious sincerity, their honest care for detail, their rejection of all 'insolent artifice' – the Nazarenes seemed to be doing exactly the kind of thing of which Ruskin would have approved. But we must reject the explanation offered by Mr Andrews, who ascribes Ruskin's feelings to insanely anti-Catholic prejudice[6]. Although this might have been an element in the feelings of the youthful critic, it would certainly not account for the unvarying sentiment of hostility which continues into Ruskin's later years, when he stood as it seemed upon the brink of conversion to Rome, or at least to St Francis.

In 1858 when Ruskin had experienced his 'deconversion' from puritanism, and had begun to do shocking things like painting on Sunday, he also experienced a kind of conversion to Titian and with Titian to the world of the flesh; he declared himself to be in favour of a 'strong and frank animality' in artists and he also announced that 'no painter belonging to the purist religious schools' (and this would certainly have included the Nazarenes) 'ever mastered his art'. In an appendix to the third volume of *Modern Painters* (1856) Ruskin summarizes his thoughts on German philosophy and admits that 'I never speak of German art, or German philosophy, but in deprecia-tion.'[7] And he goes on: 'I also am brought continually into collision

with certain extravagances of the German mind, by my own steady pursuit of Naturalism as opposed to Idealism . . .' He is talking not only about painting but about philosophy, but I suspect that what he complained of in the Germans was that in their extravagant pursuit of religious goals, they turned their backs upon nature altogether.

Franz von Pforr had pointed out that for the Brotherhood of St Luke, reality was but a starting point. One might add that it was a starting point soon lost from sight. All the sublimity, all the sentiment, all the high religious emotion of the earlier Italians and Flemings was preserved (in a very nineteenth-century form). But all the visual curiosity, the affectionate examination of nature – in a word, the life – was omitted. The Nazarenes were said to avoid working from living models for fear of being affected by carnal feelings. This cannot always have been the case, but the attitude of mind which rejects the loveliness and strangeness of the visible world in order the better to render approved ideas about the universe is only too evident in many of their works, and is made the more so by their continual reference to the most serene of the High Renaissance artists. The spectacle of Raphael drained of blood in the interests of transcendental virtue is not a happy one, and we turn with relief to those Nazarene portraits which give less scope for piety and learned quotation.

In saying this I believe that I express a little of what was felt by Ruskin, the Pre-Raphaelites and a great part of the British public at that time. I do not see how else to explain the very great difference in practice between British and German Pre-Raphaelite painting, and the fact that in the end the British found what they wanted in the naturalism of the Brethren.

For all their piety – and certainly Holman Hunt at least was sincerely pious – the Pre-Raphaelites were not content with the religious themes of the Germans; if we look at the numerous imitators of the Nazarenes during the 1850s the difference is striking. One has the impression that the British painters wanted to be moral but did not want to be religious; their paintings are sentimental, pathetic and no doubt edifying, but they shied away from anything like doctrine. What really seems to have interested them, and this is why they still suit our tastes, is landscape and the detail of ordinary life.

Look for instance at *Home from Sea* by Arthur Hughes, a painter who was strongly influenced by the Pre-Raphaelites in both their phases. The subject of the picture might have been provided by Charlotte M Yonge; it is pretty, mawkish and sentimental. It could provide us with all sorts of highly 'improving' reflections on life,

ARTHUR HUGHES *Home from Sea* 1863

death, family affection, etc. As such it is trivial and even ignoble compared to the sacred histories of the Nazarenes. But what has really interested Hughes is the flowers and the foliage, the play of sunlight on the grass, the quality of ivy against an old flint wall, the light and shade upon a tree trunk, the folds on a sailor's jacket. On all these things he has bestowed a serious attention which makes his story seem doubly trivial; but all are rendered with real and serious passion.

Thus Ruskin, in his rude and explosive way, was voicing in that letter of 1859 the opinion of his compatriots who have always responded to colour, landscape and all the evidence of the senses but who, in painting, tend at last to weary of ideas.

Ruskin's early connections with the Brotherhood present something of a puzzle. In 1848 when the Brotherhood came into being he was already a famous man and an influential critic. He had published two volumes of *Modern Painters*, and at the conclusion of the first volume he delivered his celebrated injunction: 'Go to Nature in all singleness of heart, scorning nothing, rejecting nothing . . .' It was advice to students rather than to mature painters, but the Pre-Raphaelites *were* students. The whole of that first volume, with its praise of naturalism and its rejection of all academic conventions and academic subterfuge does seem to provide the programme for the

movement. Indeed Ruskin himself was later to declare that these young men were putting his ideas into practice.

The connection seems so obvious and Ruskin was later to be so much connected with Pre-Raphaelitism in all its phases, that it was most naturally supposed that he was, in a more or less direct way, the founder of the movement. It therefore comes as something of a shock to read, in a published extract from an 1868 letter of Dante Gabriel Rossetti's:

> The idea that Ruskin had by his writings founded the Pre-Raphaelite school is a mistake which seems almost universal, but it is none the less completely wrong. In fact I believe that of the painters who produced the school not one had read a single one of the admirable books of Mr Ruskin and certainly none of them knew him personally. It was not until after several annual exhibitions of their paintings [at the Academy] that this great writer generously made himself their advocate in the face of the furious attacks of the press.[8]

This surprising assertion, which many authors seem to disregard, is in a negative way confirmed by the evidence. Ruskin seems never to have been alluded to before he was called in by Coventry Patmore in 1851 to redress the critical balance. In *The Germ*, the short-lived organ of the movement, a group of young critics was attempting to attack the academic view of the Renaissance, and there was Ruskin, who had done that very thing; and yet not only is he never quoted or alluded to, there is not even a trace of that very infectious style in the paper. It is as though he had never existed, as though they had indeed never heard of him.

We do however know that one member of the group had, in a hurried sort of way, read a volume of *Modern Painters*: this was Holman Hunt. But Hunt does also confirm Rossetti's statement. He describes himself as coming quite new to the book — indeed one of his first reactions was a pleased amazement that anyone should write with so much seriousness about the art of painting. Apparently he did not know that the 'Graduate of Oxford' was a *nom de plume* for Ruskin, and he told Millais about this new and exciting author as though he had indeed made a discovery, something of which Millais would know nothing. Millais, it must be allowed, was not much given to reading books.

The circumstances under which Hunt discovered *Modern Painters* should be noted, for they lead us to the heart of the puzzle. A fellow student called Telfer had read the book and offered to lend it to Hunt; but he could lend it for one night only. The book did not

belong to Telfer but to Cardinal Wiseman, and His Eminence could spare it for only a few days. So by a heroic effort (he seems rarely to have done anything without making a heroic effort), Hunt scrambled through it, reading far into the night.

> I returned it before I had got half the good there was in it: but, of all readers, none so strongly as myself could have felt that it was written expressly for him. When it had gone the echo of its words stayed with me, and pealed a further meaning of its value in their inspiration whenever my more solemn feelings were touched in any way.[9]

Holman wrote this in an article published in 1886 in the *Contemporary Review*; but in his autobiography he goes on and describes how he brought the good news to Millais. But what was the 'good news'?

It was not, apparently, anything to do with going 'to Nature in all singleness of heart, scorning nothing, rejecting nothing' — indeed from Hunt's later account of the matter it would appear that it was not the first volume of *Modern Painters* he was lent, but the second. (It is of course possible that Telfer had both the first and second volumes temporarily at his disposal; but to have polished off both in a single night would have been an almost unimaginable feat — something which Hunt would surely have remembered, and mentioned.) It is worth considering what it was that Hunt would have noticed in his hurried survey of the second volume. Whereas in his first volume Ruskin had been entirely occupied by the landscape painters, by Turner and by questions of truth to nature, in his second volume he has almost forgotten about Turner. His thought is now rather less original; he is concerned to defend the masters of the earlier schools, he has praise for Giotto, Taddeo Gaddi, Fra Anglico, Benozzo Gozzoli (and specifically those works in the Camp Santo at Pisa which were then ascribed to Gozzoli and were later to impress the Pre-Raphaelites so much) — all these are continually magnified at the expense of the more recent masters: Bronzino, Correggio, Guido, Rubens and Guercino. Hunt pointed this out to his friend Millais, but for the seventeenth-century artists whom Ruskin most disliked Hunt substituted his own bugbears: Lebrun and the Carracci.

There was some pretty stiff theorizing in the second volume which Hunt would hardly have had time to digest. He may have noticed Ruskin's strictures upon 'coarse and slurred painting' — 'slosh' in fact. He would also have noticed the 'Oxford Graduate's' fondness for the Venetians — a strange passion for a puritan critic, but 'perfect and glowing colour will redeem even the coarsest

nudities', so it is all right. What Hunt certainly did notice, for he says as much, was Ruskin on Tintoretto. How Tintoretto escaped the charge of being 'sloshy' I do not understand, but he did. But it was not Tintoretto as a designer, or even Tintoretto as a colourist, who interested Holman Hunt (had he ever seen a Tintoretto?) – no, the Tintoretto who struck Holman Hunt's imagination was 'a kind of sublime Hogarth'.

We do not usually think of the Italian master in these terms, but Ruskin did; that is to say, he thought of him as a master of realistic symbolism. In a long and persuasive description of the *Annunciation in the Scuola di S Rocco* Ruskin tells us why the Virgin sits in a ruined house – it represents the Jewish Dispensation; a white stone, the cornerstone of the old building, with builders' tools lying near to it, represents 'the stone which the builders refused . . . become the Headstone of the Corner'. And so on. . . .

For Hunt this was to be a matter of capital importance. All his tastes as a painter inclined him to an exact realism, all his principles as a man insisted that that realism should be devoted to an edifying purpose; and this was how it was to be achieved. No wonder he felt that the passage 'was written expressly for him'. From this outburst of Ruskinian eloquence he drew the method which was to make of *The Awakening Conscience*, *The Shadow of Death* and *The Finding of the Saviour in the Temple* something more than exercises in painstaking realism and explosive emotion.[10] But it cannot have been nearly so interesting to Millais.

The Lessons of the Masters

Those of us who write about art are rather too ready to suppose that when a painter embarks upon a new method or style he does so because of something that he has read in a book. Books in studios, in my experience (which is admittedly rather out of date), are apt to be incorporated in still-lives, or they prop up a table when one of its legs fails to reach the floor, and sometimes they are used for kindling fires. Some books are of course entertaining; but the theoretical works, the volumes of philosophical speculation and all those other supposedly seminal works which feature so largely in PhD dissertations upon art-historical subjects, are not, I suspect, as influential as we sometimes suppose. It is worth remembering that to Dante Gabriel, Ruskin (even when he was making his, Rossetti's, fortune) often seemed utter nonsense. As for Millais, I wonder whether he ever did find time and inclination sufficient to take him through an entire volume of *Modern Painters*.

What does influence painters is painting, and because they often find it difficult to put their feelings about paintings into words, it would be a great mistake to suppose that they do not look at the work of other men and find in it the most persuasive and important arguments.

As we have seen, there was not much Italian work of the era before Raphael that the Pre-Raphaelites could have seen; but there was a certain amount of Flemish painting, including Van Eyck and Holbein, which was visible to the public. Also amongst the moderns it is possible that Wilkie, the Wilkie of the precise luminous, highly detailed Dutch-looking works, may have attracted their attention; we know that Holman Hunt admired him enough to copy him, which is a large compliment to pay to another artist.

But just think how much Van Eyck could have said to a young man in the year 1848, when such a young man would have had all around him the dregs of the English School of portraiture. All the artifice, the brilliance, the masterly brushwork of Sir Thomas Lawrence run to flashy rhetoric would have been familiar to him. Then he is confronted by this perfect thing, *The Arnolfini Marriage* (see page 33). He knows that by the standards of the age it is full of faults: the hands are disposed in meaningless gestures, the stance of the figures is naïve and clumsy, the faces are 'wooden'; and yet he knows it to be a masterpiece. It has an authority, a power, a mystery which makes Sir Thomas look trivial. Why this should be the case neither he nor we can perfectly understand; but the lovely and precise detail is evident, the way in which the painter has examined and described everything that met his eye and with such beautiful humility, is there for all to see. The painting presents a standing challenge to the art of the academies.

There are sentiments which seem to be transmitted from artist to artist across the centuries and which give us the feeling that we have experienced exactly what our predecessors felt when they were at work. When we examine a pair of pattens on the floor at the feet of Signor Arnolfini we do not just say 'those are uncommonly well painted': we feel, in our hands as it were, the extreme pleasure the artist felt as his brush described those oddly shaped forms; his delight becomes our delight and his difficulties ours; we long to take a pencil in our hands and to rediscover something of his emotion. This almost tactile sensation may come to us from any great master; Holbein might have been the source, or indeed some lesser master. But I believe that it is most strongly felt when our predecessors are saying something in a language which is new and strange. An artist capable of feeling the beauties of that which, by current standards, is so full of faults, must feel that the rules of his teachers are in some

way wrong; he becomes a revolutionary and therefore doubly ardent in his nonconformist admirations.

But with this deeply moving communion between the artists of the mid-nineteenth century and those of the 'gothic' past (which is after all no more than speculation on my part) went something not dissimilar – the Pre-Raphaelites had a technique of their own. And this is a matter of hard fact.

Again, I suspect that to many artists, techniques are quite as important as theories. After all, pictures are not made with ideas, they are made with paint. Nor are techniques simply methods of laying on paint; they result from a kind of morality of art. The slovenly handling of their own age had to the Pre-Raphaelites been associated with a kind of aesthetic depravity, a lack of pictorial honesty. In the 1830s and '40s it had seemed that the best hope for the regeneration of art lay in the use of fresco; this had been one of the doctrines of the Nazarenes. And it is true that, if you are going to work in true fresco in the manner of the great Italians, you must forgo all those hit-or-miss methods, those scumblings and glazings, those last-minute additions which are possible when one works with oil on canvas. In fresco there can, in theory at all events, be no correction. The cartoon must be the final and unalterable statement of the artist's intentions. Everything must be planned and foreseen in advance and when, finally, the painter traces his drawing on to the wet plaster he must be able to do so with all deliberate speed, working without hesitation or faltering. This at all events is the theory; ideally the painting is but the final stage of a process in which all corrections and additions have already been made on paper.

In point of fact the decoration of the walls of the Palace of Westminster was not carried out in this orderly and serene fashion. The plasterers had again and again to cut out the ground and re-lay it (two of them are said to have been driven mad by the process), and the final colour was nothing like the soft, glowing, non-reflective hue that had been hoped for. Presumably modern artists were not worthy of the ancient and austere technique.

Holman Hunt would have witnessed the great fresco fiasco in the House of Lords. He himself never attempted the medium; but he found something which answered the same purpose. From a student of Wilkie he had learnt certain techniques which would give a brilliant, pure and lasting colour to his work. This was very like fresco painting in some of its characteristics, and also in some of the hardships which it imposed upon the artist. Hunt did not use a cartoon, but something like a sinopia, an underpainting or rather an

underdrawing, which had been used by some of the Italians who laid in a monochrome design beneath the final coat of plaster.

Hunt's initial drawing had to be a very careful and exact line drawing in black ink upon an absolutely dry, hard white surface; over this the painter laid a coat of white from which nearly all the oil had been extracted. This second coat was so thin that the drawing could be seen below it. The colour was then applied to this 'wet white' ground with such delicacy that it would not mix with the paint to which it was applied. This, naturally, involved extremely slow working, so that it was impossible to cover more than a few inches of surface each day and this had to be done before the wet white dried up. Here too, as in fresco, no correction was possible; the entire area had to be removed with a palette knife and started anew if a single mistake was made.

Hunt describes, almost one may say with gusto, the atrocious difficulties which arose from this technique, difficulties which could be greatly increased by working in the open air. The Pre-Raphaelites seem to have done this a good deal, although so far as I can make out pictures were usually finished in the studio.

No method could have been more virtuous or better calculated to discourage — indeed to render quite impossible — those meretricious effects of which the Brethren so strongly disapproved. But in addition to the method there was of course the style of which it was the natural expression, a serious, painstaking, almost naïve style. The careful and correct description of every tiniest detail of that which the painter saw had to be honestly and exactly stated in terms of a linear drawing upon the hard white ground, and each minute shape repeated with a fine sable brush upon the treacherously yielding film of 'wet' white; everything had to be premeditated and planned — never was it possible for the painter to escape from his duty towards the optical facts by means of some charming little evasion.

At first sight it may seem strange that artists should devise a method and a style so full of difficulties. But in an age so much given to false brilliance and pretentious felicity it was, I think, no more than a rather fierce attempt at honesty. Perhaps we may understand it better if we consider a parallel reformation which Ruskin introduced into the teaching of art. At that time most polite art teaching — art teaching of the kind that was provided for the edification of young ladies — consisted in teaching the pupil easy formulae for rendering foliage, clouds, etc. There were even certain tricks with sponges and damp blotting paper with which an atmospheric scene might be conjured into existence without labour. Ruskin set students to filling a square with exactly gradated and

PLATE 3
JOHN EVERETT MILLAIS
Cymon and Iphigenia
1848—51.

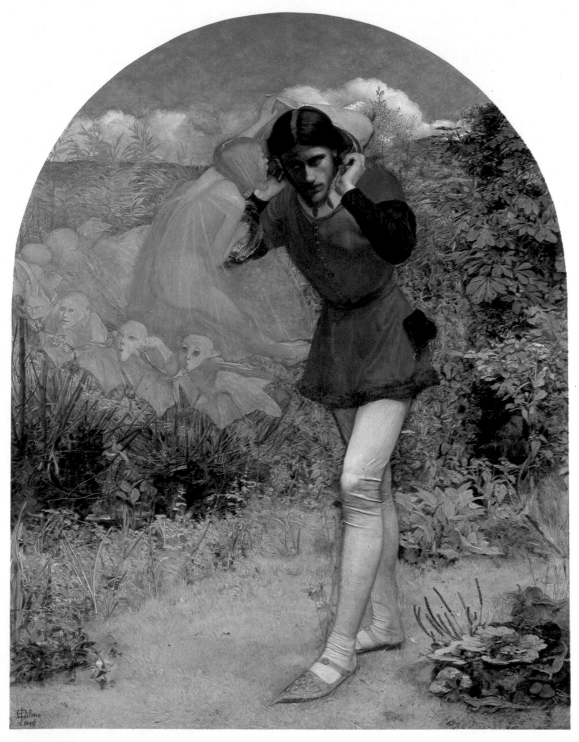

PLATE 4
JOHN EVERETT MILLAIS *Ferdinand Lured by Ariel*
1849.

exactly parallel lines; his course would, he promised, impose 'some hard and disagreeable labour', and it certainly did. There was an element of sadism in Ruskin; but did this make his teaching unpopular? Not a bit of it; in the sixteen years of its circulation *Elements of Drawing* went into sixteen thousands. There is in fact something not unattractive about a harsh technical discipline. Moreover the results must have been very seductive; the great accumulation of perfectly rendered details was in itself impressive, and it was made more so by the fact that the wet white method gave the colour a startling luminosity.

The Pre-Raphaelites were greatly opposed to the mainstream of academic thought in the importance which they attached to colour, and indeed to bright colours, frequently to colours seen in the open air. They used colour in rather an odd way, and here again we have to remember what they were reacting against in order fully to understand their practice. Hitherto the English had always, or nearly always, employed colour as an expression of joy and, to use the deprecatory words of the academicians, as a cosmetic. Such a use does not imply that the artist need either sacrifice or embellish truth; but it does mean that even the wildest explosions of colour — incandescent detonations such as Turner's *Burning of the Houses of Parliament* or his *Interior at Petworth*, which could so easily be made cruelly discordant — must be harmonized. Indeed, it is the harmonization of what might appear to be strident discords which most shows the genius of Turner. But in the generation which preceded that of the Pre-Raphaelites the harmonious picture of unified colour had come to be so much admired that artists seem to have harmonized where harmony was barely needed. There was a general avoidance of local colour, much sombre glazing and obscurity, so that the English palette — if one may suppose such a thing — began to contain an abundance of golden ochres, Vandyke browns, sepia, rose madder, terre-verte, tender dirty pinks and greys with here and there a note of black or cadmium orange.

To the Pre-Raphaelites, on the other hand, it seemed that the hues of nature were and should be rendered pure and clear. Roses were bright pink, the sky bright blue, grass green and blood, red. Most of these colours could be purchased over the counter and used without qualification. Surprisingly, and to me inexplicably, the Pre-Raphaelites seem to have hit upon a range of hot magentas, reddish blues, aggressive reds, even more aggressive violets and acidulated greens which look like the products of coal tar. But I doubt whether coal tar was being used in the manufacture of colours as early as 1848. These violent and uncompromising hues were greatly strengthened by the wet white technique, the undercoat shone back

through the film of colour to produce a startling purity. 'Like the coloured bottles in a chemist's shop', said unkind critics. And of course there was no kind of harmonization, there scarcely could be when once the colours were laid in, for nothing could be modified.

The wet white technique was originally to be a secret known only to Holman Hunt, its discoverer, and to the Brethren. The secret was imparted to Ford Madox Brown, who does not seem to have been very grateful. He writes sourly of his painting *Christ Washing Peter's Feet*, 'This picture was painted in four months, the flesh painted on *wet white* at Millais's lying instigation; Roberson's medium, which I think dangerous like Millais's advice.'[11]

Holman Hunt was the only one who never gave up the wet white method. Rossetti used it perhaps in some parts of his earlier canvases and Millais for most of his most famous works. But it took so long that even Holman Hunt could only paint two pictures in a year, and in the end it proved too wearisome for most artists. The method was not essential to the style, and the style certainly was captivating in its time. The mere idea of painting just what you see and of painting everything that is visible is in itself refreshing. The discipline was welcome and it was a simple but exhilarating thing to let nature lead one unquestioned. (To be sure at that time there were certain directions in which nature would not be so tactless as to wander.)

The practical disadvantages of the style must have made themselves felt, but gradually. The artist would have discovered that he had lost the freshness and intimacy that comes from suggestion rather than complete statement. It meant also that one of his chief weapons, the power to subdue, to select and to emphasize, became hard to use. The spectator's attention could no longer be fixed where it was needed, for the eye was led in a weary round of inspection with each part of the picture demanding equal attention; pebbles and folds, the hairs on a dog's tail, the freckles on a child's face, all made equal demands. With the wet white method where nothing could be altered or corrected all the advantages of oil paint were thrown away. The painter in oil finds out what it is that he wants to be doing while he is actually doing it; the canvas is his laboratory in which he works trying out this and that, changing, adapting, correcting, until he arrives at a final statement. The wet white method is no doubt capital, and so is fresco, if you are so sure of yourself that from the moment that you put colour on canvas you know just where you will end; but many painters – and some very good ones too – have not found it possible to work in this manner.

But, if we set all these objections on one side, and no doubt there are painters who can do just this, there are still certain

difficulties about an exact descriptive method. Despite being a method and a style admirably adapted to painters who were intent on telling the truth about nature, it was equally a style in which the whole truth could not be told. An arrow seen in profile and planted in its target can be wonderfully represented by an artist who adopts the style of Holman Hunt; he can paint the graining of the wood which forms the shaft and he can paint the highlight shining above the grain, he can carefullly and truthfully depict every single individual follicle on its feathered flight, he can render with exactness the metallic gleam upon the arrow head and the reflections upon that gleam, and to this he can add a multitude of other observations so that we can stand amazed, declaring that no representation could be more truthful. Presumably he might paint an arrow as it flies through the air with equal exactitude, if only the arrow would oblige him by stopping still in the air. One supposes that however rapid its movement these details are still, in a sense, 'there'. But here the mind refuses to co-operate. An arrow painted in this fashion is impossible to imagine. We know that the eye cannot receive that amount of detail in so short a time.

Thus when Ford Madox Brown, under the influence of the Pre-Raphaelites, painted the ribbon of a woman's bonnet streaming out in the breeze he gave the impression, even though he did render the exact shape that a ribbon in that condition would assume, of a thing cut out of tin. Or again, if we examine the same picture (*The Last of England*), we shall discover an old chap in the extreme background who is cursing his native land as he leaves her. His fist is clenched, his mouth open, and within that mouth we can count each separate tooth and also a gap where there should be a tooth; but such exactitude takes us not nearer to, but further from reality. This is not to say that *The Last of England* is not a very fine picture indeed; only that, as a representation of nature it can be faulted.

Again, if we look at Holman Hunt's picture of the Cairene streets, *The Lantern-Maker's Courtship*, we may be troubled by the wealth of laborious detail. This is not only because Hunt has attempted to paint the sudden gesture of a laughing boy – something that would be done and seen in a flash and therefore less laboriously apprehended than in this picture – but also I think because we feel that so slight an incident demands a lighter, a more rapid technique.

There is no wrong method or wrong style of drawing or of painting, although some methods may be more suitable if certain intentions are to be fully realized, and as I have said there is something captivating about such unflinching honesty of purpose. But I do believe that the 'hard-edge' technique of Pre-Raphaelitism, although clearly attractive to a great many artists, did carry with it

disadvantages which made most artists grow tired of it, and further, that this fault of the method had a most important effect upon the first phase of the movement.

But all this lay in the future. In 1848 young artists were looking for liberation, for liberation from the academies, from the long tyranny of the High Renaissance, from the dishonesty and triviality of so much contemporary work. They wanted very much to find a new purpose and a new seriousness befitting the moral perplexities of the age; above all they wanted to find some new way of painting which would make an end of the muddy empire of slosh.

The seven young men who met on a fateful afternoon in the autumn of 1848 and decided to call themselves the Pre-Raphaelite Brotherhood were no doubt very ignorant and extremely vague. 'They were,' said Coventry Patmore, 'all very simple, pure-minded, ignorant and confident.'[12] Theirs may have been, as Rossetti was later to say, 'the visionary vanity of half a dozen boys'. But although they seem to have lacked a plan or a programme, the things that they stood for (or which the public came to insist that they stood for) were highly combustible, and they had among them one man of such clearly outstanding talent that whatever they did they were bound soon to be noticed.

Chapter 2

Great Millais

One summer's morning in the year 1838, pedestrians in Soho were astonished to see a beautiful golden-haired child hanging upside down from a high building which stood at the junction of Charlotte Street and Streatham Street.

Enquiries were made, action taken, the lifeless body drawn back through the window and restored to consciousness.

The house in question served as a school, where Mr Henry Sass prepared boys for the Academy. The victim was John Everett Millais. On the previous day he had won the silver medal of the Royal Society of Arts. In so doing he had defeated one of his fellow students, a big strong brute of a boy who, enraged by jealousy and assisted by two accomplices, had tied the delicate and feeble nine-year-old by means of strings and scarves so that he was suspended from an iron window guard.

G F WATTS *Sir John Everett Millais* 1871

Thus, very early, the young Millais learnt how excellence is rewarded, and perhaps the memory of that perilous torture suggested to him that in the end one may have to kill one's genius if one is oneself to survive.

As for the brutes who committed this crime, it might only be urged that there was no other way of dealing with that victorious child. The young Millais took prizes as a boy plucks apples from a low branch, and at an age when most of us are puzzled to death by the difficulties of drawing, or perhaps still so immature that we are not even puzzled, he was calmly mastering the hardest problems with all the fluent assurance of an old hand.

Looking at his amazing juvenilia it is not always easy to know when he is or is not copying. But the little landscape of St Helier

made when he was fifteen appears to be entirely his own work. It is a painting by one who is hardly bothered by questions of scale, who disposes his landscape in space with perfect address and who has already learnt how to organize and set out a picture. There is no part of the scene which does not play its part in the whole; it is entirely adult.

By this I mean that it has a quality which is by no means universal amongst grown-up painters but is in the highest degree unusual amongst the very young, a quality which results from an impartial affection for every part of the painter's subject. Where an ordinary boy (or indeed an adult expressionist) would have seized upon one aspect or detail in nature and have spent upon it all his interest and all his ability, this extraordinary adolescent will allow no one thing to steal the picture: he permits nothing to throw him off balance, there is nothing, not a square inch of canvas, which has failed to interest him.

The power to see and, quite simply, to transfer our observations to paper, appears at first sight to be a very elementary accomplishment; in fact, as anyone who has ever studied children's drawings well knows, it is something very rare and remarkable. It means that the artist is sufficiently engaged by the actual form of things to be able to suspend his disbelief in their unexpected quality. Thus to see an arm extended in our direction and to see it for what, in our eyes, it actually is – i.e. a short lumpy object – and not for what our mind insists that it ought to be – that is to say, something long and

slender — is a power unusual in untrained adults and almost unheard of in children. Given such an ability, an artist has a tremendous pictorial engine at his command, a very high degree of facility which enables him to do what he pleases when he seeks to represent solid objects upon a plain surface. Strictly speaking, this is a mechanical rather than an aesthetic gift, but I think that it is allied to one kind of aesthetic felicity. The young Millais not only had the power to do what he liked but the power to enjoy everything that he did, and I believe that the executive power arose from the enjoyment, that is to say a happiness which comes to those who seem to be excited by everything that their eyes see.

Millais did not always enjoy this happy ubiquity of visual delight; even in his youth it sometimes failed him, and at last it seems to have gone for good. But it would surely have been stimulated by a method which demanded equal attention to and an equally meticulous description of all the details in nature. He did not invent the Pre-Raphaelite method, but it seems to me to have been perfectly adapted to his genius.

Look for instance at the portrait of Ruskin. The foliage behind the figure, the serrations of the rocks, the infinitely varied tumult of waters, the whiskers of the great man himself — all have been pursued and captured with the same devoted attention; the picture is alive in every detail. The eager, omnivorous Millais of 1844 lives on in the strong mature young painter of 1855 and with the same catholic gusto.

In 1840 Millais left the school of Mr Sass; he was only ten years old, but the doors of the Academy were open for him and some more prizes waited for collection. Soon he was no longer a pretty child — he became a beautiful adolescent, spoilt by affectionate parents who believed strongly in his genius, but simple, agreeable, high-spirited and, inevitably, much impressed by his own talent. At this time the Keeper of the Academy Schools was Mr George Jones, who painted military subjects and cultivated a resemblance to the great Duke of Wellington. The story of how he was mistaken for the Duke, and the Duke's reaction to that error ('Strange, I was never mistaken for Mr Jones') have more than anything else kept his memory alive. But it would appear that the Keeper took his duties very seriously and certainly the young Millais, who with his talents and ambitions might have been expected to attempt the grander flights of 'history' painting, did receive a pretty thorough training in academic art.

At the age of sixteen he began work upon *Pizarro Seizing the Inca of Peru*. In its use of pyramidal forms, its adroit disposition of light and shade, its painstaking composition, its graceful apposition of figures, it is a model of what such an academic exercise ought to

JOHN EVERETT MILLAIS
*Pizarro Seizing the Inca of
Peru* 1846

be and a wonderful production for one so young. And yet, it is
rather boring. Millais had reached a stage at which there was very
little that he could not express perfectly; the entire repertoire of
pictorial rhetoric lay upon the tip of his tongue; only, he could not
think what on earth to say.

It was when he was in this posture, straining his ears, as we may
say, for no matter what kind of intelligent promptings, that Fate
introduced him to the young Holman Hunt.

The friendship which united Hunt and Millais was of the most
intense kind. 'Did other men have such a sacred friendship as that
we had formed?'[1] asked Hunt when he said farewell to Millais and
set off for the Middle East. The answer, probably, is no. In any
other age, in any social climate less seriously pure, it would have
been hard not to wonder whether young men who were so very much
together, so enthusiastic not only about one another's talent but
about each other's personal beauty, could maintain so violent an
attachment in a state of perfect innocence. To my mind there is no
doubt that the conduct of Hunt and Millais was entirely chaste; but

equally it cannot be denied that they behaved as though they were lovers. Nor, when the couple became a triumvirate and Hunt began to feel the overwhelming charm of Rossetti, is it impossible that Millais suffered a little from jealousy.

The point is not unimportant in trying to discover the character of the movement in its first stage. Between Hunt and Millais there was a certain equality. Millais, obviously, was the more naturally gifted of the two; Holman Hunt, on the other hand, had a livelier intellect and greater strength of character. His *Eve of St Agnes* is in many ways a clumsy and jejune production, but already it shows a boldness of conception to which his friend had not yet learnt to aspire. In his conversation Hunt preached rebellion, he attacked Lebrun and the other false gods of his teachers, he denounced the Academy and he expounded the programme, in so far as there was a programme, which he and Millais were to follow.

Even if they had not been bound by sentiments stronger than those which usually join the adherents of an aesthetic cause, Millais could not but feel the influence of that ardent apostle of artistic sincerity with whom he was in almost daily contact. We may fairly imagine them agreeing to conquer the world together, making what Hunt called 'their compact' — the germ from which some vast regenerative force would presently emerge, the vehicle of what he called 'their system', which was to be the technique of all good painters. Just how these ends were to be achieved, how the compact was to become an engine for the destruction of the great Academic Bastille, we cannot tell; nor can we be sure that the two young men would ever have done anything but paint their own kind of pictures and hope for recognition — a policy which might have been more sensible than the one they in fact adopted. We can however be certain that when Hunt the zealous propagandist had become fast friends with Millais the great talent, they were a force to reckon with; for now, with Hunt to whisper in his ear, Millais had found something to say.

Everything was complicated, and changed, however, when in 1848 Hunt started a sudden and equally violent friendship with Dante Gabriel Rossetti. The results were dramatic and, for Millais, must have been more than a little exasperating.

Returning from a summer spent at Oxford, he discovered that Hunt was now on terms of close friendship with a person whom he, Millais, must surely have thought of as a good-for-nothing, although certainly he was a very charming Italian. (Millais despite his name always considered himself — and indeed was — thoroughly British.) Rossetti, even if great fun, even if very persuasive and well educated, was in Millais's eyes an idle apprentice, without the assiduity to

become a painter or the essential seriousness truly to understand the cause for which they were fighting. He had, nevertheless, a Neapolitan gift of the gab which enabled him almost to take control of the regeneration of art. He had been converted by Hunt, and with the dreadful enthusiasm of converts, had decided that the enemy stronghold should be stormed forthwith. Without consulting Millais, Hunt and Rossetti (it was mostly Rossetti) had for this purpose enlisted a gang – but what a gang.

We are confused by the advantage of hindsight and cannot easily tell what the new recruits looked like to Millais in 1848. Collinson was and probably could be seen to be the best of them. He had some facility, a pleasing sense of colour, and had painted some interesting pictures; I suppose it was not until later that his friends discovered he was usually half asleep and suffered, in his sleepy way, from tiresome religious vacillations. He cherished an abortive passion for Christina Rossetti, if passion be not too strong a word for the emotions of so dormouse-like a figure. Woolner also had an appearance of talent, how formidable an appearance it would be hard to say; but it must have already been clear that he was concerned only with sculpture, and his sculpture had not much to do with Pre-Raphaelitism. F G Stephens surely cannot have seemed a very promising recruit and was still very immature. William Michael Rossetti was not, and made only a few slight efforts to become, a painter.

It is sufficiently clear that Millais was not greatly impressed by 'Hunt's flock' and he must surely have been annoyed by Rossetti's enthusiasm and Hunt's weakness. To imagine that such a group could regenerate art was absurd, they had become a group of non-entities agitating for they knew not what. Perhaps, at this point, Millais regretted that he and his friends had so little in the way of a doctrine; it might at least have saved them from this impulsive way of finding allies.

In this situation Millais's course would seem to have been clear. His was the outstanding talent, without him the group could hardly have any effective existence and would surely collapse. He had only to be firm and refuse to participate in the business and there would be an end of it; he could then wait until something more formidable presented itself, or he could allow the idea of a group to die.

But Millais was not firm; either he found that his friend Holman would be too much hurt by such action, or he too was thrown off balance by the impetuous charm of Dante Gabriel. Perhaps the two motives together decided him. A stronger or a more unpleasant character might have brought that first meeting to an end without forming any kind of group. As it was the tea was drunk,

there was some talk about painting, some German engravings and Lasinio's copies of the decorations in the Campo Santo at Pisa were admired, and, somehow or other, the group was brought into existence.

Later on, turning from the unpleasant business of deciding who, in terms of artistic ability, they so lamentably were, the young men addressed themselves to a much more congenial question: what should they call themselves?

Rossetti wanted to make it an 'Early Christian Brotherhood', but to Hunt's ears this had much too Nazarene a sound. Someone remembered that Keats had spoken in favour of art before Raphael. In the Academy, Millais and Hunt had jokingly accepted the label of 'Pre-Raphaelites'; the term was current and seemed to suit them. The existing accounts of the meeting are not very explicit or very helpful, but by the end of the afternoon the group were agreed that they would call themselves Pre-Raphaelites, that they would sign their pictures with the initials PRB, and that the Brotherhood should remain a secret. As to their aesthetic aims, little more seems to have been said.

There was something in this of the secret signs and societies of childhood. They, the secret seven, would band together and hurl defiance at the Academy; but they would hurl in a quiet sort of a way lest the Academy should take notice and be cross. It was indeed, in some respects, a 'visionary vanity'.

In all this I see Millais as the leader; but a half-reluctant leader who was by no means sure where he was going. With his talents he was indispensable, and the Brotherhood would have been too ridiculous without him, but at the same time he was not a man of theories. Patmore says that his 'conversation and personality were not striking, except as being in strong contrast with his vigour and refinement as an artist. From the beginning he felt and exhibited a boyish delight in worldly success and popularity.'[2] And Patmore, it must be added, knew the Pre-Raphaelites well in those early days.

But, of course, it is this 'strong contrast' which makes us pause. There was, it would seem, 'vigour and refinement' in Millais, even if it was not present in his conversation. If we accept the early pictures and think them valuable, then surely it must be allowed that somewhere, deep in the man, there was something both genuine and formidable. I, for my part, cannot quite accept those accounts of Millais which present him simply as a kind of glorious ventrilo-quist's dummy, repeating, magnifying, embellishing the thoughts of others. But people have been explaining Millais in these terms, more or less, for a very long time. Spielmann, not a severe critic, seems to have imagined an entire committee of the Brethren,

including Hunt, Stephens, Dante Gabriel and even William Rossetti, supplying the young Millais with the imagination needed for the achievement of his great early works; and this tendency of criticism has continued in recent years, with Dante Gabriel as the movement's formative and guiding influence. For a variety of reasons I think that one should treat any such ideas with considerable reserve.

In the first place it is contradicted by both the principals — by Rossetti himself, who asserts as we shall see that it was friendship rather than any artistic collaboration which united him to Hunt and Millais, and by Millais, whose denial is worth quoting:

> The papers are good enough to speak of me as a typical English artist; but because in my early days I saw a good deal of Rossetti — the mysterious and un-English Rossetti — they assume that my Pre-Raphaelite impulses in pursuit of light and truth were due to him. All nonsense! My pictures would have been exactly the same if I had never seen or heard of Rossetti. . . . His aims and ideals in art were also widely different from ours, and it was not long before he drifted away from us to follow his own peculiar fancies. What they were may be seen from his subsequent works. They were highly imaginative and original, and not without elements of beauty, but they were not Nature. At last, when he presented for our admiration the young women which have since become the type of Rossettianism, the public opened their eyes in amazement. 'And this,' they said, 'is Pre-Raphaelitism!' It was nothing of the sort. The Pre-Raphaelites had but one idea — to present on canvas what they saw in Nature; and such productions as these were absolutely foreign to the spirit of their work. [3]

At the time when he wrote this Millais had long ceased to be PRB and had in fact become PRA; he was not unnaturally irritated by the public interest in Rossetti and by the still enduring public confusion as to what the Pre-Raphaelites were really about. Both Millais and Rossetti agreed that he, Rossetti, could hardly be accounted a Pre-Raphaelite at all if we are to use the word in its original sense; but it may still be argued that at the time of the inception of the Brotherhood there were certain ideas about painting, and even more about drawing, which they two and Holman Hunt held in common and that the origin of these ideas lies in the genius of Dante Gabriel Rossetti.

Here I think it will be illuminating to look at the sequence of events,

or rather of pictures, which marked the beginning of the Brother-hood.

After painting the *Inca of Peru* (1846) Millais set to work upon another highly academic canvas, *Cymon and Iphigenia*, which was painted for the Academy of 1848. It is full of borrowed graces, quotations taken from old masters, or at least from the old masters via Etty; there are a lot of Etty-like young women so arranged as to produce a decorative confection of an entirely artificial kind. Millais shows great skill, the skill of the prize-winning student, in his use of pose. Look for instance at the foreshortened arm of the girl who is tickling Cymon's head with a feather. Clouds of drapery, blown by those tactful gales which Academicians can summon at will, are gracefully exhibited. In fact the whole thing would be tedious were it not for the loutish figure of the still-uneducated Cymon, who, with his uncouth hound, walks straight towards us out of the picture. Cymon wrecks the picture both as a composition and as a sensational element. Perhaps it was for this reason that it was rejected by the Academy. But I think it is not entirely fanciful to see in the person of this strange intruder the emergence of something more genuine in Millais's art. What is certain is that before the work was finished Millais had met Holman Hunt and had been infected by new ideas.

> You shall see in my next picture if I won't paint something much better than 'Cymon and Iphigenia': it is too late now to treat this more naturally; indeed I have misgivings whether there is time to finish it as it is begun.[4]

If this, which is reported by Holman Hunt, is accurate, then the 'conversion' of Millais took place before the summer of 1848 when he met Dante Gabriel.*

While Millais was at work on *Cymon*, Holman Hunt was at work on *The Eve of St Agnes (The Flight of Madeleine and Porphyro during the Drunkenness Attending the Revelry)*. It was something new to take a subject from Keats. The two young men worked in the same studio and sometimes painted on each other's pictures. *The Eve of St Agnes* is a more interesting and ambitious work than *Cymon*,

* The inference is that Millais was already resolved to change his style while he was still at work on *Cymon*. This painting was sent to the Academy (and refused) in the summer of 1848; it was Hunt's picture in that exhibition which brought him into a close friendship with Rossetti, and Millais met Rossetti, through Hunt, perhaps as late as the autumn of that year. It follows that Millais's mind was to some extent made up before he met Rossetti; the original impetus, at all events, must have come from Hunt.

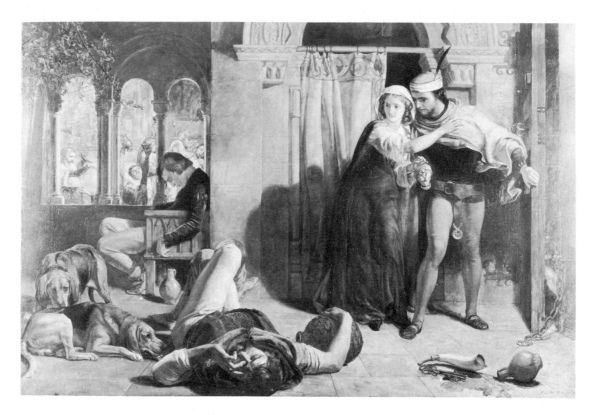

WILLIAM HOLMAN HUNT
The Eve of Saint Agnes
1848

and although Hunt is still feeling his way, so to speak, one has the impression that he is going somewhere. One aspect of the work – it may be of entirely fortuitous interest – is the division of space. Hunt places a wall parallel to the picture plane and we see through windows in it to an inner space the perspective of which is inferred and in which the action of the scene continues. He was to use the same device in his *Druids (A Converted British Family Sheltering a Christian Priest from the Persecution of the Druids)* two years later, and Rossetti and other Pre-Raphaelites were also to use it a great deal. It was *The Eve of St Agnes* which Rossetti greatly admired at the Summer Exhibition of 1848 and which led to his friendship, first with Hunt and later with Millais, and to the formation of the Brotherhood in the autumn of that year.

The transformation which took place in the work of Millais and Hunt in the year 1848–9 was dramatic. Hunt produced his *Rienzi (Rienzi vowing to obtain justice for the death of his young brother, slain in a skirmish between the Colonna and the Orsini factions)*, on an incident taken from Bulwer Lytton. Unfortunately the picture was so damaged and so extensively repainted that there is much that can only be guessed at. But it must always have looked rather odd. The Rossetti-like figure raising a clenched fist to heaven seems to have

popped out of the earth and one feels — I think because the horsemen's heads are on a level with that of this indignant figure — that the picture is too low. To this we may add another odd circumstance: the lady with two children appearing above the skyline has, because she is truncated and because of the scale of the trees upon the same skyline, the aspect of a giantess. It is in fact a far less competent painting than *The Eve of St Agnes* and I fancy that, engrossed in his new 'method', the painter lost sight of the design. Nevertheless there is something new and astonishing about the picture; Holman Hunt stumbles, but he is stumbling on the threshold of something new and tremendous.

Millais, with *Isabella*, has arrived. True, he also got into difficulties with the architecture of his scene — difficulties which he would have managed to avoid if he had been engaged on a more conventional work. But the change from 1848 is startling; it is as though the painter had a new personality, as though he had seen nature for the first time. Every single figure is real, is indeed a

WILLIAM HOLMAN HUNT
Druids (A Converted British Family Sheltering a Christian Priest from the Persecution of the Druids) 1850.

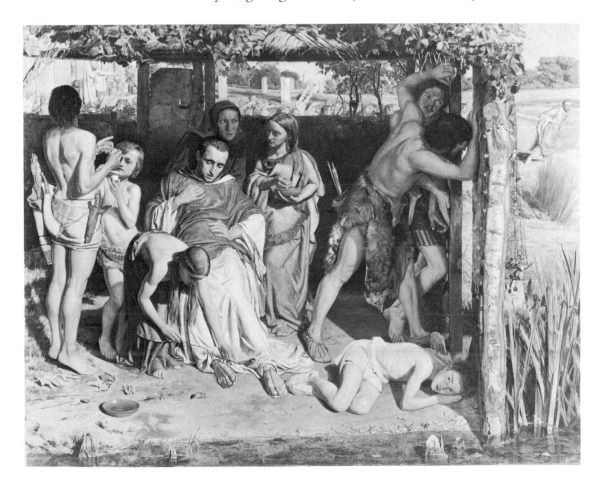

careful portrait, and almost every detail is clear, impressive and
memorable. 'The most wonderful painting', said Holman Hunt,
'that any youth under twenty years of age ever did in the world.'[5]
His enthusiasm is understandable. Comparing this extraordinary
work by Millais with Hunt's first Pre-Raphaelite picture and with
Rossetti's early productions, it is clear enough that Millais was in
full sympathy with what Hunt was doing, and we know that the
idea of naturalism came from the elder man; but Millais, when once
given a direction, seems to race ahead and to reveal powers of a
different order from those of his friend. Of Rossetti's influence I
must confess that I can see nothing.

Rossetti's first offering, made in 1849, was *The Girlhood of*

DANTE GABRIEL
ROSSETTI *The Girlhood of*
Mary Virgin 1848–49

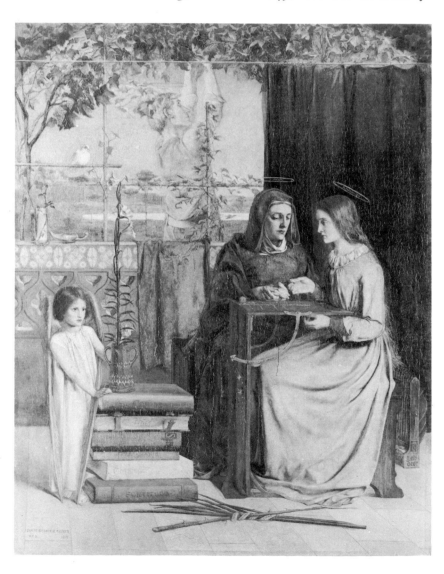

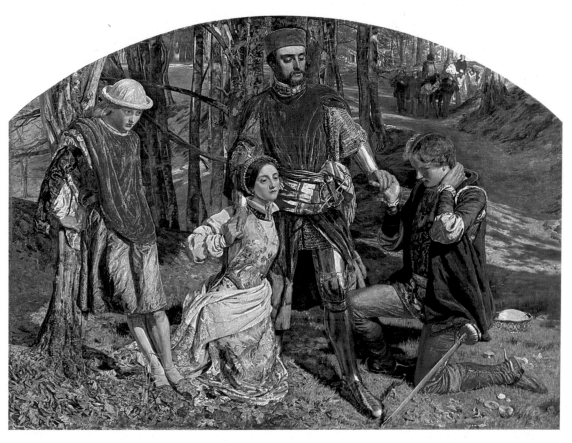

PLATE 5
WILLIAM HOLMAN HUNT
*The Two Gentlemen of
Verona: Valentine Rescuing
Sylvia from Proteus* 1851.

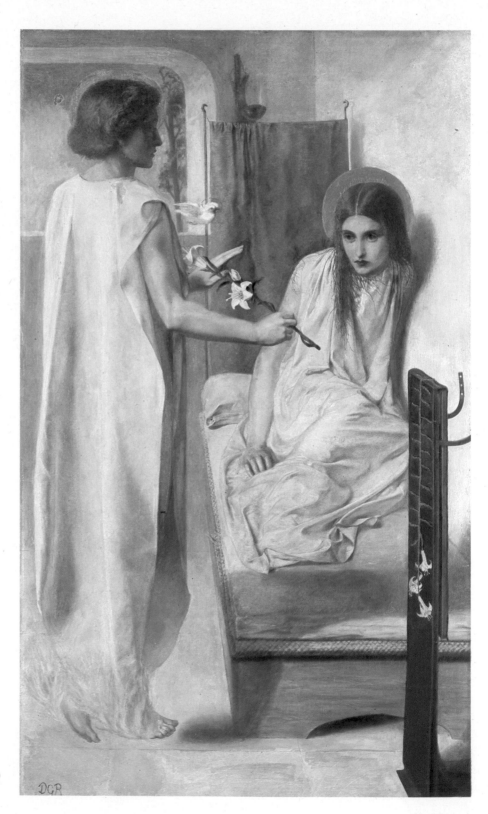

PLATE 6
DANTE GABRIEL
ROSSETTI *Ecce Ancilla
Domini (The Annunciation)*
1849.

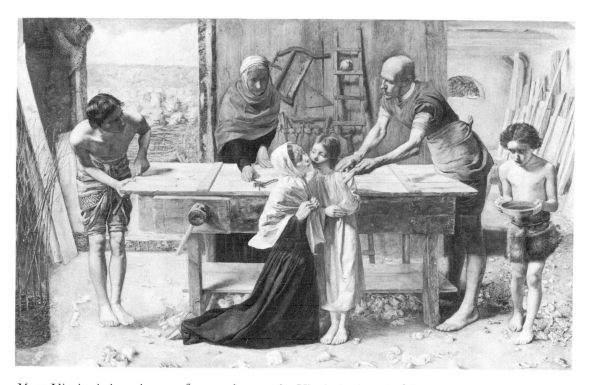

JOHN EVERETT MILLAIS
*Christ in the House of His
Parents (The Carpenter's
Shop)* 1849–50

Mary Virgin; it is a picture of some charm, the Virgin is thoughtfully painted and the still-life of books at her feet gives promise of greater achievement to come. But it is very much beginner's work; Rossetti had a good deal of assistance from his Brethren and certainly needed all that he could get. He got into a dreadful tangle with his perspective and with the feet of his immature angel, not to speak of her wings; in fact the poor urchin who sat for this figure would often run howling from the painter's yells of exasperated wrath and impatience.

It has been suggested that this very jejune effort influenced Millais in his important picture, exhibited at the Academy of 1850, the so-called *Carpenter's Shop (Christ in the House of His Parents)* and certainly it is not impossible. The rather odd space of Millais's picture may be likened to that of *The Girlhood of Mary Virgin*; and again it may be conjectured without too much improbability that Rossetti's very elaborate High Church symbolism, which must have delighted his mother and Christina, also had its effect upon Millais. On the other hand I feel that Hunt might equally well be responsible – if anyone save Millais is responsible for these characteristics of *The Carpenter's Shop*. It would not be too hard to find spatial affinities between Holman Hunt's *Druids* and the Millais, and certainly Hunt could well have imparted to his friend a taste for elaborate symbolism. Again it is worth looking for Millais's own testimony:

It was Hunt – not Rossetti – whom I habitually consulted in case of doubt. He was my intimate friend and companion; and though at the time I am speaking of, all my religious subjects were chosen and composed by myself, I was always glad to hear what he had to say about them, and not infrequently to act upon his suggestions.[6]

It is very hard to imagine a self-confident character such as Millais surely was, and one who had painted the *Isabella* and had begun to realize his full strength, going for lessons of any kind, even unconsciously, to a hesitant and in appearance incompetent beginner such as Dante Gabriel then was.

But then Millais tells us that Rossetti's 'aims and ideals in art were . . . widely different' from his and Hunt's, and when he concludes by saying that 'the Pre-Raphaelites had but one idea – to present on canvas what they saw in Nature', he forgets that they worked not only on canvas but on paper. As Mr Timothy Hilton has

DANTE GABRIEL ROSSETTI *Dante Drawing an Angel on the First Anniversary of the Death of Beatrice* 1849.

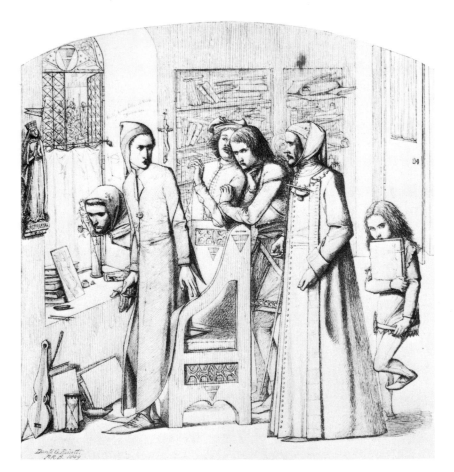

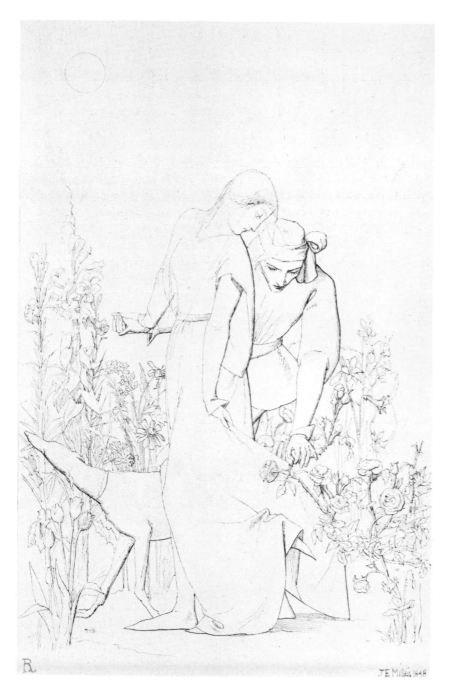

pointed out, there is a strong family resemblance amongst the drawings of the triumvirate:

> If we look at Rossetti's crowded *Dante drawing an Angel on the First Anniversary of the Death of Beatrice* (which is inscribed "to his P.R. Brother John E. Millais") it is

JOHN EVERETT MILLAIS
Two Lovers by a Rose Bush
1848

JOHN EVERETT MILLAIS
The Disentombment of
Queen Matilda 1849

obvious that the peculiarities of organization, the intensity, the refined clumsiness, the poignantly awkward movements, are very similar to Millais's style in the preliminary drawing for *Christ in the House of his Parents*. Other Millais drawings of the period have many of the same characteristics — like the beautifully sweet and sharp vision of *Two Lovers by a Rose Bush*, which illustrates a poem by Woolner and is inscribed to Rossetti.[7]

I quote Mr Hilton's words, partly because his description of the Pre-Raphaelite drawing style cannot easily be bettered, partly because, in my effort to assess Millais's position in the group it is important to know what his very just observations do in fact prove. What, so it seems to me, he does establish is that the Pre-Raphaelites or at least the triumvirate did have a common style of drawing at this period; also, when one looks at the drawings themselves they can hardly be said to present on paper that which the Pre-Raphaelites saw in nature. Look for instance at that very remarkable Millais drawing, *The Disentombment of Queen Matilda*: not only is it a drawing of something that Millais never saw, it is a drawing of something that nobody ever saw; it belongs to the world of nightmare and imagination.

A painter's drawings are often of great biographical interest, for whereas the finished canvas may contain the artist's fullest and largest ideas, his sketchbook may express his private musings, his tentative ideas, the quality of his thought. This is certainly the case

with Millais, who often seems to be drawing out his private emotions, his thoughts about marriage and romance and the supernatural, as well as his ideas for pictures. It is therefore of no little interest that there was a time when in his drawing he was very close, not only to Holman Hunt but to Rossetti.

Whether this common style derives from one member of the Brotherhood is another matter. I do not think that it owes much to Holman Hunt, who on the whole remains nearer to nature than the other two. In spirit and subject matter it owes something to Rossetti, whose early illustrations to *Faust* and Edgar Allan Poe certainly exhibit the kind of feverish drama that we find in some later Pre-Raphaelite work. But the technique, the strong linear patterning of these drawings seems to come straight from the youthful Millais, whose steady outlines suggest the influence of Flaxman.

Here perhaps we have an indication of Millais's position in the group; technically his Pre-Raphaelite work is a continuation and a development — a very startling development — of his youthful style, but now he works with an enormously stimulated imagination, and that stimulus may very well have been supplied in large measure by Rossetti.

So lively, imaginative and persuasive a person could scarcely have failed to exert a certain influence upon all the Brethren. Dante Gabriel had a social buoyancy, a great fund of high spirits which, despite the family's poverty and their misfortunes, made everything amusing. William Michael Rossetti, to whose 'PRB Journal' we are indebted for the little we know of those early days, was not, unfortunately, the man to immortalize the gaieties of the moment. In addition to this, Dante Gabriel in an unlucky hour went through the Journal tearing out pages which, for one reason or another, displeased him. The result was that when William Michael published the Journal it gave an impression of exemplary dullness. Professor Fredeman, to whom we are indebted for an edition of the Journal which contains all that can at the present day be salvaged, quotes a passage depicting what he believes 'must have been a recurring Pre-Raphaelite scene'. I can only hope that he is right in thinking so.

> *Sunday 11th* [1851]. Having sat up at Hannay's till an advanced hour in the morning, Hunt proposed that we should finish the day with a row up to Richmond, to which Gabriel, Hannay and I, agreed. We had a fine day; the lovely Spring variations of green in trees and grass were specially delightful. A bottle of champagne and a bottle of claret which we took with us from Hunt's served to drink the PRB and Tennyson and Browning in. [8]

Somehow one would never have thought of Hunt's studio being so

well stocked with liquor; it is rather comforting to know that at times it was.

'The Brotherhood, it may be mentioned, neither smoked, drank, nor swore,' writes John Guille Millais, the great man's son and biographer. Children, and particularly the children of eminent Victorians, were not always well informed by their parents on points such as these; but still it may be noticed that Millais was not on this expedition to Richmond, and it is not improbable that he led a rather more sheltered life than the others. He alone of the triumvirate came from a reasonably well-to-do family, who provided him with a studio from which his parents were firmly but gently excluded. He could therefore paint at home in relative comfort. Also he was a good deal less interested than Hunt and the Rossettis in the kind of intellectual speculation with which they were concerned.

Altogether Millais seemed the child of good fortune. Already he was beginning to sell: *Isabella* had provoked some cautionary remarks, he and Hunt were accused of archaism, but the critics were not really hostile and the picture sold for £150, by no means a bad price. And then came disaster, a disaster in which Millais found himself in the very thick of things.

In the Academy of 1850 Hunt exhibited his *Druids* and his *Claudio and Isabella*; Millais exhibited the untitled picture now usually called *The Carpenter's Shop*; and Rossetti exhibited *Ecce Ancilla Domini*, which, like *The Girlhood of Mary Virgin*, was not submitted to the Academy selectors, but was sent to another exhibiting society where it would not have to face a jury. All these works were received with roars of derisive laughter and howls of abuse. The public seems suddenly to have discovered the existence of the Pre-Raphaelites and to have hated what it discovered.

One can find a great many reasons for this sudden and dramatic hardening of popular taste. The Millais family considered that the fault lay with Rossetti: that undependable Italian had revealed the secret of the initials PRB to a journalist, and this indeed may have been one of the reasons for the hubbub. A semi-secret society is rarely popular and at that time, when the country was experiencing a violent, almost hysterical fit of anti-papal emotion, a clandestine group, composed to a large extent of men with foreign-sounding names and with a strain of High Church sentiment apparent in much of their work, might well have provoked angry suspicion. It has been pointed out that Rossetti has been rather severely treated in this matter; so many people must by then have been in the secret that within a fairly short time it would surely have been a secret no longer even if Dante Gabriel had not blabbed.

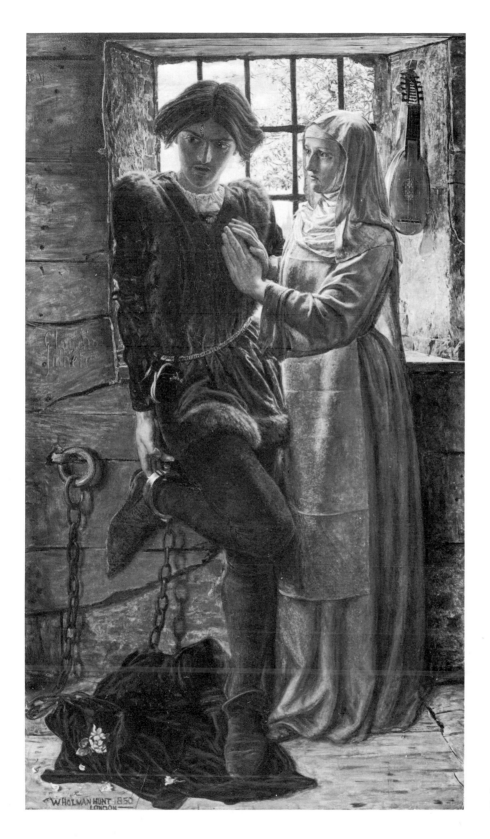

WILLIAM HOLMAN HUNT
Claudio and Isabella 1850

But certainly the incident caused ill feeling, and it was natural that the Millais family should have been upset. It had always seemed to them that their John was destined for a career of continuous and easy success; everyone had always said so, the Academicians had been so flattering, so confident. And now it was come to this: all the Brethren were being abused, but Millais, by bringing ugliness and squalor (for thus it seemed to the public) into a sacred picture, had earned a special meed of abuse. *The Times* had practically accused him of producing an obscene blasphemy; his picture, said Charles Dickens, was such that the spectator should prepare himself for 'the lowest depths of what is mean, repulsive and revolting'. [9]

Millais, it is clear, was painfully astonished. What had he done? Why was he singled out for the fiercest abuse? The answer is I think that he had done more than he intended. He had discovered and rejoiced in highly naturalistic painting. He was, perhaps in a rather vague way, sincerely religious, and so had painted a realistic religious work without I think seeing what risks he incurred and without realizing that he might be starting a revolution more shocking and more iconoclastic than anything so far dreamt of by his Brethren. In *The Carpenter's Shop* he had suggested that the great persons of the Christian religion were rather ordinary, rather ugly human beings; he had suggested even that they might belong to the lower classes. How could he hope to escape the indignant censure of the cultivated public?

When, in the following year, Ruskin came to the defence of the movement he described their aims thus:

> They intend to return to early days in this one point only – that, as far as in them lies, they will draw either what they see, or *what they suppose might have been the actual facts of the scene they desire to represent* [*my italics*], irrespective of any conventional rules of picture-making; and they have chosen their unfortunate though not inaccurate name because all artists did this before Raphael's time, and after Raphael's time did *not* this, but sought to paint fair pictures, rather than represent stern facts; of which the consequence has been that, from Raphael's time to this day, historical art has been in acknowledged decadence. [10]

What Ruskin, and probably Millais, had in mind when they established this opposition between fair pictures and stern facts is made clear in the third volume of *Modern Painters*, published six years later. There, instead of defending Millais, Ruskin takes the war into his opponents' camp. In the first of two chapters entitled 'Of the False Ideal' he directs his attack upon Raphael himself. 'In

early times,' he writes, 'art was employed for the display of religious facts'[11], but in the High Renaissance 'religious facts were employed for the display of art' and the fault lay, clearly, with Raphael. His paintings had been received as 'representations of historical fact' whereas in truth they were no more than '"compositions" — cold arrangements of propriety and agreeableness, according to academical formulas'. He takes as his example a Raphael which the English public could see, the cartoon for *The Charge to Peter*, when the resurrected Christ shows Himself to a group of His disciples who have taken a miraculous draught of fishes upon the Sea of Galilee.

In a passage which must be abridged here, Ruskin tells us what really happened, 'the actual facts of the scene'. He describes the apostolic fishermen upon the sea, their fruitless hauls, how in the early morning someone was seen from the shore, how John, shading his eyes from the morning sun, made out who it was, and how poor Simon Peter, not to be outrun this time, tightens his fisher's coat about him, and dashes in over the nets, and how they haul in their wonderful catch.

> They sit down on the shore face to face with Him, and eat their broiled fish as He bids. And then, to Peter, all dripping still, shivering and amazed, staring at Christ in the sun, on the other side of the coal fire, — thinking a

RAPHAEL *The Charge to Peter, cartoon for a tapestry* c. 1515

little perhaps, of what happened by another coal fire, when it was colder, and having had no word once changed with him by his Master since that look of His, – to him, so amazed, comes the question, 'Simon, lovest thou me?' Try to feel that a little, and think of it till it is true to you; and then take up that infinite monstrosity and hypocrisy – Raphael's cartoon of the Charge to Peter. . .[12]

It is one of Ruskin's finest passages and one of his naughtiest. For here, as so often in the first volume of *Modern Painters*, he paints a convincing verbal picture of what he boldly calls 'the actual facts of the scene' in order, later on, to blame Raphael for having failed to depict that which he, Ruskin, had decided to be the truth. The trick is all the more scandalous in that he had the Evangelist to bear witness – instead of which he presents his own carefully coloured version of the 'facts'. Still, it must be said that he manages to score heavily off the unfortunate Raphael. Raphael is found guilty of painting the 'handsomely curled hair and neatly tied sandals of the men who had been out all night in the sea-mists and on the slimy decks':

> Note their convenient dresses for going a-fishing, with trains that lie a yard along the ground, and goodly fringes, – all made to match, an apostolic fishing costume. Note how Peter especially (whose chief glory was in his wet coat *girt* about him, and naked limbs) is enveloped in folds and fringes, so as to kneel and hold his keys with grace. No fire of coals at all, nor lonely mountain shore, but a pleasant Italian landscape, full of villas and churches, and a flock of sheep to be pointed at; and the whole group of Apostles, not round Christ, as they would have been naturally, but straggling away in a line, that they may all be shown.
>
> The simple truth is, that the moment we look at the picture we feel our belief of the whole thing taken away. There is, visibly, no possibility of that group ever having existed, in any place, or on any occasion. It is all a mere mythic absurdity, and faded concoction of fringes, muscular arms, and curly heads of Greek philosophers.[13]

Ruskin, as it happened, did not much care for *The Carpenter's Shop*; but here, surely, he produces a complete justification for it. I speak here in religious terms, conscious of my audacity in venturing into that particular area of discussion, but it is not possible to do otherwise if we hope properly to examine British art in the year 1850. From a Christian point of view then, Ruskin's case against Raphael is also the proper case for Millais. The poverty and the

squalor which must belong to the life of the labouring poor, to those who are born in a manger and reared in a journeyman's workshop, who find their colleagues amongst poor fishermen and die at the hands of the public executioner, may be unpleasing to the refined worshipper. But if we would love Him we must love even the roughness of His earthly existence, and the more real, the more one of the poor, necessitous 'us' the artist can make Him, the more approachable He becomes.

Such an argument, developed with the apologetic skill suitable to the subject, would I think convince most modern amateurs. The difficulty today is to understand and sympathize with the people who were shocked.

And yet they had a case, and it is a case which we ought to respect. After all, Raphael is a superb painter, and it is very doubtful whether any of the works discussed in this book are half so good as that wonderful production *The Charge to Peter*. Nor is the religious argument quite so simple as Ruskin would have us believe. Is it in fact necessary to believe that these events ever did take place beside the Sea of Galilee? Is it not more agreeable to our sense of what is fitting to see in this story not just a fisherman's tale (and fishermen's tales do not have a good reputation) but a kind of parable? It is surely legitimate to think of the apostles as 'fishers of men' and their fishing as an early Christian propaganda exercise which, failing in its beginnings, later, with the aid of the risen Christ, becomes miraculously successful. And if we are in the world not of crude reportage but of parable, surely we may suppose apostles dressed in whatever manner seems most suitable from a pictorial point of view. There is not the slightest evidence to show that Simon Peter, Thomas a Didymus and the sons of Zebedee were *not* curly-headed; and all those charming inventions with which Raphael so beautifully adorns the scene — why should they be dismissed as mythic absurdity, are they not rather a form of visual poetry?

But it was not arguments such as these which moved the spectators of the year 1850 to an excess of passion. What hurt them was the idea that the Holy Family might be ugly and common. Raphael — and 'everyone' was brought up on Raphael — had established lovely and entirely amiable conceptions of what our Holy personages looked like. Many people must, unconsciously, have seen in his work a part of the Christian religion itself, and to such people St Joseph with his sinewy carpenter's arms, or the Virgin, that battered, prematurely aged working-class mother, in Millais's paintings appeared monstrous inventions, veritable blasphemies.

The fury of the public at the exhibition of anything that looks new, sincere, or deeply felt, at anything that looks like artistic bad

manners – and sincerity is nearly always ill bred – is something to which any student of nineteenth-century art history is well accustomed. The denunciation of Millais was echoed on the other side of the Channel by the denunciation of Courbet and of Manet, and then, later on, of the Impressionists and their successors. In England there was not to be another such outburst of aesthetic violence until, in 1910, we saw the Post-Impressionists. But in the case of Millais and his Brethren there was a difference. When the English saw Van Gogh and Cézanne they laughed at what they believed to be childish incompetence; they could not altogether laugh at Millais, for they were unable to hide from themselves the fact that, despite what they regarded as his wilful archaism – and the very ugliness of the figures looked like an imitation of the early Flemings – he was in his horrible way enormously competent. He painted like an angel; but he was an angel who had fallen. 'With a surprising power of imitation, this picture serves to show how far mere imitation may fall short, by dryness and conceit, of all dignity and truth.'[14] Thus *The Times*, and it was natural that Millais should be singled out for the most violent abuse, for he

> exalted sat, by merit raised
> to that bad eminence
> (*Paradise Lost*, II. 1)

Clearly he was shaken and so shaken that never again would he venture into that particular direction – the vein of 'probable history' or at least of probably sacred history. *The Carpenter's Shop* was his first and last essay in the genre. When, in 1856, Ruskin launched his counter-attack upon Raphael, Millais had turned to less displeasing subjects.

Oddly enough, it was Rossetti who welcomed Ruskin's onslaught upon the great Italian. Writing to Browning, he said:

> I'm about half-way through Ruskin's third volume which you describe very truly. Glorious it is in many parts – how fine that passage in the 'Religious False Ideal', where he describes Raphael's *Charge to Peter*, and the probable truth of the event in its outward aspect. A glorious picture might be done from Ruskin's description.[15]

Oddly enough, I say, for Rossetti was not always so polite about Ruskin's criticism and, when one thinks of such works as *Mary Magdalen at the door of Simon the Pharisee*, he does not seem much more devoted to probability than Raphael himself. But Dante Gabriel was not a very consistent person. He too had attempted a

probable religious history, and perhaps he was enthusiastic about Ruskin's prose.

One might think that the great champion of this kind of art would have been Holman Hunt. At the time of the foundation of the Brotherhood he was undergoing a period of doubt, and for this reason perhaps he was more concerned with morality than with sacred history. His *Christ and the Two Maries* was begun before the Brotherhood came into existence and was not finished. But when he did attempt the portrayal of Christ, in 1853, and produced *The Light of the World*, he produced something much more in line with popular conceptions of what a religious painting ought to be like than was *The Carpenter's Shop*. Hunt was hardly to blame in that Ruskin, who surely cannot have felt that this was an example of 'stern facts', wrote an enthusiastic letter to *The Times* praising the painting to the skies. Of course *The Light of the World* does not represent any actual incident. It shows a pensive Jesus knocking at a gate which is not only closed against Him but which has to all appearances been totally overlooked for a very long time, so rampant are the weeds that have overgrown it. But although the situation of Jesus is idealized, it is a little astonishing to find the sternest of the Pre-Raphaelites accepting so much in the way of finery. What relationship is there between this magnificently decorated visitor and the humble folk of *The Carpenter's Shop*? It was left to Carlyle to make the point:

> Do you ever suppose that Jesus walked about bedizened
> in priestly robes and a crown, and with yon yewels on His
> breast, and a gilt aureole round his head? . . . Don't you
> see that you're helping to make people believe what you
> know to be false, what you don't believe yourself?[16]

It is curious how close Carlyle comes to echoing Ruskin on the subject of Raphael — 'we feel our belief of the whole thing taken away'. Carlyle said a great deal more, much of it hardly to the point, and as an art critic he need not be taken very seriously; but he was all the same voicing what one would have thought was the Ruskinian and Pre-Raphaelite point of view. Diana Holman Hunt says that in fact Hunt was severely thrown by Carlyle's assault. He sold his painting for a very large sum and it has remained one of his most popular works; but surely it represents something like a betrayal of the principles of the Brotherhood.

It is said, on the same excellent authority, that Christ's robe in this picture was to be made of an old tablecloth, it was to be fashioned into the kind of night shirt which the Saviour wears so gracefully in this picture, but there was some mistake and the first

J M CAMERON *William Holman Hunt in Eastern costume* 1864

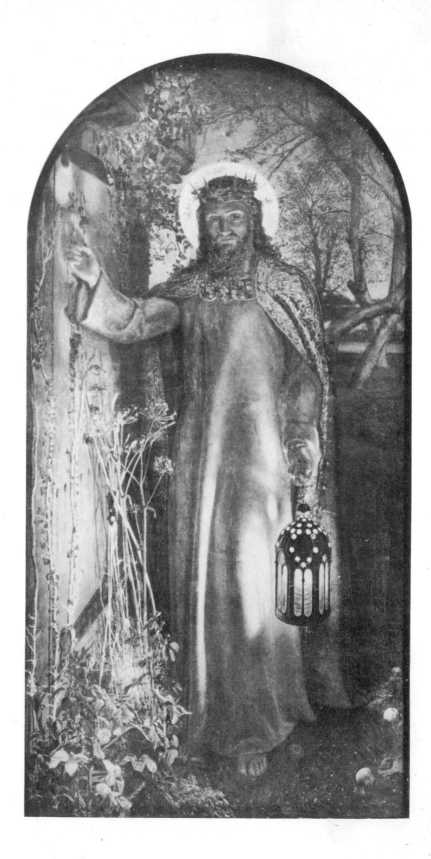

WILLIAM HOLMAN HUNT
The Light of the World
1853–56

batch of material came back from the tailor in the form of a tail coat and trousers. One wonders whether, if Hunt were indeed to be true to his principles, he should not have adopted the suggestion that fate offered him. Should not our Lord have been dressed as any itinerant preacher walking in the streets of London in the year 1853 would have been dressed? The usual course of an avant-garde movement is to work to the extreme and logical ends of its own doctrine. If the Pre-Raphaelites had been more courageous, or more certain of their own beliefs, perhaps it was to audacities of this kind that their principles should have led them. If the Bible story had been clearly and unequivocally re-told with the grime, the fog, the pavements of London as its scene, with apostles from Billingsgate, Mary of Piccadilly, Barabbas MP and Sir Pontius Pilate KCSIE, then indeed the Brethren might have brought Christianity from the world of Raphael and make-believe to that of solid everyday reality.

But of course this did not happen and in fact the future lay with the opposite camp, that of the romantic dreamers.

Holman Hunt managed, in a sense, to avoid the issue. In *The Light of the World* he made a compromise: he was minutely realistic, as always, he told a kind of truth and he told it working under very difficult circumstances; but the truth he told was the truth he had arranged to see — he chose, he even designed, the studio props to which he was going to be faithful. For a man such as he the solution was too easy; the religious realist must find some harder way to prove his fidelity to nature. Hunt found it in the Near East; here modernity had not yet corrupted ancient manners and ancient costumes, the Bedouins of the desert, even the Arabs of the towns used the same equipment as their ancestors of two thousand years before, or at least it was very likely that they did so. Here then a man could devote himself faithfully to a description of that which lay before him and yet be safe from the ugliness of modernity. In Holman Hunt's case it was all the better that this region of the world should be in a state of political ferment, that the journey there should be physically dangerous and the conditions of work quite horrible. In these circumstances a man might forget that he was in truth choosing an intellectually comfortable solution to his difficulties.

To return to Millais and *his* difficulties: one of the objections to *The Carpenter's Shop* was that the Holy personages were, so it seemed to contemporary eyes, so very ugly. In a general way the Pre-Raphaelites in turning away from Raphael were thought to have turned away from beauty. The Brethren it was felt had been guilty of working from very ugly models. Ruskin himself allowed that

these belonged to 'a type far inferior to that of average humanity'[17]. He refers here to the features of the girl on the left in Millais's *The Return of the Dove to the Ark*. But in general Ruskin does not feel able to defend the Brotherhood against this continually repeated charge. The accusation may seem strange to us today, for we associate the Pre-Raphaelites with a group of very beautiful women. Nevertheless it has to be taken seriously, if only because it bears upon the value of contemporary criticism. It came not just from Ruskin but from Mr McCracken of Belfast, Rossetti's patron, who besought the painter, just for once, to find a decent-looking model instead of those carroty-haired scrawny wenches whom he usually employed. In some cases the painters were in fact compelled to repaint faces in order to meet the needs of their customers. I am not sure that the accusation was as absurd as it now seems; if we look at the face of the girl in Hunt's *Claudio and Isabella* I think we may find it hard not to agree with the critic who complained that she was the very last person to inflame the passions of an Angelo.

In the early years of the Brotherhood — and it is in this period that these accusations seem to have more force and substance — the Pre-Raphaelites painted entirely from unprofessional models, their friends and relations for the most part, and these paintings conformed with the actual appearance of the sitter rather than with an ideal. At this period the Victorian ideal, in so far as we may deduce it from keepsakes and fashion plates, the books of beauty and the works of popular artists, was quite a recognizable type. A fairly precise figure emerges with a roundish face, a chin that is all ready to double up, a little mouth, a short straight nose, big dark eyes, dark smooth hair parted in the middle, plump arms and a tiny waist. The rest is conjecture. The lady clutching her side in P H Calderon's picture *Broken Vows* is quite a good example, and if we compare her with the girls of Millais and Holman Hunt we shall see how far they were from the ideal.

Remembering that Degas and even Renoir were once felt to be purveyors of ugliness, we need not be surprised that in the early 1850s the Pre-Raphaelites were in the same way condemned. But the prevailing fashion in beauty was not what they sought. Later on they found more seductive models and with Rossetti they began actually to set the fashion in female good looks; for the moment it was one of the tribulations which they had to bear.

In the Academy of 1851 Millais exhibited his *Return of the Dove to the Ark* and *Mariana*, Hunt showed *Valentine Rescuing Sylvia from Proteus*. Their paintings were greeted with the same violent abuse as in 1850. They were both desperate and Hunt was near to starvation. Rossetti had decided never to exhibit again. *The Times* critic wrote:

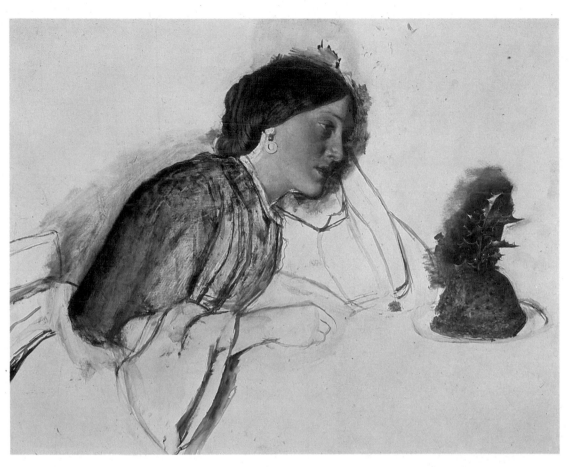

PLATE 7
ROBERT BRAITHWAITE
MARTINEAU *The Poor
Actress's Christmas Dinner*
c. 1860.

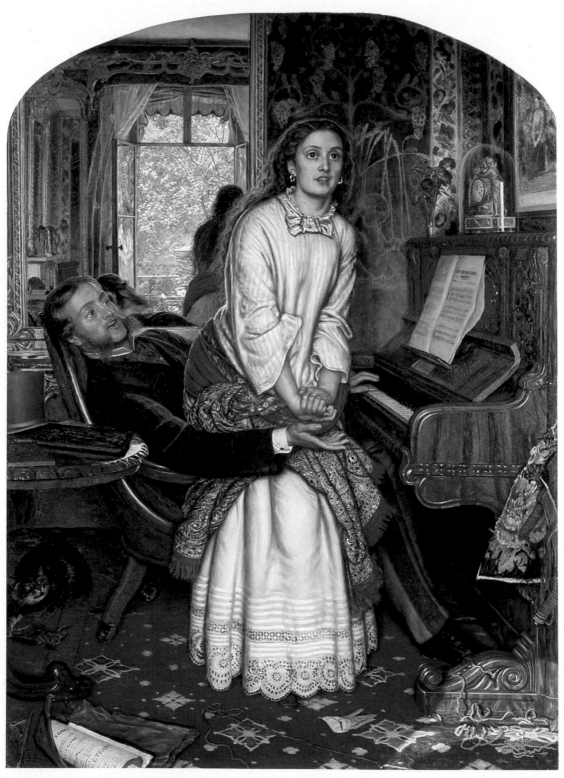

PLATE 8
WILLIAM HOLMAN HUNT *The Awakening
Conscience* 1852.

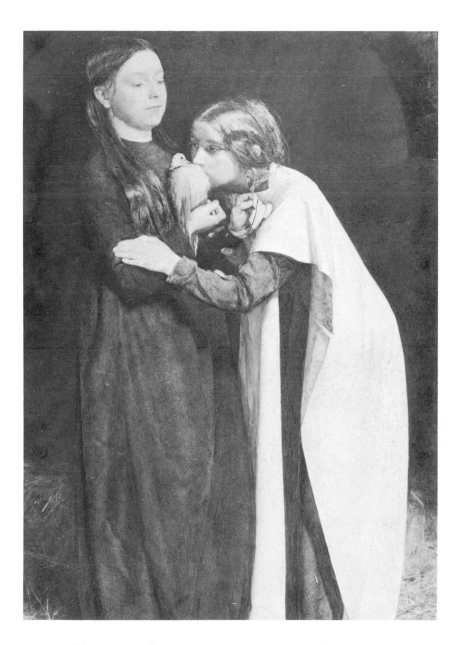

We can extend no toleration to a mere servile imitation of the cramped style, false perspective, and crude colour of remote antiquity. We want not to see . . . faces bloated into apoplexy, or extenuated to skeletons; colour borrowed from the jars in a druggist's shop, and expression forced into caricature. . . . That morbid infatuation which sacrifices truth, beauty, and genuine feeling to mere eccentricity, deserves no quarter at the hands of the public.[18]

JOHN EVERETT MILLAIS
The Return of the Dove to the Ark 1851.

The Brethren agreed that something had to be done. It was Millais who understood what was needed. He went to Coventry Patmore, Coventry Patmore went to Ruskin, Ruskin went to the Academy Exhibition and wrote those two celebrated letters to the *Times* which mark the turning point in the fortunes of the Brotherhood.

Ruskin's letters to the *Times* are by no means an unqualified eulogy of the Brethren. He found much in their work of which he disapproved; he suspected that they might be Roman Catholics or fellow travellers – a charge which they hastily denied – but they were on the right track and as they gained experience they would 'lay in our England the foundations of a school of art nobler than the world has seen for three hundred years'[19]. This was gratifying; but there was something better, there was a victory.

Nowadays, when critics differ, there is very little they can do to decide which one is right. In the nineteenth century it was, or could be, different. If at that time Critic A were to say that Mr Smith could not draw while Critic B declared that he could, Critic A might score a momentous victory by pointing to a drawing by Mr Smith in which both the eyes were on the same side of the sitter's nose. Today any critic would be laughed at who dared to suggest that so trivial a circumstance had any bearing on the argument. When the *Times* critic accused the Pre-Raphaelites of sacrificing beauty and genuine feeling to mere eccentricity, Ruskin might tell him that he was wrong but he could not prove his point. But when that critic accused the Brethren of false perspective, Ruskin could reply that there was not a single error of perspective in four out of the five pictures under discussion, and in Millais's *Mariana* there was but one; further, that he, Ruskin, would undertake to point out and demonstrate a dozen worse errors in perspective in any twelve pictures taken at random from among the popular painters of the day. In other words he accused the critic either of making a false accusation or of being an incompetent judge.

It must have been rather unpleasant for the *Times* critic. At that time Ruskin had not yet published his essay on perspective; but anyone who had read the first volume of *Modern Painters* would have known that Ruskin had a scientifically exact eye and a gift for lucid explanation which, if the critic were to attempt to argue the point, would be used to tear him into contemptible little shreds. The *Times* critic had no doubt thrown in that unlucky remark about false perspective because he was in a temper, because he enjoyed being rude and perhaps because he thought that no one would dispute his statements. And here he was challenged by the most powerful adversary anyone could wish to avoid. He could fight and be crushed or he could run away. He ran away.

Having once entered the fray Ruskin began to lay about him with vigour. He lectured, he wrote letters to the *Times*, he used his influence with wealthy people who were persuaded to buy Pre-Raphaelite pictures, he bought some himself, and he published annual guides to the Exhibitions of the Academy in which he saw to it that the young rebels should have fair play and that the old reactionaries should be savagely and horribly mauled. Like any good propagandist Ruskin declared that his side was the winning side:

> The 'magna est veritas' was never more sure of accomplishment than by these men. Their adversaries have no chance with them. They will gradually unite their influence with whatever is true or powerful in the reactionary [i.e. protesting] art of other countries; and on their works such a school will be founded as shall justify the third age of the world's civilization, and render it as great in creation as it has been in discovery.[20]

With what emotion, one wonders, did the Brethren read these words? Rossetti might, one imagines, have been ribald, but even he would have to allow that 'the visionary vanity' of those boys now that they were five years older was being taken very seriously.

No one will suppose that, when Ruskin intervened, all the difficulties of the Pre-Raphaelites were over, and that the world changed its view of the movement at Ruskin's command. But the world, although it was not entirely converted, became much less abusive, the hysterical outbursts of 1850 and 1851 were greatly mitigated, and although there was still a great weight of conservative public opinion against them they now had a really powerful friend and one whom other critics greatly feared. Also, as will be seen, they were gaining a great many recruits.

For Millais personally the accession of Ruskin was in the highest degree momentous. Soon after the publication of the second of his letters to the *Times*, Ruskin met his new protégés. It was a very pleasant occasion, they were sincerely grateful and he appreciated their gratitude; amongst other things it licensed him to lecture them about their paintings and to point out their many faults, an exercise which he seems to have enjoyed immensely. Naturally enough he sought out Millais and Millais became his particular friend. It was very clear to Ruskin, at this time, that Millais was the great man of the movement. Ruskin saw in him the natural successor to Turner, the great future hope of British art. Millais saw in Ruskin a splendid patron, a wonderful advocate and, before long, the husband of a remarkably charming young woman.

But the fear of persecution remained with him, and it was not for many years that the shock of 1850 and its cruel diatribes could be forgotten. For the Academy of 1852 he painted one of his most accomplished works, *Ophelia*, and another work in which for the first time he used a professional model. The latter seems to have begun with a very vague idea of two lovers standing by a garden wall, and it was Hunt who insisted that it should carry a more didactic message, a message which Millais found in Meyerbeer's opera *The Huguenot*. It is worth giving the title in full: *A Huguenot, on St Bartholomew's Day Refusing to Shield Himself from Danger by Wearing the Roman Catholic Badge*, for it does something to explain the immediate and overwhelming success of the picture. One need scarcely add — the reader will at once have divined — that the Huguenot, a fine upstanding chap, is gently resisting the affectionate persuasions of an extremely personable companion. Here then there were no more dark Romanist tendencies, but rather splendid Protestant heroism and tender sentiment. Even the *Times* was grudgingly polite; others were enthusiastic and there were friendly crowds in front of Millais's work. The Liverpool Academy, always friendly to the Pre-Raphaelites, awarded the picture a prize of £50 and it went to a dealer for £250.

The tide had turned and, so it seems to me, Millais had begun to turn with it. He was still to paint some very remarkable pictures — the Ruskin portrait, *The Blind Girl* — but he had discovered that he could, with horrid address, catch the fancy of an unreflective public. This was a skill that did not go unrewarded. In 1853 he became an Associate Academician.

To us this may seem a rather shocking circumstance. So far as I can make out the Pre-Raphaelites themselves (and by now the Brotherhood was well on the way to dissolution) did not regard it as a betrayal but simply as a remarkable stroke of luck for Johnnie. And not so remarkable after all: it had always been clear that he would have a very good chance of ending up as President of the Academy and meanwhile his presence in the Academic ranks showed that the Corporation had adopted the slogan 'if you can't beat them, enlist them'. It does not seem to have been felt that such an enlistment put the recruit in any danger; rather it was the Academy which might have cause for unease. And indeed, in 1855 Millais took violent exception to the manner in which the hanging committee arranged matters and threw his weight about to some purpose. But when in the following year Holman Hunt, who presumably felt that he might as well follow suit, allowed his name to be put forward for ARA he was rejected. One supposes that Millais would have done all he could for his friend, but it was not enough. This was at a time

when Millais felt there was a cabal working against him in the Academy.

Altogether the relationship between the Academy and the Brotherhood is not perfectly clear. Certainly there was a strong anti-Pre-Raphaelite feeling in that body. Some of the older men, though one does not know which ones, were united in their antagonism to the movement. There was a younger man, Frank Stone, a painter of pretty inanities, who I suspect persuaded Dickens to make his violent attack upon *The Carpenter's Shop*. But Stone was not elected to the Academy until 1851, and before that had been the victim of a ferocious assault by W M Rossetti in the columns of the *Spectator* (the war was not entirely one-sided). And from the beginning, the Pre-Raphaelites also had friends in the Academy. William Dyce did what he could for them, finding jobs for Holman Hunt when he was on his uppers and helping to keep Ruskin straight before he had entirely made up his mind. Augustus Egg was equally helpful and kind, nor was Mulready unfriendly. In fact there was a small, perhaps not a very influential, group which was on the side of the rebels.

There are two circumstances which in fairness to the Academy ought not to be forgotten. One was that the selection committee was under no obligation to exhibit the paintings of these very unpopular young men; like the Salon it might simply have refused them admission. And yet this power of exclusion they never used, even when most people would have applauded the act. In 1853, when the scandal of *The Carpenter's Shop* was still recent, Millais had friends enough in the Academy to be elected an Associate of that body. It is true that the honour was not bestowed, because someone found a regulation which made it impossible for one so young to hold it, and it is true that Millais himself felt this to be an injustice. But surely under the circumstances it is a remarkable and creditable thing that his candidature should have got so far at that time. The distress and indeed the terror of the Brethren seems in a sense to have been exaggerated, in that the sanctions which could have been imposed were not. But perhaps this very circumstance added to their misgivings: the Academic powers were held *in terrorem* and were the more terrifying for that.

If, as I think, Millais was in 1853 and for many years to come a frightened man, one who, having seen the public face turned in anger against him, could never quite recover his nerve, then it must have been a great comfort to find himself an Associate of the Academy (full membership came in 1863). It must have been a comfort to be able to depend upon the good will of Ruskin. But this comfort was, in a manner, to be withdrawn. In that year which saw

his election Millais went to stay with Mr and Mrs Ruskin at Glenfinlas in the Highlands. It was here that he painted Ruskin standing amidst rocks and water, an oddly urban figure in very wild surroundings. But the weather was vile, so that progress became difficult; held indoors, Millais began a series of experiments in decorative art. The experiments were surely instigated and, one would think, conducted by Ruskin; they were based upon the idea that the decorative artists should as far as possible respect natural forms. To distort, to conventionalize, to simplify was wrong, and so the helmets of soldiers were to be adorned with life-like images of the great cats, Effie Ruskin should have a chain of doves with outstretched wings around her throat, and sofas should be created out of recumbent sea lions. The difficulty of arranging these natural shapes for decorative ends without distortion demanded and was met with some ingenuity – and yet, in the end, some kind of distortion seemed unavoidable. Many observers point to the affinity between Millais's design for gothic tracery based upon the figures of angels and that much later form of design which was called art nouveau. It is a pity that Millais did not do more in this direction, a direction in which so far as I know he was entirely alone. But it was not to be; Ruskin could no longer be of assistance, the days of collaboration were over, the famous portrait had to be finished with Ruskin no longer perched among rocks but half-way up the stairs at his home in Denmark Hill. It was finished in silence, the sitter and the artist being no longer on speaking terms. Or at least Millais was no longer on speaking terms with Ruskin.

The story of their estrangement is well known and may be briefly told. At Glenfinlas Millais had discovered that he was in love with Effie Ruskin and she with him. This passion enabled Mrs Ruskin to discover that her marriage to Ruskin was in fact no marriage at all. Her flight, the annulment of her marriage, and her susequent union with Millais were to provide London with a most enjoyable scandal during the next two years. To Millais it seemed that he and Ruskin must now be enemies; to Ruskin, on the other hand, it appeared that the transaction by which Effie became someone else's wife had distinct advantages. He clearly regarded the completion of the portrait as something very much more important than the disposal of Effie Gray, and to Millais he appeared provokingly, indeed disgustingly, cool about the whole business.

Millais it seems was not only indignant but scared, and it was a weeping artist who had to be comforted by his rather more experienced bride as they departed on their honeymoon. Perhaps he imagined that where Ruskin had failed he might too founder. Who could tell, and how uncommonly awkward it would be to inquire

just why it was that Mrs Ruskin had kept her virginity. Perhaps on her second wedding night Effie might reveal some blight or blot sufficient to freeze a husband. Happily it was all right. Mr and Mrs John Everett Millais were a normal and happy couple with a steadily increasing nursery and a steadily increasing income. Millais remained convinced that Ruskin was a blackguard, Ruskin was equally convinced that Millais was a genius. He continued to say this in print, and although there were some people naughty enough to suggest that this was no more than gratitude on Ruskin's part, I think it shows a certain critical disinterestedness and greatness of mind.

In his annual *Academy Notes* Ruskin continued to make war upon the enemies of the Pre-Raphaelites. In 1855 he had as we have seen told a lecture audience that he and his friends were winning. In 1856 he declared that 'the battle is completely and confessedly won'[21], and this was in a way true, although it was an odd kind of victory. The Brotherhood had gone. Three years earlier Christina Rossetti, in a celebrated sonnet, had pointed out that, with Hunt on his way to the Holy Land, Woolner in Australia, Dante Gabriel not exhibiting and William Michael not painting, Stephens a critic, there was not much of the Brotherhood left:

> And he at last the champion great Millais,
> Attaining academic opulence,
> Winds up his signature with ARA[22] *

But outside the Brotherhood Pre-Raphaelitism was prosperous.

The reader has perhaps seen those downland fires that burn in the spring: born of a little flame they swiftly grow, roar and expand, flames rise high in the air, a cloud of smoke darkens the sky, with seemingly irresistible force an incandescent wall of flame sweeps over the hillside; and then, finding no further fuel for its sustenance, the conflagration falters. A moment later nothing remains but a blackened slope on which a few sparks appear, only to perish. The sudden and complete character of its extinction is as amazing as the earlier rage and splendour of its beginning.

I hope I may be excused this purple passage. The bare facts in

* Hunt in his autobiography sees and deplores the hostility to the Academy prevalent in Christina's circle; it was this kind of thing, he says, which set the Academy against the Brotherhood so that they (ie Hunt and Millais) became the victims of the indiscretions of their allies. Admittedly Hunt finds more serious indiscretions in the writings of F G Stephens; but these date from 1859 when the whole round table was indeed dissolved.

themselves look undramatic, and yet, when considered, they are extraordinary — one of the most remarkable things in the history of British art. The Brotherhood was founded in 1848; within ten years painting in Britain had been transformed, everyone, almost, was painting Pre-Raphaelite pictures; and then, quite suddenly, it was all over. Walk through the Tate Gallery in London and look at those eminently Pre-Raphaelite works, nearly all of them painted by artists who were not members of the Brotherhood, and notice their similarity of subject and technique. Notice also that they were all painted within a very short space of time, and the equally striking fact that we know these artists only by reason of their 'Pre-Raphaelite' period: few of them made more than one or two attempts in this manner. It was an astonishingly sudden and astonishingly transient phase.

About sixteen artists whose names are still remembered and whose works hang on the walls of the galleries during the decade 1850–60 produced, say, thirty clearly memorable and clearly Pre-Raphaelite pictures. Obviously these figures can be disputed, for we have no unchallangeable criteria by which we can say whether a painting is or is not remembered. But this is about the size of it and it will at once be noticed that the output per artist was not large. These were the 'fellow travellers', painters travelling so close to the Brethren that they can hardly be distinguished therefrom. Deverell, who did actually become a Brother when Collinson resigned for religious reasons, was one of these; also Charles Allston Collins, who was Millais's candidate when Collinson resigned; and of course Ford Madox Brown. Very close to these were the youngish men, roughly coeval with the Brethren, such as Arthur Hughes, W S Burton, Henry Wallis and P H Calderon. Then there is a group whom it is much harder to describe as Pre-Raphaelite, such as William Henry Hunt, William Dyce and John Frederick Lewis, who were older than the Brethren and who either arrived at something like the Pre-Raphaelite method independently or, as Ford Madox Brown put it, 'threw away their old time-worn canvases and tried to see in vivid colours'[23]. I suppose that Augustus Egg may be classed with these. Finally there were those Pre-Raphaelites who were specifically landscape painters, of whom the most celebrated today are John Brett, J W Inchbold and Atkinson Grimshaw. For some reason these were an exception to my rule, for they remained Pre-Raphaelite; while others changed or reverted to an older style these were constant.

All classifications of this kind are difficult, and it seems absurd to class W M Rossetti and F G Stephens as Pre-Raphaelites because they were in fact Brethren, and not at the same time to call Ford

Madox Brown one. The latter's very peculiar, more or less *pleinairist* works may or not have had an enormous influence upon the Brethren; but the Brethren had an enormous influence on him and in the decade 1850–60 he was surely one of the leading Pre-Raphaelites. This was the period when he produced that strange, somewhat unsympathetic landscape, *The Pretty Baa-Lambs* (1951), and that astonishing exercise in realism, *The Last of England* (1852–65). The latter was a less ambitious production than *Work* (1852–65) and less perfect in its realistic poetry than *An English Autumn Afternoon* (1852–54), but it is of particular interest in that it appears to be at once completely factual and highly composed. A most ingenious and most energetic serpentine composition is wonderfully married to an oval, almost circular, canvas.

Perhaps at this period Brown was the greatest of the Pre-Raphaelites. Subtler in his observation than Holman Hunt, more thoughtful than Millais, he was certainly the least fortunate. Ruskin disliked his work. He never found it easy to sell, his integrity was complete and at times farouche. Without Hunt's very acceptable brand of piety, he also lacked, to an even greater degree, the easier charms of painting. His inventions have little grace, his colours are

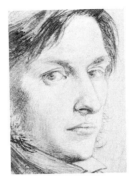

DANTE GABRIEL
ROSSETTI *Ford Madox
Brown* 1852

FORD MADOX BROWN
Work 1852–65

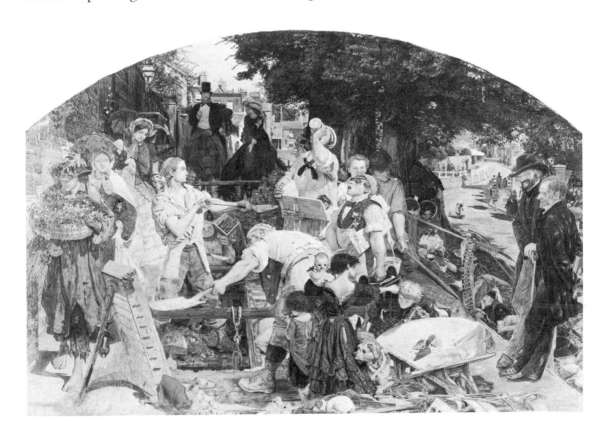

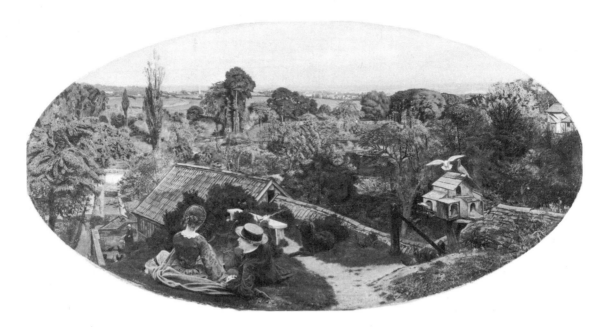

FORD MADOX BROWN *An English Autumn Afternoon* 1852–4

harsh, and those long-nosed, long-chinned, thin-lipped women are anything but seductive. His strength lay in his tremendous sincerity and eventually even this was, if not lost, at least overlaid by an unhappy fate which led him into a kind of decorative manner entirely unsuited to his genius.

Beside Brown poor Deverell (he was the model for the laughing auburn-haired youth on the left-hand side of Millais's *Isabella*) looks slight enough. He died young of consumption, leaving one odd, immature, perhaps gifted work – *Twelfth Night* (1850). C A Collins, who is also remembered for one picture, *Convent Thoughts* (1850), did not die young, but his painting seems to have done so.

Arthur Hughes is remarkable in that, almost alone of these artists who flourished in the decade 1850–60, he felt the influence of Rossetti. Nevertheless, if one looks for specimens of the 'hard-edge' style, one can hardly do better than to inspect his *April Love* (1855–56), *The Long Engagement* (1859) or *Home from Sea* (1863). Here we have all the Pre-Raphaelite characteristics almost carica-tured; the sharp focus on detail laboriously but in his case fluently treated, is as accurate as the most resolute efforts of Hunt and as painterly as Millais. One could almost say as much of W S Burton's *The Wounded Cavalier* (1856) or Brett's *The Stonebreaker* (1858). The Pre-Raphaelite method was applied frequently at this period to historical subjects such as Wallis's celebrated *The Death of Chatterton* (1856). But among the famous Pre-Raphaelite pictures of the time (and remember I am dealing only with more or less familiar productions) the greatest deal with contemporary life, as for instance

Arthur Hughes's *Home from Work* (1861), and there is much that reminds one of the novels of the period. *Too Late* (1858) by W L Windus, *Broken Vows* (1857) by Calderon, *Past and Present* (1858) by Augustus Egg, *The Last Day in the Old Home* (1862) by R B Martineau, all seem to be taken from the more sentimental pages of Dickens or Trollope, while H A Bowler's painting *The Doubt: Can These Dry Bones Live?* (1856) looks forward to *Robert Elsmere*. In fact the painters at that time, and Millais was one of these, did do a great deal of illustrative work and it must have been a valuable source of income.

Of the artists who followed a line similar to that of the Pre-Raphaelites and had been doing so before the Brotherhood came into existence, there was I think only one who can fairly be claimed as a convert, and this was William Dyce. Dyce had always been various in his methods and in some ways he anticipated the Brethren but in the '50s I think one can speak of a definite Pre-Raphaelite influence. *Titian's First Essay in Colour* (1856–57) is an eminently successful essay in Pre-Raphaelite method, so too is *George Herbert at Bemerton* (1860); his finest Pre-Raphaelite landscape, if not the finest of all Pre-Raphaelite landscapes, is *Pegwell Bay* (1859).

I call these paintings produced during this period Pre-Raphael-ite because, looking at them, one is struck by the exact detail, the

HENRY WALLIS *The Death of Chatterton* 1856

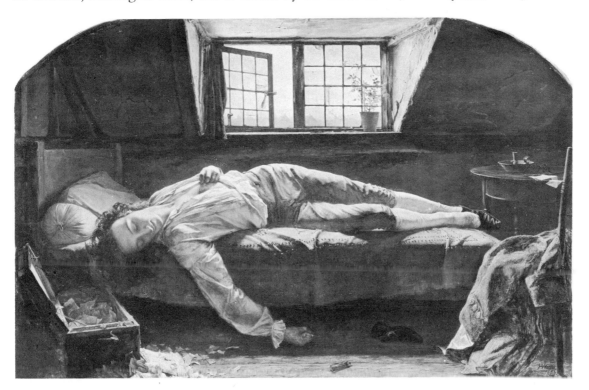

delight in complex forms such as foliage, and the use of a much brighter palette had been unusual before the Pre-Raphaelites started to astonish the public. But it must be admitted that in subject matter these 'near Pre-Raphaelites' stood apart from much of the movement; at least they seem much closer to Millais than to Holman Hunt. They seem to avoid sacred history, whether it be that of *The Carpenter's Shop* or that of *The Light of the World*; there is a good deal to remind one of *Mariana, Ophelia, The Woodman's Daughter* and *The Proscribed Royalist*. No doubt Hunt's *The Awakening Conscience*, which dealt with an enormously popular theme, that of prostitution, had its effect; but I cannot find that he was otherwise influential.

The phenomenon is rather hard to examine because there were painters – Redgrave was one – who had produced essays in modern genre painting before the time of the Brotherhood and perhaps were barely affected by it. Frith is another case, yet one would hardly call him a Pre-Raphaelite, and when Ruskin detected Pre-Raphaelite influence in his work Frith was angry; on the other hand his earlier work is 'historical', and he did not venture into modern genre until the Pre-Raphaelites showed him the way. Yet it is very hard not to think of painters such as Hughes and Brett as Pre-Raphaelites who kept away from religious subjects, and in some of their work it looks as though Holman Hunt's 'wet white' technique had been used. Not surprisingly however this method found very few imitators, and Millais himself seems to have abandoned it in the mid-1850s. Martineau, who was Hunt's pupil,[24]* certainly did not always use it. An odd unfinished picture of his in the Ashmolean, *The Poor Actress's Christmas Dinner*, shows us how a follower of the Pre-Raphaelites might set to work. The poor actress and her plum pudding are rendered with the utmost detail, the rest of the canvas being almost empty. There is no outline drawing upon which the painter will work; the unpainted forms are only slightly indicated with a sable brush and colour. Clearly, for Martineau, the method was too laborious and perhaps others made the same discovery. This may explain the short life of the movement.

There are in fact many possible reasons for the sudden extinction of this curious efflorescence. It is significant that so many painters seem to have given up after a very few attempts. A highly detailed account of nature makes a fascinating study, but unless one has something new to say it can be a rather dead-end adventure; when realism has been achieved it does not seem to lead to anything else. There is nothing to do but repeat oneself. Again we may surmise that when mid-Victorian England had taken a long hard look at

* Hunt did not think him a good technician.

itself, much as Holland did in the seventeenth century, it decided after a time to look no further, having perhaps caught a glimpse beneath the prosperous varnish of that age of those nasty stains and blemishes to which Ruskin began to draw our attention.

There is however a consideration of a different kind which ought to be examined. The imitators of the Pre-Raphaelites, as we have already seen, were chiefly imitating Millais; he had always been the great man of the movement; he still was. And Millais, in the years between 1850 and 1860, had begun to falter.

In 1855 he exhibited *The Rescue* and had begun to loosen his style. It did him no damage in Ruskin's eyes, indeed Ruskin in his *Academy Notes* said that Millais's was 'the only *great* picture exhibited this year. . . . The immortal element is in it to the full.²⁵' *The Rescue* was followed by *Peace Concluded* and *Autumn Leaves*, and again Ruskin was enthusiastic. I do not think we need differ with him, for if *The Rescue* was the most boldly and strongly designed of Millais's pictures *Autumn Leaves* was the most poetic.

Millais's offering in 1857 was entitled *A Dream of the Past*; it has become known as *Sir Isumbras at the Ford*. It shows a charming old knight in armour mounted and carrying across a river two pretty children on a very large horse. The horse ended by being so large that the artist persuaded Tom Taylor the playwright and journalist to concoct a pseudo-mediaeval poem, or at least one stanza of it, largely devoted to saying what a particularly indeed abnormally large horse it was. Nevertheless, in spite of this prudent essay in justification and the fact that he did work very hard on it, the painter seemed to have misgivings about the picture, and so had his family and friends. They were fully justified. Ruskin fell upon the thing with fury:

> The change in his manner, from the years of 'Ophelia' and 'Mariana' to 1857, is not merely Fall — it is Catastrophe; not merely a loss of power, but a reversal of principle; his excellence has been effaced, 'as a man wipeth a dish — wiping it, and turning it upside down'. There may still be in him power of repentance, but I cannot tell: for those who have never known the right way, its narrow wicket-gate stands always on the latch; but for him who, having known it, has wandered thus insolently, the by-ways to the prison-house are short, and the voices of recall are few.²⁶

It was, said the great critic, incompetent, ill and falsely observed, inept in every way; and Millais's other picture, *The Escape of a Heretic*

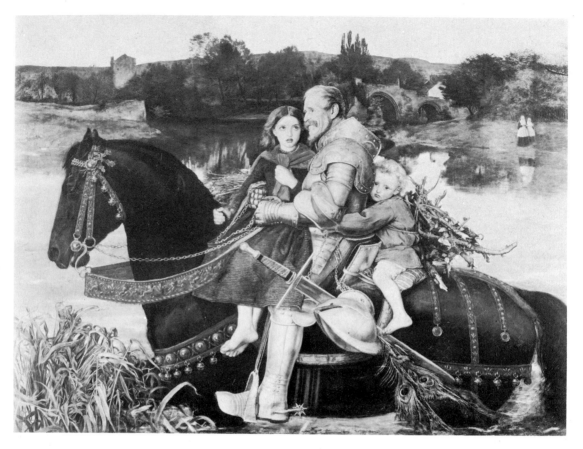

JOHN EVERETT MILLAIS
Sir Isumbras at the Ford
1857

1559, was even worse: all the bad things that had been said about the Pre-Raphaelites were here made true: 'For Mr Millais, there is no hope but in a quiet perfectness of work.'[27]

Comparing *Ophelia* with *Sir Isumbras* one can see what Ruskin means; and the *Escape of a Heretic*, to judge from a reproduction, is really dreadful. There is a failure of visual curiosity. An exact attention to the facts of appearance has been replaced, in *Sir Isumbras*, by some fairly commonplace sentiment, and the horse (although it has since been reduced) is still a ridiculous beast. But what made Ruskin speak in this dreadfully prophetic manner? How did he know with such certainty that something had gone wrong with Millais? For the plain fact of the matter is that he was right: 1857 was the turning point. Millais still had some good work ahead of him, such as *The Vale of Rest*, and quite a lot of work which, without being first rate, has considerable merits; there are moreover modern critics who can see high value (invisible to me) in some of his late landscapes; but everyone is I think agreed that after 1857 the lovely springtime talent of his youth is gone.

He, presumably, did not realize how truly Ruskin spoke, and

perhaps, art is so curious a business, he could persuade himself even in later years that he remained as good as he had ever been. But he was, as we have already seen, dreadfully sensitive to criticism. When *Sir Isumbras* returned unsold from the Academy he kicked a hole in its middle. He must have been horribly depressed and perhaps lonely, for the friends of his youth were no longer with him; marriage had placed an insensible but important barrier even between himself and Holman Hunt. He was no longer on speaking terms with Rossetti, and he became increasingly suspicious of his fellow Academicians, feeling that there was a cabal of painters and critics who wished him ill. He had of course the comfortable support of a devoted wife. But how good and how important a support was that?

'My dear, she simply ruined his painting' — such, forty years later, was the common gossip of Kensington. Effie, I suspect, was rather bored by art; she had after all been listening to Ruskin on that topic for a great many years. It is true that she still served as a model and stood bare-shouldered for three icy nights at Knole while Millais painted *The Eve of St Agnes*; but I doubt whether she was much called upon for advice or would have had much to give. No doubt the mere presence of a wife and family was a brake upon all adventurous impulses, but I very much doubt whether Effie was responsible for the 'popular subjects' — I mean things like *The Boyhood of Raleigh*; these, I am afraid, Millais could summon from his own imagination.

What was happening, I believe, quite apart from the increasing use of trivial subjects, was that Millais was losing that happy curiosity concerning facts which had once sustained him. *The Carpenter's Shop* was a demonstration of quite intransigent realism, a realism which needed no advertisement and which indeed seems to have been offensive. Here the shavings on the workshop floor are treated with as much care and as much affection as the face of the Virgin Mary or the sheep's head in the background. In *Mariana* the observation of facts is no less important than the search for authenticity; Millais took the greatest trouble to find 'real' stained glass in an Oxford window. But in *The Woodman's Daughter* of 1849 the programme demanded that a little boy should offer strawberries to a little girl, and so they had to be purchased out of season — which, given Millais's feeling for authenticity, was proper enough; but it was not really necessary that the world should know of the pains that he had taken. Here, at least, there was a sufficient motive; but in *The Order of Release* (1853) this careful fidelity becomes what one can only call a gimmick. Effie, who posed for the Highland matron who brings the document that will set her lover free, was

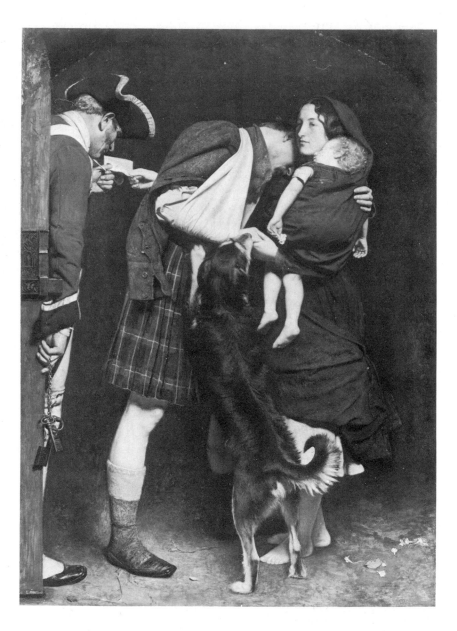

armed with a genuine order of release signed by the governor of
Elizabeth Castle, Jersey, when clearly any billet of clean white paper
would have served; here there is more of showmanship than of any
real care for truth.

In *The Black Brunswicker* (1860) we are shown a German officer
saying goodbye to his girl before going off to be killed on the field
of Quatre-Bras. We are told that Millais entered into every minute
detail of the officer's uniform; moreover, to set the picture more
thoroughly in its period, an engraving of David's *Napoleon Crossing*

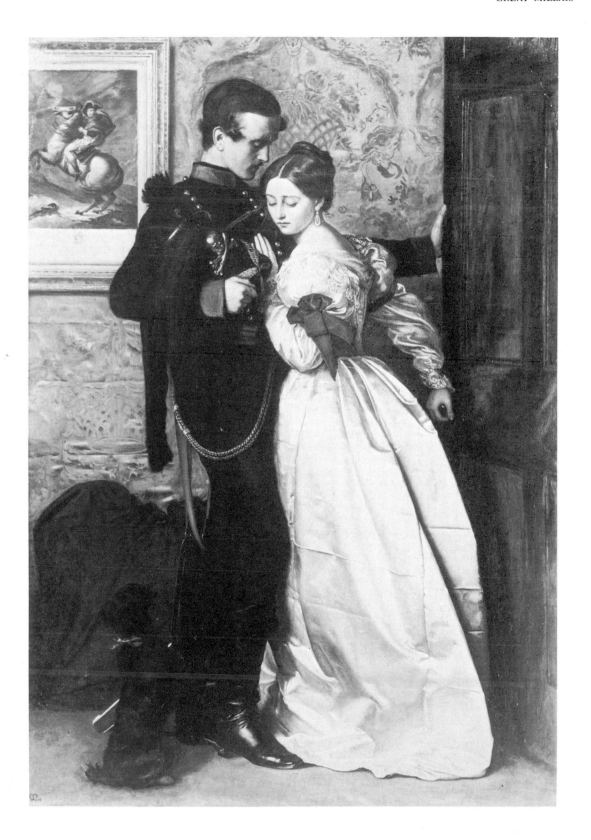

the Alps is carefully represented on the wall behind the lovers. But
the one detail that would have ensured historical fidelity is falsified.
A fashionable woman of the year 1815 would have worn her waist a
little below her armpits, from which point a loose envelope of some
plain material would have fallen, possibly with a flounce or two, to
the floor. Kate Dickens, the model for the girl, in her hair style, her
earrings, her wide puffed-out sleeves, her trim restricted bodice and
her big spreading skirts, belongs, obviously and no doubt charm-
ingly, to the year 1860. The Empire style was not admired; it was
therefore impossible that it should be worn. From a Pre-Raphaelite
point of view this was not only slovenly but dishonest. Millais
seemed to have lost his integrity.

In what is a fairly crude illustration of Millais's growing
indifference to truth, the passion for facts becomes, first, a mere
search for authentic props, then a kind of gimmick, and finally a
thing that can, when inconvenient, be forgotten. But to try and go
rather deeper I would suggest that the reader turn from that
remorseless but still deeply felt catalogue of facts in *The Carpenter's
Shop*, to the hump of drapery behind the Black Brunswicker – an
unexplained mound which almost seems to be there lest Miss
Dickens should give the officer so hard a push that he falls on his
backside. The drapery is of course perfectly handled, Millais could
always be trusted to make a professional job of such things. But is
he at all interested in it? Does he love every fold and crease, does he
delight in the shape and solidity of the thing? I think not; it is there
because he has to have something there. It is padding. In 1850
Millais had no use for padding.

I think he needed advice and, perhaps even more, now that he
had turned to a looser, more rapid style, someone or something to
show him how to prevent fluency from degenerating into weakness.
In *The Eve of St Agnes*, painted three years after *The Black Brunswicker*
and to my mind a much finer picture, there is a suggestion that he
was not unaware of this need and perhaps he was finding someone
who might help him. Here there is an altogether more intelligent
examination of space; the painting is very free, and we know that in
fact he worked at unusual speed. The great oblong patch of
moonlight and the vast darkness of the room with its solitary figure
do suggest a new kind of visual interest.

Philippe Burty, a contemporary critic of great acumen and one
of the first to applaud the genius of Degas, noticed that at this time
Millais was looking in quite a new direction. He had seen the
paintings of Whistler, a visitor to London but one who was soon to
settle there for good. The American had brought from Paris a new
and freer style, a different kind of realism and a repertoire of

compositional devices which owed more to Japan than to Raphael. Compare *The Eve of St Agnes* with *At the Piano*, a work exhibited by Whistler at the Academy of 1860: is there not a similarity of feeling, of illumination and of the use of rectilinear forms?

Whistler already knew Rossetti, but in that year he met Millais, who may have been merely polite but is on record as saying, 'What! Mr Whistler! I am very happy to know you – I never flatter, but I will say that your picture is the finest piece of colour that has been on the walls of the Academy for years.'[28] In 1862, when some critics were falling foul of *The White Girl*, Millais was enthusiastic, comparing it with Titian and Velásquez. Whistler, for his part, seems to have appreciated and been ready to learn from Millais; between them there was therefore a certain measure of respect and of friendship. A time would come when Whistler had few friends, when Millais would condemn his work as 'clever, a damned sight too clever', while Whistler for his part probably considered Millais 'stupid, a damned sight too stupid'. But in these earlier and happier years of his residence amongst the English the young American was ready to teach and even to learn.

Could he have taught Millais something of value? Burty seems to have thought not, and he was in a position to judge. Nevertheless, if we may attribute the new, interesting and hopeful qualities of *The Eve of St Agnes* to the influence of Whistler, and if we concur with Whistler himself, Degas and many French critics of the time in admiring this picture – *La Femme Verte* as they called it – we may well regret that Millais went no further along this path.

The idea of a Millais stimulated in middle life into a new and different appetite for nature, not by Holman Hunt and the primitives but by Whistler and the Japanese, is perhaps too improbable to be entertained. But if Whistler was not what Millais needed, he certainly needed something. As it was he wandered, and not always happily even by the standards of material success; there was a time in the mid-1860s when he felt that the world had turned altogether against him, and he responded only with a rather unsuccessful search for a really popular subject – *The Widow's Mite, The Gambler's Wife*, pictures of children and leisure hours: the public admired them but colleagues and critics did not. Then, in 1870, he decided to strike out upon an entirely new line. He would paint a nude.

This was something that the Brotherhood had left alone. Even in their working sketches there was a kind of hurried reticence about their treatment of the human figure. This is true even of Millais who, as a student, could turn out an *'académie'* with the best of them. For nearly all Victorian artists the nude offered something of a problem: it was so very improper, but it was also so very artistic.

But for the Pre-Raphaelites it was practically out of the question. The minute realism which offended even when it was applied only to a sheep's head or a shaving upon the floor, would have been inexpressibly shocking in the treatment of a naked body. There had to be some places where the stark uncompromising realism of the hard-edge school would not go, and the nude was one of them; at the same time the anti-academic and purist side of the movement deprived the naked body of its chief sanction. The nude was the caryatid of the academic edifice, it had been given to us by the Greek sculptors and the High Renaissance – all the more reason for making an end of it. But by 1870 the ideas of the Brotherhood had been so much forgotten that the nude was, for Millais at all events, a possible theme; but one to be treated with care.

Millais, in whom there was always a kind of naïveté, decided to paint a picture of a young woman whom some inconsiderate person or persons had bound naked to a tree (for what purpose we do not know). A knight in armour is cutting her bonds with his sword; he has to do this in a somewhat awkward fashion because he is carefully looking away from the lady, gazing in fact to the middle distance lest he should see too much. The lovely prisoner, covered with confusion and a few tactful strands of hair, turns away from her liberator.

It is hard to know whether the artists's purpose is served or thwarted by this intense consciousness of the indelicacy of the situation. 'Mrs Grundy', says Millais's biographer, 'was shocked, or pretended to be, and in consequence it remained long on the artist's hands.'[29] One feels that Mrs Grundy had a fair case; it is a very prurient work.

The Knight Errant (1870) may be said to represent Millais's final and complete abandonment of Pre-Raphaelitism. The Brotherhood had long been dead and apart from a few landscape painters only Holman Hunt struggled on in the old hard-edge manner. Millais became enormously wealthy, with a palatial house in London and a shooting box in the Highlands. He became a baronet and eventually, when Leighton died, President of the Royal Academy. He was immensely popular.

It is said that when, in 1855, there was a retrospective exhibition of his works, Millais was seen leaving the gallery in tears. When questioned he replied: '. . . You see me unmanned . . . in looking at my earliest pictures I have been overcome with chagrin that I so far failed in my maturity to fulfil the full forecast of my youth.'[30] The story may not be true, one hopes that it is not; he had done nothing to deserve so terrible a revelation.

JOHN EVERETT MILLAIS
The Knight Errant 1870

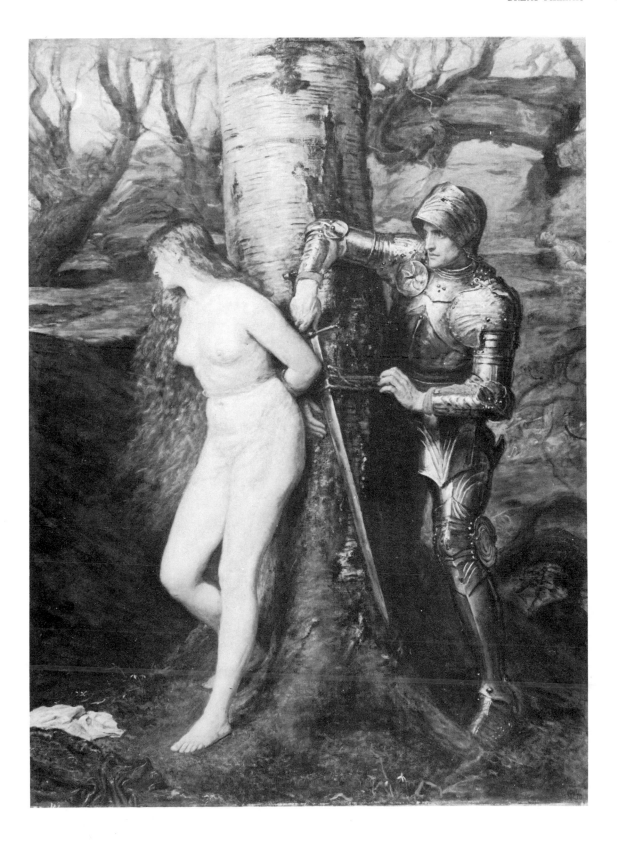

The Second Generation

DANTE GABRIEL
ROSSETTI *Self Portrait*
1847

By the time of his death (in 1896) Sir John Everett Millais PRA had become an eminently respectable old gentleman. Once, in his youth, he had fallen in love with a married woman but then, by a happy chance (he was a man noted for his good fortune), the married woman turned out not to be married after all; she became Lady Millais and herself a very respectable person. It is true that, such being the mores of the time, Effie Millais, although she had never been accused of any kind of misconduct, was excluded from Her Majesty's presence – the mere fact that her name had been connected with so great a scandal was sufficient to condemn her. But even this tribulation was in the end cured. Sir John on his death-bed asked the old Queen to cease this senseless social cruelty, and she did; the exertion is one which does the dying man some credit. Apart from this unhappy connection with the case of Gray versus Ruskin, the Millais family was quite overpoweringly *comme il faut*.

When Holman Hunt died, fourteen years after Millais, I

suppose that the world at large would have found him equally respectable – almost. There were no doubt sticklers for propriety who would object that he had married his deceased wife's sister, something which was illegal in England, so that the marriage had to be solemnized in Switzerland; very religious people thought this wrong and amongst them, I am sorry to say, were Christina and Mrs Rossetti, who behaved with uncharitable stupidity when the second Mrs Hunt called upon William Michael Rossetti. But Holman Hunt – 'Holy Hunt', as he was called ('Mad' was the name given him by his friends) – was such a very devout painter, so serious, so industrious, so obviously deserving of the Order of Merit, that he achieved a kind of respectability hardly less exalted than that of his old friend the President. He has of recent years been made to appear rather less chaste and very much more interesting, through the wit and erudition of his granddaughter, Diana Holman Hunt. In her splendid book, *My Grandfather, His Wives and Loves*, Mad is revealed as having been Mad about girls. The tale of his frequent and frequently injudicious amours makes exceedingly interesting reading, and one is tempted, when one thinks of his public pronouncements and the tremendously moral character of his paintings, to set him down as a hypocrite. To me the term seems too harsh. He was so very much in earnest in his adventures, so very serious in his endeavours to make his girl friends – and some of them were pretty terrible – into virtuous, respectable young ladies, and above all so unconscious of his own inconsistencies, that we should not condemn him out of hand. There was, admittedly, a good deal that had to be hidden from the public gaze and it was very efficiently concealed. Hunt, who always achieved what he wanted by pure obstinate industry, finally achieved respectability.

But Dante Gabriel Rossetti was never respectable, not at all events in this sense of the word. He was the kind of person who gave artists a bad name amongst decent God-fearing Victorians, the very type of the bohemian, with his girls, his whisky and his laudanum. This, and the fact that he was generally thought to be the most successful of the Brethren as an artist, has made him a favourite of the biographers and few years pass without a new life of him.

The Millaises – gentlefolk in an unpretentious way, from the island of Jersey – and the Hunts – warehouse-keepers in the City of London – belonged as William Michael Rossetti said to the middle or lower-middle class of society, and, he continues:

> Not one [of the Pre-Raphaelites] (if I except my brother
> and myself) had that sort of liberal education which
> comprises Latin and Greek, nor did any of them not

even Millais, though connected with Jersey — read or
speak French. Faults of speech and of spelling occurred
among them *passim*. Of any access to the 'upper classes'
through family ties there was not a trace.[1]

From this the reader will deduce that the Rossettis had some grand
relations. This was not exactly the case, although the Rossetti
children's aunt Charlotte was a governess in the Earl of Wicklow's
family. But they were in a way distinguished. Mrs Rossetti had been
a Polidori of the same family as that unhappy Polidori who
accompanied Byron to Greece; they were people of some intellectual
distinction. Gabriele Rossetti, the father, son of a blacksmith of
Vasto in the then kingdom of Naples, had been domiciled for many
years in London. His children were to become, in many ways, very
English, but although old Rossetti never returned to the Two Sicilies
he remained, morally and culturally, an expatriate. He had been the
laureate of the Bourbon court in Naples, and then the eloquent but
injudicious poet of revolution — that was during the brief liberal
uprising of 1821. Exile had followed; he had some English friends
and he became Professor of Italian at the University of London, a
smaller post than it sounds. His daughters — dark-eyed, handsome,
Italian-looking women — were much given to religion, as was his
wife. They were very High Anglicans and one of them, Christina,
was a great poet. The boys were bilingual in English and Italian. All
the children painted pictures, wrote poems and were quite highly
educated.

'I now wish,' said their mother, 'that there were a little less
intellect in the family, so as to allow for a little more common
sense.'[2] Poor woman, she must also frequently have wished that
there were a little more money. Signor Rossetti's stipend as Professor
of Italian was very small, and his books — monuments of learned
absurdity in which, with Baconian ingenuity, he explained Dante
and much else in terms of a secret anti-papal society — did not sell.
The girls had to go out and work as governesses while the family
kept open house for hungry refugees from an oppressed and divided
Italy.

The only one to show anything like solid, businesslike ability
was William Michael. He soon discovered that he was not an artist,
although he continued from time to time to write poetry; but his
main employment was in the civil service, where, it would seem, he
showed little brilliance and rose very slowly up the official ladder.
He has earned the gratitude of art historians for the Pre-Raphaelite
records he kept, even though he was sometimes more tactful than
informative. In almost all ways William seemed the opposite of his

brother – hard-working and thrifty where Gabriel (to give him the name by which he was christened, and known in his family) was lazy and feckless, sedate where he was passionate, holding 'advanced' views where Gabriel held none at all (that is in politics and religion); for years William allowed his brother to sponge upon him whenever he, Gabriel, was short of 'tin', and for years he tried to persuade the public that Gabriel was not only a man of genius, but a perfectly respectable member of society. Morris called William Michael a fool, but Morris was irritated at the time.* I suspect that there was more to William than met the eye and that beneath that carefully buttoned frock coat there was yet another brilliant and complicated Rossetti. 'Lazy, irresponsible, untrustworthy' – that about summarizes the picture that Holman Hunt gives of Dante Gabriel Rossetti in his autobiographical study of the Pre-Raphaelites; undoubtedly there is much truth in the description. The youthful Hunt, in his dealings with the young Dante Gabriel, had no doubt a good deal of which to complain. Rossetti was reckless and insouciant in his demands on his friends. In his own interests he could be ruthlessly businesslike; but he could also be exceedingly generous to other artists, and I fancy that his offences were more easily forgiven in the early days of the Brotherhood than when, years later, they were reckoned up and remembered with indignation. One can easily forget that he and Hunt for a time lived together in the same studio, that they were close friends, and if, as is said, it was the fact that Rossetti made free with Hunt's girl Annie Miller which made the break between them, still we cannot know all the circumstances of the case.

Although his Brethren when they grew older found it easy to condemn Dante Gabriel, the modern reader is likely to be more indulgent. His vices have a charm which – unjust as this may be – is lacking in the virtues of Millais and Hunt. He speaks across the years with a cheerful and irreverent voice and with a lack of pomposity which endears him to posterity.

In the 1860s there was an invasion scare. It was believed that the French might land upon the coast of England and overwhelm us. In order to meet this danger a great volunteer movement arose. The Artists' Rifles, commanded by Sir Frederick Leighton, included Millais, an excellent soldier, Holman Hunt, Charles Keene and many others. It did not include Rossetti, until one day he turned up at Pirbright or wherever it was that the regiment exercised, and

* Rossetti had complained of *Sigurd the Volsung* that he could not take a hero seriously who had a dragon for a brother. 'Better a dragon than a damned fool like your brother William,' was the reply.

joined the ranks. At his first shot he scored a bull's eye. The following dialogue was then heard:

> *Commanding Officer:* Comp'ny, ABAAHT turn!
> *A quiet voice from the ranks:* Why?

The quiet voice belonged, of course, to Dante Gabriel Rossetti, nor is one astonished to learn that he never again reported for duty. The point I am trying to make is that one can hardly imagine such a retort from Millais, Hunt, or indeed any other painter of that period; in fact such disconcerting frivolity could, in that decade, only have come from Rossetti, or perhaps Whistler. In the 1880s it would have been much less remarkable. In this fashion Dante Gabriel was rather ahead of his time, and I suspect that in its manners no less than in its aesthetics *fin-de-siècle* London owed him a good deal.

Certainly, as an artist, he was a seminal figure. The *élan* he gave to the Brotherhood may or may not have been social rather than aesthetic; but his importance as the re-creator of a movement that would otherwise have perished, and as the inspiration of the next generation, can hardly be exaggerated. On the face of it he was, almost from the beginning, an opponent of the uncompromising realism of Holman Hunt, the exponent of a kind of painting which was concerned with beauty, rather than with truth, which found its sources not so much in nature as in art itself, and, whether he was conscious of it or not, of an aesthetic form which could be adapted to the purposes of decoration.

Realism is a rather confusing word, nevertheless, it was used by Prosper Mérimée when, confronted by the work of the Pre-Raphaelites, he likened them to the French Realists of the time. He pointed out that in both cases there was a revolt against idealism, against beauty and against the teachings of the academies; what he omits is the strong moral bias of the English realists[3].

Rossetti came as near to Pre-Raphaelite realism, in this sense, as he was ever to do in *The Girlhood of Mary Virgin*. But in his next effort, *Ecce Ancilla Domini*, he was still very much within the doctrines of the movement. He had seen and been impressed by the quiet naturalism of Memling when, with Hunt, he went to Bruges in the autumn of 1849; and presumably he had seen engravings of the Annunciation by Italian masters of the period before Raphael. But *Ecce Ancilla Domini* is essentially a very modern picture: where the older masters show us the Queen of Heaven, regal and sedate receiving the embassy of God, Rossetti shows us a half-frightened girl huddled awkwardly upon a bed. It is his one essay in 'probable'

religious art, and because it is so remorselessly factual in its treatment of the theme, it is impressive. In another sense it fails, partly because the painting of a white picture was, at that time, beyond his technical ability, also because the annunciate angel, a wet young man standing upon what can only call a wet sort of flame, is so ineptly drawn. But it is a splendid failure.

But with these two early pictures, and *Found*, which he never finished but which, clearly, occupied his mind for many years, Rossetti's true Pre-Raphaelite work comes to an end. As I hope to show, he had to some extent discovered his own bent, and discovered that it differed substantially from that of Holman Hunt, before the end of 1849. Rossetti might still at times be a realist, but his realism was to be of his own kind.

Just how far Pre-Raphaelite realism might be pushed beyond the naturalist doctrines of Holman Hunt and in the direction of a really unflinching examination of the harshest facts of modernity, is I think made clear not so much by the paintings as by the literary remains of the Brotherhood.

We usually think of Rossetti's verse as a search for beautiful fictions clothed in beautiful language. Two stanzas from 'The Blessed Damozel', which was published in 1850 in *The Germ* may suffice as a specimen:

> 'We two,' she said, 'will seek the groves
> Where the Lady Mary is,
> With her five handmaidens, whose names
> Are five sweet symphonies,
> Cecily, Gertrude, Magdalen,
> Margaret and Rosalys.
>
> 'Circlewise sit they, with bound locks
> And foreheads garlanded;
> Into the fine cloth white like flame
> Weaving the golden thread
> To fashion the birth-robes for them
> Who are just born, being dead.'

This surely is thoroughly poetical poetry. It is the work of one who loves harmonious words, who rejoices in musical names and fine images, a poem belonging to another world, half Christian, half personal. A poem in fact about beauty.

Compare it with this:

The evidence of Dr Wallinger
Ended the case, 'I was called in to see
The body of the deceased upon the sixth:
Life then was quite extinct; the cause of death,
Congestion and effusion of the ventricle.
Death would be instantaneous. Any strong
Emotion might have led to that result.'

The Coroner, in course of summing up,
Commented on the evidence, and spoke
Of deceased's conduct in appropriate terms;
Observing that the Jury would decide
Upon their verdict from the testimony
Of the professional witness – which was clear,
And seemed to him conclusive. He could do
No less than note the awful suddenness
With which the loss of life had followed such
A glaring sacrifice of duty's claims. [4]

'Mrs Holmes Grey' by William Michael Rossetti is indeed a surprising work.* It is a squalid enough story of a doctor's wife who falls in love with a young surgeon and dies of a heart attack – we learn of it through the chance meeting of two old friends on a wet afternoon in a dull watering place. The unhappy wife's guilty and unrequited passion comes to us from the angry lips of the husband and through the unsympathetic accounts of servants and neighbours giving evidence to the Coroner. The poem ends on a note of hate-filled unforgiving bitterness; nowhere do we catch a saving glimpse of beauty, or romantic sentiment.

Now this almost wantonly ugly poem was supposed to be the literary equivalent of *Ecce Ancilla Domini*, *Mariana* or *Rienzi*. 'The informing idea of the poem was to apply to verse-writing the same principle of strict actuality and probability of detail which the Pre-Raphaelites upheld in their pictures. It was in short a Pre-Raphaelite poem.'[5] I quote from William Michael's own account of the matter. He is anxious that we should take the point, for he continues (he was writing in 1868): 'The reader will observe the already remote date (1849) at which the poem was written. Those were the days when the Pre-Raphaelite movement in painting was first started. I, who was as much mixed up and interested in it as any person not practically an artist could well be, entertained the idea that the like principles might be carried out in poetry. . . .'

* Too long for inclusion in *The Germ*, as intended, it was published separately by W M Rossetti in 1868.

Professor Fredeman calls 'Mrs Holmes Grey' a 'key poem in the Pre-Raphaelite movement', and he is surely right; but the key seems to open a door beyond which we dimly perceive paintings which never in fact got painted, works having something in common with Daumier or perhaps with Degas in his genre manner, or even with Sickert. Perhaps it is in the paintings of those who were close to the Brotherhood without being in it — Ford Madox Brown's *The Last of England*, Brett's *The Stonebreaker*, Windus's *Too Late* — that we approach most nearly to the uncompromising realism of 'Mrs Holmes Grey' although I do not think that we ever find in the paintings of the movement quite so unrelentingly modern a treatment.

Holman Hunt regarded himself, and I think we may fairly regard him, as the intellect and conscience of the Brotherhood in its early stages; moreover he was not only Dante Gabriel Rossetti's intimate friend but for a time his teacher, and one who, I believe, exerted a lasting although certainly not a dominant influence on him. But there is very little in Holman Hunt's *oeuvre* that looks as though it were inspired by the ideas which so much attracted William Michael. There is in his painting a moral intensity and a desire to teach which is very unlike the cool objectivity of 'Mrs Holmes Grey'. In fact, only two early works by Hunt seem to be based upon an objective study of modern life: *The Hireling Shepherd* and *The Awakening Conscience*.

The Hireling Shepherd does display a certain almost disquieting realism. The shepherd and his girl are sufficiently heavy and brutish specimens of the rural proletariat, and are made to look all the more earthy by reason of the very attractive landscape against which they are painted. But here the painting is so obviously and vehemently symbolical, so much addressed to an erring and silly public, that, although even now there seems to be some difference of opinion as to just what it is that we are being taught by the painter, it seems impossible to avoid the impression — the perfectly correct impression — that we are indeed being instructed.

The Awakening Conscience is in a way different; it too is a highly moral picture, but we find it so because we know what the moral is. But — and this illustrates the limitations of painting as a didactic form — when it was exhibited at the Academy of 1854 the public was greatly puzzled. It could not imagine what was supposed to be taking place. 'People gaze at it in a blank wonder, and leave it hopelessly,'[6] said Ruskin. 'Innocent and unenlightened spectators', said the *Athenaeum*, 'suppose it to represent a quarrel between a brother and a sister.'[7] We are today perhaps more enlightened; certainly less innocent. We realize that we have here that great stock

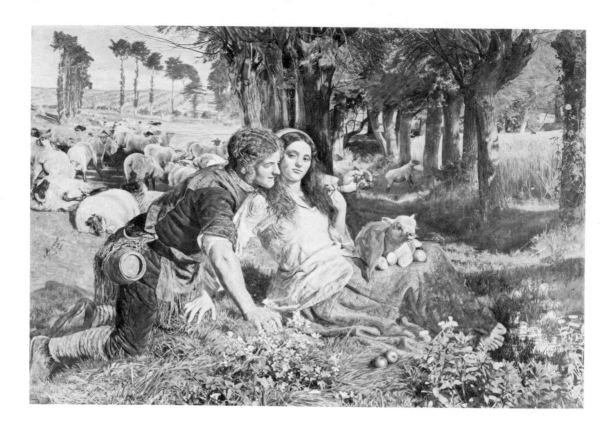

WILLIAM HOLMAN HUNT
The Hireling Shepherd
1851

in trade of the Victorian artist — the fallen woman. William Bell
Scott had celebrated her guilt and her sufferings in *Rosabell*, Rossetti
was to do something of the same kind in *Jenny* and in *Found*; it is
a theme which we know in novels and in opera. Holman Hunt
shows us the lady at the point where she has just realized the
lamentable nature of her situation. Singing with her paramour at
the piano she has chanced upon 'Oft in the stilly night', the title of
which is clearly visible upon the page before them. She suddenly
realizes that she is lost, damned; she is stricken with terror and
remorse. And so, while he continues idly to strum at the piano, she
leaps to her feet, as Holman puts it, 'recalling the memory of her
childish home, and breaking away from her gilded cage'. In the
original version, so we are told, the expression of dismay upon her
face was so awful that it had to be painted out and softened down.

And yet, as we have said, there were those who entirely missed
the point. The painter had done his very best to supply us with
explanatory details. Ruskin confessed that he was at a loss to know
how its meaning could be rendered more distinctly. A cat, here
symbolizing the predatory male, devours a bird under the table; the
picture above the piano represents the woman taken in adultery, the

roll of music lying on the floor is that for 'Home Sweet Home'. To quote again from Ruskin:

> There is not a single object in all that room – common, modern, vulgar (in the vulgar sense, as it may be), but it becomes tragical, if rightly read. That furniture so carefully painted even to the last vein of the rosewood – is there nothing to be learnt from that terrible lustre of it, from its fatal newness; nothing there that has the old thoughts of home upon it, or that is ever to become a part of home?[8]

And, in case anyone should still have doubts, notice that the gentleman has cast a soiled glove upon the floor.

The more we learn about this picture the further we seem to be from the objective statements of 'Mrs Holmes Grey'. Indeed for my part I am sorry not to be able to enjoy the innocent vision of those who thought it represented a family tiff, for in its pictorial fluency, its energetic composition and the loving description of commonplace things this seems to me one of Hunt's most successful efforts. But no doubt it is wrong, in trying to assess so thoughtful an artist, to ignore his intentions. They were remarkable; in later life he was to declare that 'the purpose of art is, in love of guileless beauty, to lead man to distinguish between that which, being clean in spirit, is productive of virtue, and that which is flaunting and meretricious and productive of ruin to a Nation'[9].

Hunt's method of teaching the world to distinguish between virtue and vice was, in the first place, to produce a painstakingly accurate account of that which he could see – or rather, of that which, after prolonged examination, he could discover about nature; at the same time, to arrange that nature should contain objects which would be of symbolical importance and appropriate to the particular moral and historical situation with which he was concerned; and finally, to load the principal actors of his dream with the heaviest possible charge of expressive emotion. (I am of course speaking here of his history paintings; whether his use of landscape can be accounted an engine of moral improvement I do not know.) All these methods were employed to the full in *The Awakening Conscience*. The scene in the tawdry little *maison damnée*, as F G Stephens called it, is certainly rendered with high fidelity, even though the details verge upon the improbable. How could any room manage to contain so much morally appropriate detail? Still, the great wealth of symbolism falls so naturally upon the eye that, as we have seen, many spectators were quite unaware of it. We have to

take the horror on the girl's face on trust – though judging from some other examples of Hunt's work, it was indeed horrid.

But what strikes us, even though we are fully instructed concerning the purpose of this painting, is the mass of carefully painted detail. Today, perhaps, it is the documentary fidelity of the work that at first impresses us: here indeed is a Victorian interior of a very perfect kind; it is as informative, perhaps more informative than a good photograph. Hunt's contemporaries would not have been interested in the painting as a document, but even they found the abundance of information distracting. I quote again from Ruskin. 'I can easily understand that to many persons the careful rendering of the inferior details in this picture cannot but be at first offensive, as calling their attention away from the principal subject.[10]' Of course Ruskin hastens to tell us that these details are in truth full of tragic moral significance. Nevertheless it can hardly be denied that Hunt's stern naturalism is at war with his didactic purpose. A painter who was ready to obscure, omit, distort or dramatically illuminate his scene, a Rembrandt or a Goya, would have found it very much easier to point his moral or elucidate his dream. As things stand we are likely to become as much interested in the gentleman's whiskers or the highlight upon the glass clock-case as in the specifically pathetic or at least symbolical elements in the picture.

The factual impartiality of Hunt's method stands between him and his purpose. He would teach us, but he forbids himself to do that which would make his lesson clear; he depends upon our acumen and our perseverance – we are to examine every detail and to examine it, not simply as painting but in a more intellectual fashion, considering not merely the appearance (which so strongly claims our attention) but the intention of every detail. If we do so and if our extrinsic knowledge be sufficient we may indeed be rewarded. Look then at the wall behind the head of Annie Miller (for it is she whose conscience is being awakened, and not a moment too soon). You will perceive certain conventionalized plants; they are vines, at least they bear grapes, in their branches birds have settled, and below them there are ears of corn: 'And it came to pass, as he sowed, some fell by the wayside and the fowls of the air came and devoured it up' (Mark 4:4).

It did not escape Ruskin's attention, but I think that it would have escaped mine, and yours too very likely. But if we had discovered it for ourselves how pleased we should have been; we should have congratulated the painter on his ingenuity in this using the very wallpaper to explain the young woman's unfortunate situation and we should have congratulated ourselves. But is there any moral grandeur in this ingenuity? And is it really necessary so

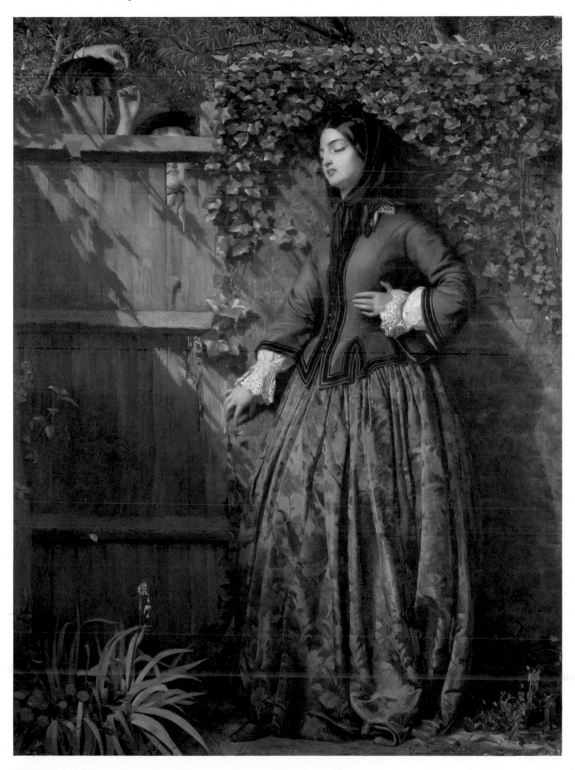

PLATE 9
P. H. CALDERON *Broken Vows* 1857.

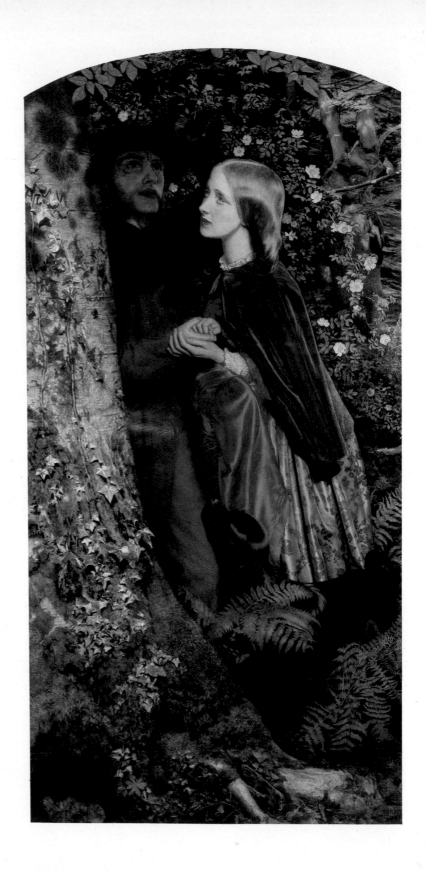

PLATE 10
ARTHUR HUGHES *The
Long Engagement* 1859.

far as the didactic purpose of the artist is concerned to play this elaborate game of hide-and-seek with the spectator? Does it really help us to distinguish between virtue and depravity to make the same point in so many different ways?

Hunt clearly had a passion for this kind of pictorial guessing game; it was an inoffensive and very understandable passion, and no doubt it is a source of delight to art historians. But in one who regarded himself as a moral teacher it seems strange. If one is to exalt the righteous and to chastise the wicked surely it is necessary, in the first place, that the wicked should be aware that they are being chastised, and that the virtuous should know that they are being commended. Hunt's audience did not know; his pictorial rebus was so deftly planted as to be almost invisible. Sometimes he would explain what he had in mind by means of a written description; but it would seem that his purpose was frequently misunderstood or disregarded, and there are points on which his meaning is still obscure and still a matter of debate amongst the experts. His paintings provide a fascinating subject for study, but as moral propaganda they can hardly be considered successful.

There remains one dramatic device which might make everything clear: the use of highly expressive physiognomy. Hunt provides it in good measure: whether we find it a satisfactory method or not will depend upon individual taste. To me, I must admit, it

WILLIAM HOLMAN HUNT
The Finding of the Saviour in the Temple 1854–62

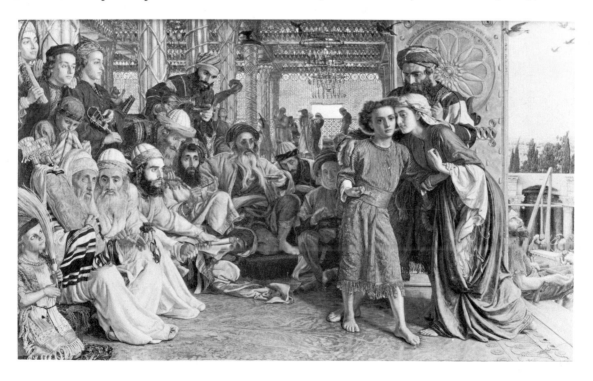

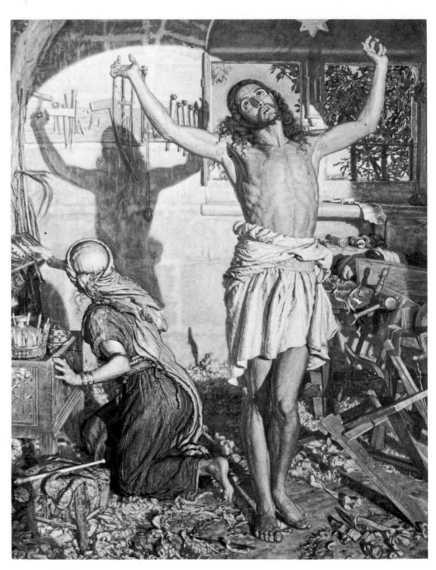

WILLIAM HOLMAN HUNT
The Shadow of Death
1869–73

seems disastrous, and yet another instance of Hunt's dreadful ability to destroy himself as an artist. Compare the Holy family as represented by Millais in *The Carpenter's Shop* with that which Holman Hunt gives us in *The Finding of the Saviour in the Temple*. Both artists are trying to give us a faithful account of life; but somehow Millais's people are real while those of Hunt are totally unconvincing. They are unconvincing I believe because Hunt has a dual purpose, he wants to be true to life but he wants also to idealize, he must idealize or what becomes of the moral message? As in *The Light of the World*, he cannot approach a sacred theme without trying to go beyond the facts of the situation, and the effort lands him in the most uncomfortable sentimentality.

I think that the spectator will find the same uneasy compromise in *The Triumph of the Innocents* (in particular that version which is in the Fogg Art Museum), and again in a particularly painful, almost vulgar form in *The Shadow of Death*. There is a fatal incompatibility between Hunt's belief in the didactic purpose of art and his natural tendency towards detailed naturalism, and this is made all the more unfortunate by the technical methods which were so well adapted to the latter purpose. The attempt to give nature a supernatural quality results in a kind of mawkish religiosity which is made all the more painful by reason of the diligent thoroughness with which it is stated — with which indeed it has to be stated, for in the highly wrought presentations of detail of which his pictures were in piecemeal fashion composed, some kind of special effort was required if the faces of holy persons were not to be lost in the general mass of exactly stated information. Thus there is no escaping from the detailed, exact, but emotionally charged exhibition of piety. There is no loophole for the imagination, no mitigation at all. Hunt knows where his duty lies and we are left with a devastating record of his achievements.

Although he was to wander far from the aesthetic of his master, Rossetti it would seem never quite forgot Hunt's early teachings; in some of his work there seems to be an infirmity of purpose rather similar to that of Hunt; but Hunt's sense of pious obligation is happily absent from Rossetti's work, and Dante Gabriel never had a didactic purpose. Very early in the days of the Brotherhood, in the autumn of 1849, he seems to have realized that he was not or could not be a teacher and that his mission in life was to make works of art, not for humanity, but for himself.

Rossetti published his declaration of artistic faith, for such I take it to be, in *The Germ*, the short-lived organ of the Pre-Raphaelites, subsequently renamed *Art and Poetry*. In fact there was a good deal more poetry than art about it; the printers did manage to produce a few rather poor engravings, but for the most part it was a literary magazine. It is indeed astonishing, and a measure of the Pre-Raphaelite inclination towards literature, or perhaps of Dante Gabriel's persuasive power, that any group of painters should have been responsible for such a journal. It printed some memorable poetry, but from an art-historical point of view it is rather disappointing reading. If only its brief florescence had coincided with the first public attacks upon the Pre-Raphaelites (in fact it ended just before they began), it might have contained some apologetic writing which would have given us a clearer idea of what the Brethren really believed they were doing. As it is it seems

strange that there was no kind of manifesto, no statement of doctrine.

The most that the young men would do was to ask William Michael Rossetti to write a poem which would be printed on the cover. This he did; but it was so awkward a sonnet, so tortuously expressed, and printed in so crabbed a gothic type face as to be well nigh unintelligible. Fortunately the poet has told in plain prose what he was trying to say:

> What I meant is this: A writer ought to think out his subject honestly and personally, not imitatively, and ought to express it with directness and precision; if he does this, we should respect his performance as truthful, even though it may not be important. This indicated, for writers, much the same principle which the PRB professed for painters — individual genuineness in the thought, reproductive genuineness in the presentment. [11]

This is indeed very similar to the Pre-Raphaelite creed as recorded elsewhere: 'To have genuine ideas, to express, to study Nature and to sympathize with what is direct and serious and heartfelt in previous art.' In both cases the advice seems excellent, but it might have come from the President of the Royal Academy.

Elsewhere in *The Germ* we shall find a few interesting passages, as for instance John Tupper's plea for modern subject matter in pictures — which unfortunately is contained in a theoretically muddled and quite horribly ill-written essay; Ford Madox Brown's purely technical article on the mechanism of the historical picture, which tells us little save that the artist should know his history; F G Stephens on the purpose and tendency of early Italian art; and John Orchard's 'Dialogue on Purism'. Stephens's situation is both difficult and typical, for he has to build his defence of the Italian Primitives upon a basis of ignorance. There is so very little that he has actually seen. He is a good deal happier when he can turn from the achievements of the past to the disasters of the present, and above all when he can attack the degraded, voluptuous and sensual painting of the period. His moral tone is extremely high, and this is true of most of the contributors — although no one can, in this respect, compete with John Orchard. Orchard believes firmly that art must be the handmaiden of religion and morality — feeling this, he is perfectly ready to dismiss all English and Dutch painting, and comes near to dismissing as well all Greek and Roman art, which he finds quite disgracefully sensual. The ancients do however present a difficulty for the purist, and one which Orchard is unready to deal with simply by saying that they were bad. The other great difficulty,

with which he strives manfully, is the 'ineptitude' of the earlier Italians. These problems must have presented stumbling blocks for the young enthusiasts of the time and it is not uninteresting to see in what manner they contrived to get round the difficulties which, clearly, were deeply felt.

But Dante Gabriel Rossetti's contribution to the first number of *The Germ* is in another way interesting. It takes the form of a short story entitled 'Hand and Soul'. Perhaps it also reflects the notion that almost any modern artist is better equipped technically than his predecessors of past centuries, a notion which might allow a nineteenth-century student to imagine himself transported back into the past armed with a technical ability that would at once place him at the head of his profession. I think that Rossetti was possessed by some such fancy when he wrote 'Hand and Soul'. The story is set in Pisa, the period being slightly before that of Cimabue; it is introduced by some confected art history and Rossetti was delighted later to discover that his spoof had been well enough contrived to take some people in. But the pretence that this is not fiction is very soon discarded altogether, and it seems legitimate to suppose that Gabriel's hero, Chiaro dell' Erma, is indeed himself, or to a very large degree himself. Certainly his feelings and opinions belong to the mid-nineteenth century. The main difference between Chiaro and Gabriel is that Chiaro is credited with a mastery of his craft, or at least a superiority to all his rivals, which Gabriel would no doubt have liked to have.

Chiaro, a native of Arezzo, visits Giunta Pisano and at once discovers that he, Chiaro, is very much the great man's superior; tactfully he keeps this to himself. But his talents being so much above those of the acknowledged head of the profession, exertion seems unnecessary and he therefore relaxes, does no work and has a good time with the Pisan girls (this is certainly Gabriel). He continues this idle and profligate life until the arrival in Pisa of an equally gifted youth called Bonaventura. Confronted by this menace, Chiaro wakes up; he takes to 'work diligently'. Within a few years he is famous. But he is not happy, he feels that his motives have not been pure, in fact he becomes extremely introspective:

> But now (being at length led to enquire closely into himself), even as, in the pursuit of fame, the unrest abiding after attainment had proved to him that he had misinterpreted the cravings of his own spirit — so also, now that he would willingly have fallen back on devotion, he became aware that much of that reverence which he had mistaken for faith had been no more than the worship of beauty. Therefore, after certain days passed in per-

plexity, Chiaro said within himself, 'My life and my will are yet before me: I will take another aim to my life.'

From that moment Chiaro set a watch on his soul, and put his hand to no other works but only to such as had for their end the presentment of some moral greatness. . . .[12]

One feels that Hunt would have approved: the young man was on the right track and the story would be edifying. But it is at this point that it begins to take a rather unexpected turn. Chiaro's conversion, if one may thus describe it, alters his painting, but not for the better; his paintings become 'cold and unemphatic; bearing marked out upon them . . . the measure of that boundary to which they were made to conform'. Neither does it seem to have made Chiaro himself much happier.

Rossetti leads us to the crisis of his story by describing a great feast day·in Pisa and a ceremony in the church of S Rocco where Chiaro has painted a moral allegory of Peace. It is in front of this work and in a place fully visible to Chiaro himself, who has become a spectator of the proceedings, that the rival factions in the city, having exchanged harsh words, presently come to blows, 'and there was so much blood cast up the walls on a sudden, that it ran in long streams down Chiaro's paintings'. Not unnaturally, Chiaro is greatly depressed; as a didactic painter he seems to have achieved very little.

> Where I write Peace, in that spot is the drawing of swords, and there men's footprints are red. When I would sow, another harvest is ripe. Nay, it is much worse with me than thus much. Am I not as a cloth drawn before the light, that the looker may not be blinded; but which sheweth thereby the grain of its own coarseness, so that the light seems defiled, and men say, 'We will not walk by it.' Wherefore through me they shall be doubly accursed, seeing that through me they reject the light. May one be a devil and not know it?[13]

Having come to these very uncomfortable conclusions Chiaro retires to his room and is soon very unwell. In his fever he has a vision. It takes the form of one of those grave, gentle, golden-haired young women who were so frequently to inhabit his, that is to say Gabriel's, pictures. This apparition explains to Chiaro that she is the image of his soul, and the conversation which follows may therefore be considered as a kind of feverish introspection. Her argument, like many of Gabriel's pictures, is adorned by expressions indicating extreme piety. She never denies the claims of religion, indeed she sees her mission as being essentially religious; nevertheless the

morality to which Chiaro's soul appeals does seem essentially different from that of Tupper, Stephens, Orchard or Hunt. The apparition commends Chiaro for having escaped venality as an artist, but blames him for trying to paint didactic pictures. It is, she suggests, presumptuous:

> Give thou to God no more than he asketh of thee; but to man also, that which is man's. In all that thou doest, work from thine own heart, simply; for his heart is as thine, when thine is wise and humble; and he shall have understanding of thee.[14]

In fact Chiaro is urged to listen not to the voice of ambition, nor to that of philanthropy; rather he is urged to be faithful to her, his own psyche: it is she whom he should paint. He obeys at once, depicts this seductive vision of his own mind, and sleeps at last, deaf to the continuing tumult in the city and to the chanting of the mass for those who have been slain.

To me it seems that Rossetti is preaching a doctrine of artistic self-sufficiency; it is, to be sure, presented as a superior form of piety, but the clear moral is one that could be accepted by any artist who believed in what is called 'self-expression'. The painter must be true to his own genius and must set it above any didactic purpose howsoever admirable. It is no business of the artist to try to set the world to rights, he will probably do no good to the world and it will be bad for his painting.

Thus at a very early date Gabriel was ready, in theory, to part company with Hunt – although we need not suppose that in 1849 Hunt himself had with any clarity or certainty arrived at that sternly moral and strongly patriotic conception of the artist's duty to which he was later to give so characteristic an expression.

But if Rossetti, as I think, broke away from Hunt's morality and religiosity at an early date, he was much slower to depart from Hunt's conscientious naturalism; indeed, I am not sure that he ever was completely separated from it. Here again it seems to me that the Pre-Raphaelite technique was the really powerful and attractive contribution to the movement. There are indeed some very freely painted essays by Rossetti of the 1850s and '60s in which hard-edge naturalism seems quite forgotten; but he returns frequently to a much more exact and, in intention, a much more realistic method.

Look for instance at *The Day Dream*, painted in 1880; at first sight it appears almost to be a pure decoration, a study of rhythmic movements, drapery, foliage, and Mrs Morris. One feels that it could almost be made into a repeating pattern. It began as *Monna*

Primavera or 'the Vanna picture', and Gabriel writes to Jane Morris concerning it:

> The *Vanna* picture has quite a finished look now but is as yet unframed, nor is it really near a finish as to colour and tone. But I fear I shall have to change the name and call it perhaps *The Day Dream*, reserving the other title for another of the series. Since I painted the Spring leaves, the picture has undergone much remodelling; and though it is a fact that many of the largest leaves were on the tree together with the smallest, still it looks very full in leaf for a spring tree, and I think the snow-drops will not do with it. I have removed them but not substituted another flower yet, and really almost think I may have to put off the flowers to the early part of next year. . . .[15]

And ten days later:

> I have come to the conclusion that a wild honeysuckle of the slight white and yellow order might stand for the flower. It seems to be longer in all the year round than anything else. Have you anything of the sort? If not, I think I know of a little boy who could be suborned to search for one.[15]

And about a fortnight later:

> It was very sweet of you to send these sweet honeysuckles. I have painted one today, but don't know whether it is right yet. I have been a good deal out of sorts since I saw you and much troubled about the head in the picture. . . .[15]

There is here an almost Ruskinian deference to botanical truth and a Pre-Raphaelite respect for 'probability'. Unfortunately these two canons of fidelity are not always compatible. Rossetti found, as I suppose we must all find, unless we are ready either to dismiss apparent truth or to submit entirely to what the facts give us, that nature will not always play the game as we could want it played. It was a fact that the sycamore leaves were of different sizes at the same season, so that nature herself seemed perversely to desire to appear unnatural. But the fact was unacceptable; it seemed to fly in the face of probability. It became necessary, as Holman Hunt had found in a rather different connection, to reshuffle and rearrange the evidence. The subject must be made acceptable before it can be painted, but the acceptable subject must at the same time be true.

It has to be borne in mind that these letters were written in 1880, when Rossetti was about fifty-six years old and that he was no fool. It does seem extraordinary, this being the case, that having for

DANTE GABRIEL
ROSSETTI *The Day Dream*
(Monna Primavera) 1880

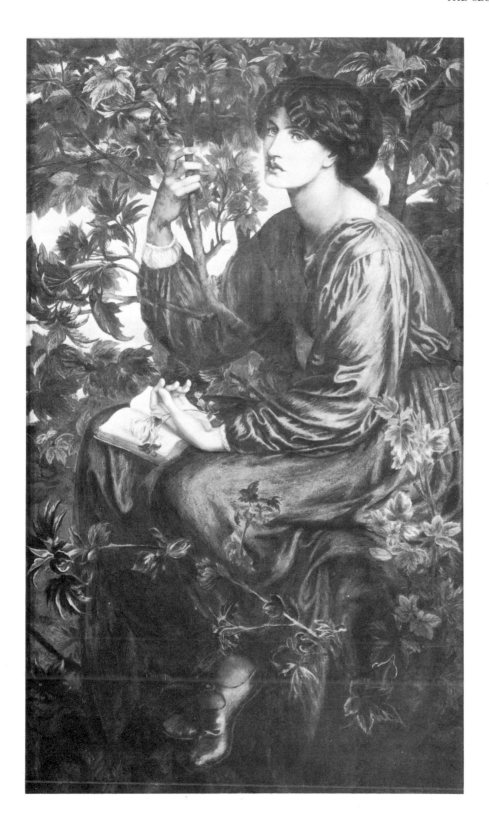

about thirty years practised the art of drawing, and therefore having been continually made to realize how nature behaves, he should have continued to puzzle over such questions as these. It is all the more extraordinary when one remembers that in some of his earlier work he really shows himself quite indifferent to questions of appearance and probability. That he still did puzzle seems to indicate that a very decided 'set' had been given to his mind by the teachings of Hunt and perhaps, despite some scoffing remarks, of Ruskin. At the same time there is something rather admirable and rather touching in this continuing preoccupation with hard facts, at a time when Rossetti was so much engaged, and so profitably engaged, in the production of glamorous 'stunners'.

Throughout almost his entire life as a painter Rossetti was haunted by the idea of painting a picture which should be 'realist' in a very full sense of the word, that is to say a faithful, detailed account of an incident in modern life. His attempt was the painting which was to be entitled *Found*.

Found deals with much the same subject as *The Awakening Conscience*. But whereas Holman Hunt deals with the sudden awareness of sin, Rossetti looks rather at the social predicament of morality's victim — 'the deadly blight of love deflowered'. At daybreak in London a young drover brings a calf to market and comes upon his former sweetheart prone upon that pavement which has become her place of business. He attempts to raise her but she, knowing that she has sunk too far, that she is, like the netted calf, a doomed captive of society, will have none of it.

> She cries in her locked heart, —
> 'Leave me — I do not know you — go away.'[16]
> ('Found')

The long, confused and unhappy story of how Rossetti attempted to finish this picture has been admirably told by Alistair Grieve.[17] Again and again the thing was abandoned, restarted, changed and redesigned, and the painter was still trying to complete it, for the last of a series of frustrated patrons, in the year before he died.

Unfinished though it is, it is a monument to Rossetti the realist. He would, he declared, refute 'the charge that a painter adopts the poetic style simply because he cannot deal with what is real and human.'[18] Why then did he fail and fail so often? The simple answer is that he was too lazy. *Found* presented a formidable problem and one not wholly to his taste. It would always have been tempting, when the first excitement of discovery or rediscovery had

evaporated, to turn again to one of those luscious confections, difficult though they may also have been, in which beautiful women in beautiful surroundings so prettily contrive to do nothing in particular. But I would suggest that the structure of *Found* involved the artist in special problems and particular dangers.

A finished drawing in the British Museum gives one a fine notion of what the original conception must have been. This drawing is full of poetry, full also of quiet force, an energetic quality which derives from the relationship of the foreshortened bridge, which swings away nobly to meet the distant city in the background, and the steeply dynamic drawing of walls and pavements in the foreground. The spring of the design is reinforced by the vigorous shapes of the man and the woman on the pavement, and is sufficient to carry the less impressive mass of the cart and the calf. The composition is full of felicities; consider, for instance, the interaction of the coping on the wall, the steps descending from the bridge and the arch. Altogether a neat and highly efficient piece of drawing; no wonder Rossetti was always greatly taken by its possibilities.

It was a lovely drawing to have made and it must have seemed a wonderfully promising starting point for a finished picture; but to supply texture, colour and naturalistic detail was a peculiarly difficult proposition. How difficult may be seen when we compare the drawing with the unfinished painting in Wilmington, Delaware. The strength of the original composition lay in its suggestion of deep unbroken space, the thrust of the bridge being carried down in one continuous sweep to the foreground; the weakness of the unfinished painting results from the artist's manifest inability, when he uses paint, to connect foreground and background. In the Wilmington picture the original idea seems to have been smashed and to lie in useless fragments before us. The problem has been made more difficult by the Holman Hunt-like detail of the brick wall, which brings the design to an abrupt and disastrous check just where it most needs a continuation. In the sketch this problem does not arise, for here the landscape can be summarized in the form of an elegant almost two-dimensional pattern. But in the picture the middle distance badly needs to be but has not been described.

A deep continuous recession exactly rendered in minute detail must always present formidable difficulties; Holman Hunt and Ford Madox Brown come near to achieving it; but there are very few Pre-Raphaelite paintings which attempt anything so exacting as the task that Rossetti had set himself here. Usually he goes out of his way to avoid such things and solves the problem of recession by interposing barriers placed in the middle distance and parallel to the picture plane (we have already noticed that the youthful Hunt made use of

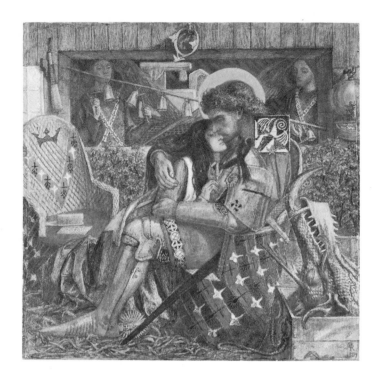

DANTE GABRIEL
ROSSETTI *The Wedding of
St. George and Princess
Sabra* 1857.

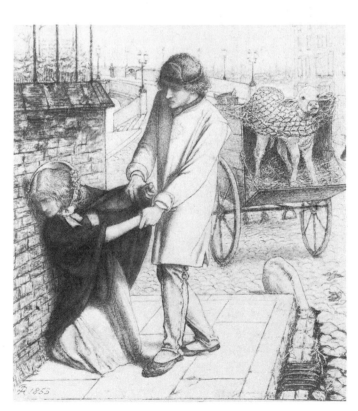

DANTE GABRIEL
ROSSETTI *Found, drawing*
1853

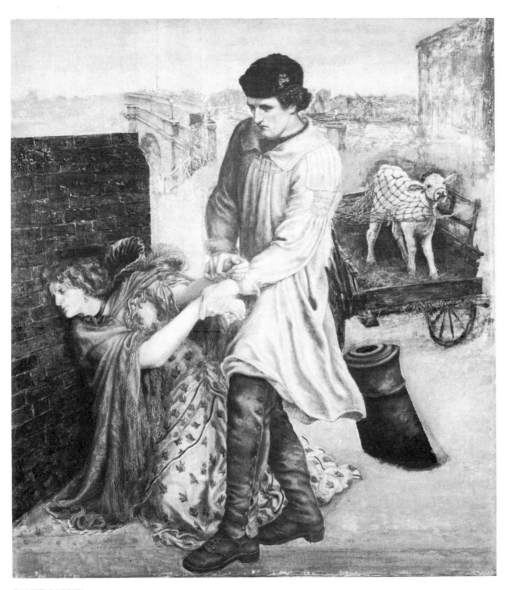

DANTE GABRIEL
ROSSETTI *Found*
1853–59

this device). A drawing belonging to Professor Fredeman suggests that at some point Rossetti meditated an escape from his difficulties in *Found* by the use of just such a contrivance as this. The receding wall on the left-hand side of the picture is redirected so as to block our view and the couple stand squarely in front of it; the recession on the right is masked, perhaps completely obscured by the drover's cart. This is much more like Rossetti's usual management of space. The trouble is that all the charm and strength of the original design has had to be sacrificed. One supposes that Rossetti must have felt this, since in later drawings and in the Wilmington painting this solution is abandoned.

But even so, in the painting compromises have been made. The very beautiful passage which I have tried to describe — the elegant ascending curves formed by the man's arm, the pavement and the architecture of the bridge — was, as one may well imagine, very hard to render in paint; it depends so much on the linear quality of the drawing. In the painted version this area has been very much changed; there is an inconclusive muddle of drapery over the woman's shoulder, a much weaker description of the man's arms, indeed of his entire pose, and some vague, inconclusive rearrangement of the bridge.

It is painful to consider the extent of Rossetti's failure and the very mediocre work which in the end resulted from that first brilliant conception, but it is further evidence that he never ceased to be serious in his pursuit of something harder and harsher than the saccharine products of his later years. It may also be thought to indicate a curious duality of purpose. Chiaro dell' Erma was fortunate in finding only one alter ego to inspire him. His creator was perhaps possessed by two: on the one hand the painter of *Ecce Ancilla Domini*, and the would-be painter of *Found*; on the other a decorator, a romantic opposed from the very first to the realism of the Brotherhood.

In 1868 M Ernest Chesneau asked Rossetti whether he had in fact been the leader of the Pre-Raphaelites. He replied that so far from being the leader of the school (*chef de l'école*) he was hardly a Pre-Raphaelite at all:

> The qualities of emotional but extremely minute realism which mark the Pre-Raphaelite style are to be found principally in all the pictures of Holman Hunt, in most of those of Ford Madox Brown, in some pieces by Hughes and in the admirable work of the young Millais. It was friendship (*la camaraderie*) rather than any real stylistic

collaboration which joined my name to theirs in the enthusiastic days of twenty years ago.[19]

One can scarcely accept such a disclaimer at face value; it is the kind of overstatement one makes when one is trying to set someone right who has been greatly misinformed. But, undeniably, that side of Rossetti which was impatient of the claims of nature and factual truth in art was, when it could be allowed full scope and when Rossetti had indeed become the leader of a school, all-important. It made him the seminal figure that he was.

In the very early days of the movement, Rossetti and Hunt, according to Hunt, had imagined themselves as creating great workshops, something not unlike the mediaeval guilds, with themselves as guild masters. They would create a new decorative style which would change the look of architecture and the applied arts, they would rehouse, refurnish and reclothe mankind. This was perhaps a necessary consequence of the 'political' side of their imaginings: under their influence it was not only painting but mankind which was to be regenerated. The idea was sufficiently potent and sufficiently much 'in the air' to have affected Ford Madox Brown who, like Hunt himself, designed his own furniture, adapting Egyptian originals which he found in the British Museum. And as we have seen, decorative essays of the same kind, but in this case influenced by Ruskin, were attempted by the young Millais at Glenfinlas.

But the very nature of Pre-Raphaelite painting in its first stage of evolution made such ideas very difficult of realization. When you attempt to paint exactly what you see in nature you end — if you succeed at all — by producing a kind of alternative world within the picture frame. This remains true even when you design your own frame, as some of the Pre-Raphaelites did. That gilded margin, painted with the one colour which will not be found within the frame, marks a frontier between the imagined world of the painter and the 'real' world outside. In consequence your picture can be removed and replaced almost anywhere. It bears no fixed relationship to the wallpaper or the wall against which it is set; it is not designed to play its part in the architecture of a house, still less in some manner to continue the design in which the house itself is set. A decoration or a decorative picture may, although it need not, do all these things. Again, a hard-edge Pre-Raphaelite picture, because it is intended to show us, as though through a window, a world imagined by the artist, must attempt to create imagined recession; it must in a manner of speaking break and penetrate the surface on which it hangs.

Compare this kind of illusionist painting with the kind of picture which Rossetti was producing in the 1850s and 1860s. Look, for instance of *The First Madness of Ophelia* or *The Wedding of St George and Princess Sabra* or *The Tune of the Seven Towers*. Here there is hardly more than a suggestion of real space, there is neither sky nor ceiling nor floor, the picture is airless, crowded with figures, and flat. Here there is no attempt at deep continuous recession. Rossetti seems deliberately to flatten his background, reducing it to a two-dimensional pattern as flat as an emblazoned shield or a playing-card royalty. It becomes something which could be assisted by, even if it does not have, a decorative context, just as an illuminated capital is helped by the surrounding text or a patterned paper by the adjacent skirting board. Rossetti turns from the painting of easel paintings to fixed decoration, as in Llandaff Cathedral, and he does so without any substantial alteration of his style. His work is now of a kind that can easily be translated into tapestry or stained glass.

In this flattened decorative work he is able to exhibit qualities which had hardly been evident in his earlier efforts at realism; he shows himself to be a brilliant colourist, using paint with the utmost freedom and taking new liberties with space – as for instance in *The First Madness of Ophelia*, where the shields on the tapestry which, in principle, should be behind the figures, are brought forward to enrich, and to destroy, the surface of the picture, or again in *The Wedding of St George*, where the figures seem to be fitted in amongst the innumerable boldly patterned surfaces.

Rossetti remains greatly concerned with his story, very often with his poem, but in all other respects he seems to have parted company with the idea of illusion. He is indeed painting his own kind of picture which is quite unlike anything else that was then being produced in Europe. If it can be called Pre-Raphaelite, it is because such disregard of appearances and of probability may be found in the art of the Middle Ages and perhaps in the paintings of William Blake.

By the mid-1850s, hard-edge modern subject realism was at its apogee and Millais still looked like becoming one of the very great European masters. The Brotherhood was all but extinct, but two young men at Oxford who were ready to enlist in the service of the Pre-Raphaelite movement instead discovered Rossetti; and Rossetti had by then begun to produce an entirely new kind of painting with a very different kind of aesthetic. They accepted his leadership with enthusiasm and, as the hard-edge movement petered out, the future lay in his hands.

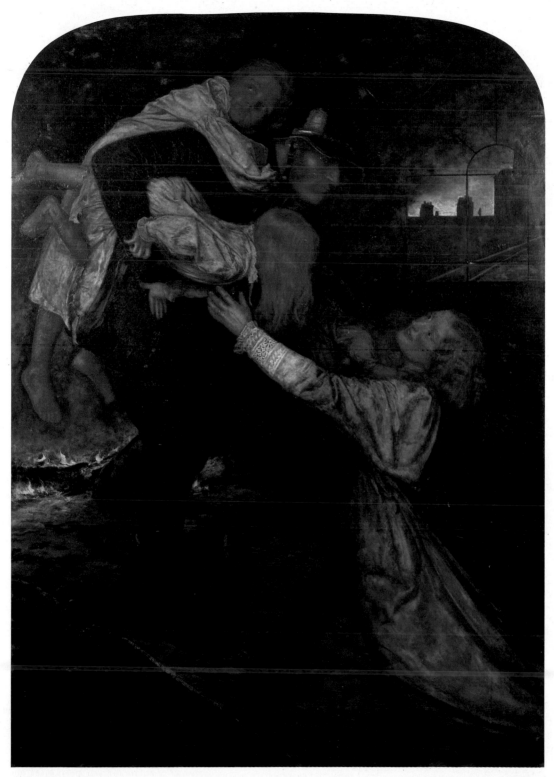

PLATE 11
JOHN EVERETT MILLAIS *The Rescue* 1855.

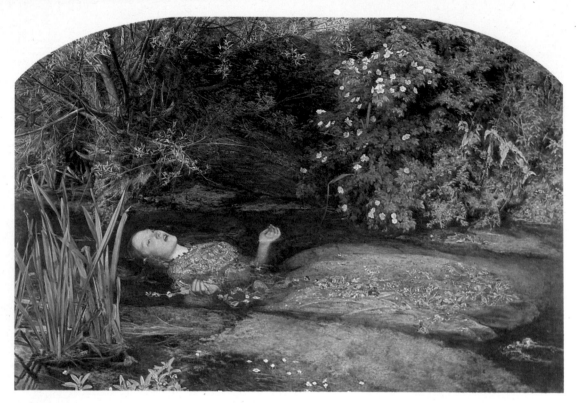

PLATE 12
JOHN EVERETT MILLAIS
Ophelia 1851-2.

The Ascendancy of Rossetti

I began by suggesting that the Pre-Raphaelite movement arose largely from a feeling that the questioning, anxious spirit which was already apparent in the poetry and the architecture of the period ought also to be expressed in its painting. At that time, in the 1840s, that national anxiety was for serious-minded people involved in two main questions: the religious question, which in its most simplified and dramatic form might be resolved by a conviction that it was only by a return to Rome that a spirit perplexed by the doubts of the age could find comfort; and the political question, which – again in its most extreme form – resulted from the lively fear, or hope, of revolution. In the 1850s and 1860s those questions persisted but in a much milder fashion. The political question seemed for the time being to have been resolved by the failure of Chartism at home and the defeat of liberalism abroad – the victory, as William Michael Rossetti put it, 'of the worser party'. At the same time the domestic scene began to appear more cheerful after the Great Exhibition of 1851, and to most Englishmen it seemed that theirs was a fortunate island of civil peace and industrial prosperity. At the same time the never-ending perplexities of religion were concerned less with the authority and doctrine of rival creeds, than which nothing had been more bitterly divisive, and more with a common concern to defend religion itself from the work of the scientists and the textual critics. The agonizing perplexities of the earlier period were perhaps reflected in a harsh emotional realism and a continual preoccupation with religion; this was slowly replaced by a form of art in which the myth was still all-important, but important for its own sake and not because of its relation to morality or to belief.

Compare these lines taken from Tennyson's *In Memoriam*, with which I adorned an earlier page, with an even more familiar quotation:

> We shift and bedeck and bedrape us,
> Thou art noble and nude and antique;
> Libitina thy mother, Priapus
> Thy father, a Tuscan and Greek.
> We play with light loves in the portal,
> And wince and relent and refrain;
> Loves die, and we know thee immortal,
> Our Lady of Pain.
>
> ('Dolores')

Swinburne himself said that none except his earlier works could possibly be called Pre-Raphaelite, and of course in a strict sense he

was right. Neither was Burne-Jones, to whom Swinburne dedicated *Poems and Ballads*, in any strict sense a Pre-Raphaelite painter; but by 1866 when *Poems and Ballads* was published, Pre-Raphaelitism itself had undergone a metamorphosis. Whereas in the years of the Brotherhood the poet, like the painters who followed him, was in pursuit of truth, in the 1860s poets and painters alike were in pursuit of beauty. This momentous change was just beginning when in 1853 Mr Jones and Mr Morris came to Oxford, and the education they received there – or rather discovered for themselves – led them to take part in it. They went up to become clergymen, they came down to become artists.

At the beginning it was an immensely exciting prospect. The two young men had heard of what had been going on at Oxford during the past twenty years and came all ready for the fray. They would throw themselves into the High Church movement, they would agitate, argue, meet other enthusiasts who surely would lead them into the most exciting spiritual adventures. They were prepared to confront perhaps even to be seduced by, the Scarlet Woman.

The trouble was that their information was rather out of date. Already the great sectarian convulsions were beginning to subside. Oxford, hitherto the deeply troubled heart of the controversy, was settling down to a more peaceful and more normal existence. As the din and smoke subsided there were some who found themselves in the Roman Church, others who settled in some appropriate mansion of the Anglican edifice, quite a few who found themselves in no fold at all. Newman was gone in one direction, Pusey in another, Froude in a third; the fireworks were extinguished and the party was over. Oxford was again a pleasant enough town without too many unhealthy intellectual excitements to trouble the fat slumbers of the Church.

For both these young men it must have been a dreadful anti-climax; but for Burne-Jones it must have been very hard indeed. He was particularly susceptible to the excitements that Oxford might have been expected to provide, a romantic with all the nostalgia for the past that one might expect in one who was born at No 11 Bennet Street, Birmingham. Morris, the son of a well-to-do bill broker who lived in a comfortable and pleasantly designed house in Walthamstow, at that time a rustic village north of London, was I fancy less to be pitied; from the first he was rather less vulnerable and rather more of a realist than his friend.

The two men became acquainted and were soon inseparable. They were both at Exeter College, but found a group at Pembroke which was particularly congenial. With this group they shared an

admiration for Tennyson, Keats and Ruskin and together they seem, almost consciously, to have imitated the Pre-Raphaelites of the Brotherhood. They too would found some kind of society, perhaps a quasi-monastic phalanstery, and they too would have a journal, the *Oxford and Cambridge Magazine*; and they too failed, the monastic body ended in talk, the magazine lasted no longer than *The Germ*. But they were not painters, their interests were mainly literary.

Burne-Jones was the only one who had the slightest training in art. He, indeed, had received some education at the Birmingham School of Design. 'Might do better if he exhibited more industry,' reported the head teacher. Lady Burne-Jones, writing many years later, was indignant: it was most unjust; at sixteen Ned had already shown an infinite capacity for taking pains. I am sure she was right; but then how could she know that poor Mr Clark, who taught Ned both at the King Edward School and at the School of Design, had, at the latter establishment, no less than 480 students on whom to report. Indeed, he was bound to make mistakes; the work was too much for him, he found solace in the arms of female students and was, in consequence, fired. But I digress.

Morris seems to have received no art education before he came to Oxford, but he had, clearly, a considerable knowledge of Gothic architecture and must have had an eye for the fine arts.

One way or another the first intentions of these undergraduates were changed. A career in the Church was no longer so very enticing. They wanted something else. For Burne-Jones there was a long period of vacillation and of anguish. Should he, he wondered, 'sink his doubts and go over to Rome'? His doubts appear to have floated and he himself drifted into some kind of rather noncommittal Theism. Morris, to judge by later developments, lost his faith altogether. What they sought and eventually found was a new purpose. At the end of a walking tour in France, which was in effect a pilgrimage from one Gothic church to another, they found themselves one memorable evening walking along the quays of Le Havre. Here Morris announced his determination to become an architect. Burne-Jones declared that he would be a painter.

Already, before they left Oxford, Morris and Burne-Jones had seen something of Pre-Raphaelite painting. Both Millais and Holman Hunt were known to them. 'But', says Burne-Jones,

> Our greatest wonder and delight was reserved for a water colour of Rossetti's, of Dante drawing the head of Beatrice and being disturbed by people of importance. We had already fallen in love with a copy of *The Germ*, containing Rossetti's poem of the Blessed Damozel, and at once he

seemed to us the chief figure on the Pre-Raphaelite Brotherhood.[20]

By 1855 it seemed natural that Rossetti should be regarded as the leader of the Pre-Raphaelites; as we have seen he had, as one may say, been left in charge of the movement, or very soon would be. But for Burne-Jones there was in any case a more potent reason why he should turn at once to Rossetti. If one compares Rossetti's drawings of the '50s with the very youthful but, in their awkward and angular way, expressive illustrations which the young Burne-Jones made for Archibald MacLaren's *Fairy Family*, one must surely feel that although the young man had not yet seen Rossetti, and was no doubt influenced by other masters, it was Rossetti whom he needed. The intention of those early works is clear: he is far from nature and is greatly concerned with the situation of decorative ideas within a given space. Rossetti was doing what he himself was already trying to do.

They came to London – Morris articled under Street, the architect of the Law Courts, Burne-Jones to learn to draw. They both met and were enchanted by the Pre-Raphaelites. Were they, one wonders, a little surprised, a little disconcerted even, to find Dante Gabriel Rossetti engaged upon work which was already so different from that which Millais and Holman Hunt had made famous and which was at that time creating so much excitement and carrying all before it upon the walls of the Royal Academy? If so they kept quiet about it. They followed Rossetti and no one else, and although so many painters were then attempting to imitate the style of Millais they never attempted anything in this line.

Rossetti reciprocated Burne-Jones's friendly admiration and declared that he was 'quite the nicest young man in Fairyland'. Morris soon to become known as 'Topsy', was generally regarded as something of a joke; how much real affection and regard lay behind the continual ragging of Topsy it would be hard to say. It has to be remembered that whereas Ned Burne-Jones was desperately poor, Morris was rather well off, and I think it will be found that whereas young artists will seldom make fun of poverty they regard the affluent as fair game.

Thus a new life began for them in London: it must have been exciting. But they had not quite done with Oxford. Ruskin and his friend Acland had managed to place the new Science Museum of the University in the hands of a brilliant young architect – Benjamin Woodward. Woodward also designed the new debating chamber of the Union. At the same time Ruskin had been struck by the idea

that young artists might volunteer to decorate the walls of public buildings; they should do it for love. Thus an old idea was revived: since the time of Haydon and perhaps even earlier, English artists had keenly regretted that unlike their predecessors of mediaeval Italy they had none of those great mural spaces to fill, and none of those fine roads to High Art and public acclaim which had once been offered to the aspiring painter. The Reformation had whitened the walls of English churches and the palaces of the landed gentry had been left to foreign hands. The decorations of the Palace of Westminster had proved a disappointment. It was time to make a new attempt. Rossetti agreed, and decided that he was the man to do it. With characteristic impetuosity he called upon the painters of the newest generation, some of them so new that they had not yet learnt to paint. They came joyously to his call. They descended upon Oxford, and found the walls of the debating chamber newly finished, the bare bricks covered with a tempting sheet of whitewash; they sent for brushes and colour, and soon great designs began to cover the virgin walls. The theme was to be the Arthurian legend.

Today it is hard to imagine what those decorations looked like when first they saw the light of day; but Coventry Patmore, writing in the *Saturday Review* for 26 December 1857, gives us a notion:

> The characteristic in which they strike us as differing most remarkably from preceding architectural painting is their entire abandonment of the subdued tone of colour and the simplicity and severity of form hitherto thought essential in such kinds of decoration and the adoption of a style of colouring so brilliant as to make the walls look like the margin of a highly-illuminated manuscript. The eye, even when not directed to any of these pictures, is thus pleased with a voluptuous radiance of variegated tints, instead of being made dimly and unsatisfactorily conscious of something or other disturbing the uniformity of the wall-surfaces. Those of our readers who have seen Mr Rossetti's drawings in water-colours will comprehend that this must be the effect of a vast band of wall covered with paintings as nearly as possible in that style of colouring.[21]

That the efforts of these painters should have resulted in such a 'voluptuous radiance' seems appropriate. The conditions of work were wholly delightful, the atmosphere high-spirited, drinks were on the Union; it was not so much a working party as quite simply, a party and a very good one. Dante Gabriel, having come into his own at last, proved an amiable despot and found, as he always found, that his band of fellow workers were glorious fellows — 'stunners',

men of the highest gifts. And what larks they had, what endless fun
with Topsy, with what bright morning promise they all looked and
laughed at the lovely world that lay before them. It was indeed 'a
jovial campaign'.

'The fact is they're all the least bit crazy, and it's very difficult
to manage them.' That was Ruskin's view of the matter and he
should have known. Indeed he should have spoken. After all the
miseries of the Westminster fiasco – and that was after all preceded
by some quite serious technical enquiries – it seems almost incredible
that Rossetti, no longer a child, should have been ready to unleash
his band of painters upon a brick wall that had no damp course and
was covered by nothing more substantial than whitewash.* But
Gabriel when he had the bit between his teeth was hard to check.
If Ruskin did warn Rossetti of what would almost certainly happen,
one can only suppose, with Holman Hunt, that Rossetti was too
impatient to listen.

What followed was a disaster. The whitewash, affected by the
weather, soon began to crumble and to collect dirt, the dirt could
not be removed without removing the whitewash and of course the
painting with it; it was impossible even to take away the great
accumulation of spiders' webs, for merely to blow upon the paint
was to destroy it. Never easy to see, for they were painted against
the light of the rose windows with which the wall was pierced, the
decorations soon became invisible. Early in this century, when
something still remained on the walls, photographs were made
which give a notion, a blurred and blackened notion of the splendour
which once delighted Patmore. All that now remains are a few
almost dematerialized ghosts haunting the gallery of Woodward's
debating chamber.

There had been technical difficulties from the first; there was
also the difficulty of Rossetti's character. He had conceived a
remarkable design, which is preserved in his drawings: the sleeping
Lancelot is prevented from seeing the Grail by Guinevere, who
stands between him and it, her arms outstretched between the rose
windows. This design he liked so much that he tried to use it again
in later years; but neither then nor in 1857 could he complete it. He
lost interest. He went away. Of the work of the rest – Pollen, the
most experienced of Rossetti's band; Spencer Stanhope, who was to
be a figure of some importance amongst the second generation of
Pre-Raphaelites; Val Prinsep, the genial, gigantic, but not very
talented scion of Little Holland House – little remains save a vague

* Not quite incredible perhaps; as I write these words I recollect that I myself
have behaved with almost equal folly. But the circumstances were rather different.

adumbration of forms. Enough does remain of the work of Arthur Hughes to suggest that he had an interesting idea of how to use the rather odd space to which he was confined. Burne-Jones's effort does not look impressive; but it would be quite unfair to judge by the remaining evidence. William Morris undertook Sir Tristram and the Belle Iseult but made the most unholy mess of it, wisely he covered his ineptitude with a great many large sunflowers. Rossetti, who had perhaps fallen a little out of love with the project, suggested that Topsy might go and hide his neighbour's work with scarlet runners.

But when Morris had finished as best he might, he decided to decorate the plasterwork between the rafters of Woodward's ceiling. He invented a bold rhythmic pattern perfectly suited to the architecture, filling and animating the space. Unlike the mural paintings it remains to this day. It was clear and clean and vigorous; unlike everything else it was in every way a success. Morris it will be remembered, had decided to become an architect. Rossetti in his airy irresponsible way had persuaded his young admirer to abandon architecture and become a painter. Now, during that long vacation of 1857, Morris's entire life was recast: he learnt that he could not paint, at the same time he learnt that he was a designer; and he became engaged to the most beautiful of all the Pre-Raphaelite women, Jane Burden.

It is probable that Morris knew of the efforts the Pre-Raphaelites had made to design furniture, and that they were looking for something different from the mid-Victorian work by which they were surrounded. Unlike the Brethren he had a certain amount of architectural training, as well as some money; also he now had a wife who would need a home. Thus he found an enterprise well suited to his peculiar genius; he would create a workshop.

It was a momentous decision. Not only did the world receive a new kind of decorative art, it began to receive a new conception of the role of the designer and of his importance in society. As we have seen, the ornamentist was on the very bottom rung of the academic ladder; he was a craftsman working humbly and without any high ambitions at a trade which was hardly to be distinguished from that of the milliner or the pastry cook.

The young designer entered a very humble profession. He was even more unlikely than the easel painter to make a name for himself (how many painters, how few goldsmiths or potters were still remembered). Until the mid-century there was no special training for designers, except in a few factories; designing for industry was an occupation in which one found oneself when one had failed as an

artist, and for many young men this seemed a proper arrangement. Anyone who could wield a pencil wanted at least a fair chance to prove himself a Raphael or a Titian, he demanded an education that would give his talent (and we all believe that we have talent) a fair chance even though it might lead the vast majority, untrained or half trained, to the factory floor. This demand caused a great deal of trouble in the early and tumultuous history of the first art schools.

But the idea from which this urgent demand arose — the idea that is of a natural hierarchy of the arts, with the history painter at the top of the ladder and the craftsman at the very bottom — was being undermined. It was undermined by a revolution in the methods of production which, while it destroyed the old craftsmen, gave the crafts themselves a new importance and a new status.

The introduction of steam and of precise reproductive appliances meant that the hand worker working in his own shop, and very often as his own retailer, was put out of business. It meant also that, in many branches of industry, he was put out of a job, for he had become too expensive to be employed when machinery could take his place. And so, except in very remote pre-industrial situations or in trades which produced goods so expensive that the additional cost was bearable and in a sense reputable, the craftsman vanished, and this — as Morris was to point out — was a fearful social tragedy. But if we consider the other side of the picture, looking at it in terms of aesthetic appreciation and applying the principle (usually valid) that 'cheap is nasty' we find a very different situation.

To the pre-industrial society cheap certainly did seem nasty. Sèvres, Meissen, Chippendale, Aubusson — names such as these suggest, not only certain manifestations of taste, but the employment of much expensive labour upon very expensive materials: given whatever might pass for the 'correct' taste of the age, these seemed the most beautiful artefacts that society could produce. They were, of course, essentially hand-made objects, and so too were the blackjacks, cheap earthenware, homespun and shoddy cloth of the rural itinerant; but because these last were the work of cheap, i.e. uneducated, hands they were good only for clowns, and would have remained despicable on account of their cheapness even had they been made from reputable patterns.

But the advent of the machine meant that the most labour-expensive products of highly skilled craftsmen — or, for that matter, of artists — could be imitated. Machines could do so cheaply, that was their *raison d'être*, and for this they had to be condemned. The hand-made thing now became a rarity, and the very term 'hand-made' now conferred a certain *cachet* upon an object. The products of industry, although they might hide their base character beneath

the term 'manufactured', were in fact devalued simply because they were not made by hand and were in consequence cheap.

Apart from the luxury goods already mentioned, hand-made artefacts were now either relics of the past, or the work of peasant craftsmen. Either way they were in a sense romantic; usually they were rare and relatively they were expensive. In nineteenth-century manufactured brasswork we often find that a machine was employed to simulate the kind of effect that the worker working with a hammer would have produced; such hammer marks were unnecessary, but they were imitated in order to suggest the efforts and even the blunders that would be found in the hand-made things. To such an extent have we carried our reverence, now that we have destroyed him, for the craftsman.

One result of this new method of valuation was the emergence of a new kind of craftsman, drawn frequently from that middle class which provided most of the painters of the nineteenth century, and these craftsmen were to play an important part in the development of the fine arts. There were many, but by far the most celebrated was William Morris. He, more than anyone, was responsible for the climate of opinion and taste out of which grew the arts and crafts movement, which sought to fill again the psychologically important need for the manual exertion and manual dexterity which had once been common. Through his own work and through his ability to bring artists celebrated for their 'High Art' to devote themselves to such tasks as the decoration of furniture, the design of wallpapers, the making of stained glass and fine printing, he gave a new status and a new importance to the craftsman. Also he ended by giving to the nineteenth century something that it had hitherto lacked: a style of its own.

The developments which may be said to have begun with the decoration of the ceiling of the Oxford Union in 1857, took shape and found an efficient engine when Morris, a young married man, began to furnish a place for himself at The Red House, Bexley Heath. Timothy Hilton in his study of the Pre-Raphaelites advances the characteristically novel and stimulating idea that Morris was inspired by feelings which were not only aesthetic but social (perhaps, though Hilton does not say so, the first stirrings of the directly social preoccupations of his later years):

> Morris, young, rich, talented, artistic, had made, in terms of his social background, a most unorthodox marriage, and not a welcome one; his parents, it seems, did not attend the wedding ceremony. Jane was a working-class girl, the daughter of an ostler, and had

been picked up at a theatre. Her staggering beauty, her unique ability to represent in her person all that Morris and his friends aimed at in art, could be reconcilable to the social fact of marriage only if that marriage were totally removed from the upper-middle-class Victorian milieu in which Morris had been brought up. This was the only way in which . . . art and life could be combined. Hence the importance of the totally artistic environment.*[22]

That The Red House and all that followed from that 'palace of art' resulted in the first place from Morris's desire to find a worthy setting for the exquisite jewel which he had picked, if not from the gutter, at least from some very lowly hiding place, is certainly an attractive and an interesting idea, although I think that it must to some extent remain speculative. But it would seem that in pointing to this particular marriage the full aesthetic results of which were made possible only by the fact that Morris had money, Mr Hilton points also to what was a general tendency amongst the Pre-Raphaelites and one which may perhaps help us to understand them better.

For it is worth noting that Morris was by no means peculiar in making what his family would have called a *mésalliance*. The Pre-Raphaelites suffered in a marked degree from what I should call the Pygmalion syndrome (if only I knew what people mean when they talk about a syndrome). What I mean is that they would find some lovely piece of common clay – a girl without fortune, without experience of the world, even perhaps without reputation – and mould it so deftly, so gently – that from the dirty uncouth chrysalis (I do not often write like this) there would emerge presently a perfect, lovely, chaste, beautiful, high-principled, well instructed paragon of a wife. This I suppose was the case with Ford Madox Brown, who, having lost his first wife, found some pretty creature, a child, in a farm or a slum or some other underprivileged situation. She was to be made, not I gather without some difficulties, into a perfect wife. It sounds a most dangerous undertaking and one which could easily have led to disaster. But Brown's wife must have had a

* This plausible and interesting suggestion is to be welcomed. But when Mr Hilton goes on to say that when Ruskin wanted to marry Rose La Touche he was, in the same way, constrained to imagine the Guild of St George and a 'society where there were to be no rich, no poor, no steam-engines, only a pleasant and useful agricultural life', a vision that was 'quite clearly determined by the notion that this was the only environment in which he, a fifty-year-old divorced man, could live in untroubled happiness with a child of twelve', I must protest that Ruskin met Rose in 1858 when she was nine, the Guild was founded in 1871, and he had no intention of ending the distinction between rich and poor.

livelier time of it than the bride of Frederic James Shields. Shields was the most Rossettian man in Manchester. He followed the Master rather as depression follows influenza; with all its late-Rossetti curvature of the composition, twisted contrived drapery and general air of hard, forced design, there was a bald emphatic ugliness about his work which was all his own. Well, Shields found some pretty child to rear for the altar. She was confined in seminaries, she was made subject to people of the most aggressive piety, she was forbidden to dance, to go to theatres, to listen to any secular music, to read any books save those of a wholly elevating character. Even on her wedding day she was sent straight back to school because Shields had some religious scruples. I am happy to say that as soon as she could do so she gave Fred the push.

Compared with these desperate efforts at wife-training and social elevation the Morris marriage appears almost unadventurous; and, from what one knows of Morris, I should say that Jane Morris was never made to feel her husband's social superiority.

Perhaps the most remarkable efforts at conjugal reclamation were undertaken by Holman Hunt. Not for nothing did his friends call him 'Mad'. He looked into no ostler's stable, no modiste's workshop, for the raw clay from which he would fashion his Galatea; poor old Mad used mud. A hard word, but how else shall we describe the really dreadful Annie Miller, born in a slum of 'ditch begotten drab' or not far off, illiterate, dirty, untruthful and promiscuous. While Hunt chased the scapegoat across the deserts of Arabia, this social problem, to use the then-current euphemism, was, with the aid of F G Stephens, a trollopy boarding-house keeper and a well meaning instructress, to be made into a perfect Christian lady, clean, well mannered, with all the necessary aitches and high principles ready for the returning Hunt. She would meanwhile earn her bread by sitting as a model – but only in the chastest manner, only to the most honourable painters and under all sorts of safeguards. To Hunt's amazement the wretched girl was so ungrateful as to think that this was not a particularly amusing prospect.

One may wonder whether Hunt could have done anything more to ensure that his scheme of moral and social rehabilitation would turn out badly. The answer is yes, he could leave Annie within easy reach of Gabriel, and this he did. Even the hireling shepherd, deplorably lax though he certainly was, distracted though he might be by Emma Watkins (another of Hunt's girls), even he did not actually keep a wolf within the fold.

Annie, the model for *The Awakening Conscience*, was Helen of Troy for Rossetti, she – and not, as we had supposed, Effie – was Millais's *Girl in the Pink Bonnet*. For my part I cannot help feeling

that there was probably a great deal to be said for her. True, she did sleep around, she was rude and dishonest and in many ways an unsatisfactory character; she tried to blackmail Hunt when he returned to find her still unredeemed. But what a time she must have had of it with those artists with their odd scruples and their odd lack of scruples. How could she take Hunt seriously, with his highly moral paintings, when he was ready to jump into bed with any bit of skirt that he could find? He treated her as a wayward child and was himself almost unbelievably childish. He claimed at one and the same time the privileges of a lover and those of a pastor. The final irony of the business was that Hunt's great effort to make Annie fit to be the wife of the most pious of painters, did make her sufficiently literate and sufficiently accomplished to marry a cousin of Lord Ranelagh – not it would seem a very respectable person, but much more suitable for Annie.

Millais married well, a bit above his expectations perhaps, and so did Burne-Jones although here again the quality of inequality, of condescension and, to put it rudely and crudely, of 'slumming', is faintly suggested by the fact that Burne-Jones's bride became betrothed to him when she was hardly more than a child: she was not yet sixteen. Slumming is no doubt too strong a word, particularly in this context, for Mrs Burne-Jones was in so many ways Burne-Jones's superior; but I use it to point to an aspect of the marriage customs of the Pre-Raphaelites, in which gentlemen found the money and the confidence to pay for and direct the education of girls who in due course would become their wives. Arrangements of this kind were much commoner then than now – if indeed they happen at all nowadays. If I remember rightly Trollope builds one of his plots around an educational venture of this kind. It depends upon the notion that it is proper that a girl should be bound by ties of financial dependence and gratitude, and that she will submit to a process of education in which her inferiority is taken for granted.

I do not think that the Pre-Raphaelites saw it in this light. Of course they did take it for granted that they, being men, belonged to a superior sex; but in this they hardly went beyond the general ethos of their times. Where they seem to differ from most of their contemporaries is in choosing mates who were humbly placed by age, or fortune or respectability. This made the subject state of women the more evident, but also it emphasized the great democracy of beauty. For to their admirers I think it must have seemed that whereas most men chose their women or at least their wives on the basis of an odious calculation of wealth and social advantage, the Pre-Raphaelites simply looked for female loveliness wherever it might occur and found in it a sufficient dowry for their needs.

This surely is how most people saw the elevation of Elizabeth Eleanor Siddal. Her parents were honest cutlers, supporters of primitive Methodism. Lizzie herself worked in a shop. It is said that William Allingham, the Irish poet of fairyland and a great friend of the Pre-Raphaelites, saw her through the shop window, and that Allingham brought his friend Walter Deverell, who saw in Lizzie the best possible model for Viola in his *Twelfth Night*. The stories differ, but all that matters here is that, firstly, Lizzie Siddal did definitely belong to the retail trade: she was a shop girl, a working girl, and certainly not a lady; and that, secondly, when Deverell or whoever it was went to seek her out, he took his mother along with him. Deverell's sensibilities, Lizzie's appearance and deportment, demanded that she should be treated as a lady.

Elizabeth Siddal became almost as one might say a 'mascot' of the Brotherhood; she was Millais's Ophelia, Hunt's Sylvia, and for Rossetti, to whom eventually she became attached, a hundred different heroines. She had so pure, so angelic, so ladylike an air that the fact that she lived, presumably in every sense of the word, with Gabriel was somehow forgiven. She could meet the Rossetti ladies with a high head (although they were nice in such matters). She was adored by Ruskin who indeed fussed over her and her precarious health like an old hen; she was the object of a cult of which the high priest was Swinburne. Unlike most of the other ladies who were so to speak picked up by members of the Brotherhood, she had artistic longings: she wrote poetry, she made drawings (most of them very bad), and she regarded with a haughty air those lesser creatures, the Emmas and Annies and Fannys who played a humbler role in the same milieu.

Nevertheless, and naturally enough, she wanted to marry Rossetti, and he for all his admiration and love – and he was very much in love – had his doubts. Her aspirations, his equivocations, the continual alarms concerning her health, the vigorous interventions of Ruskin, all these kept Rossetti ménage in a continual state of high tension.

It would seem – though the facts are by no means clear – that the Oxford decorations of 1857, important as they were in so many ways to the changing course of Pre-Raphaelitism, brought a crisis in the affairs of Rossetti. Things had come to such a pass that he felt he must make an honest woman of Lizzie, and, the story goes, at the very moment he came to this decision Gabriel discovered Jane Burden was the woman whom he really loved. It was not however until 1860 that Gabriel and Lizzie were married; at the same time Morris married Jane and Burne-Jones married Georgiana.

Thus for a time there was a new kind of Pre-Raphaelite society,

Georgiana and Lizzie liked each other, and the Burne-Joneses liked the Madox Browns. It was a friendly, good-humoured company of young married people, the wives liking each other and admiring each other's husbands. There were high spirits and practical joking, there was much serious painting and there was the firm of Morris & Co to make. Then came a first tragedy: Mrs Gabriel Rossetti was brought to bed with a still-born child and went almost off her head with grief; her situation may have been made a little more bitter by the birth of May Morris a few weeks earlier. Lizzie's hysteria and depression continued and on the evening of 2 February 1862 led to disaster. Gabriel, Lizzie and Swinburne dined at the Sablonière Restaurant near Leicester Square. The party broke up early, the Rossettis went home and Lizzie went to bed. Gabriel then went out again, ostensibly to the Working Men's College where he, together with Ruskin and Ford Madox Brown, taught young labourers to paint. But it is possible that Gabriel went to see another lady, the fat, voluptuous Fanny Cornforth; it is also possible that he had a row with Lizzie before he left the house. At all events, when he returned, at half-past eleven, Lizzie was unconscious. She had drunk an overdose of laudanum and she died early the next morning.

There had to be an inquest and the Coroner brought in a verdict of accidental death. The Coroner did not hear all the evidence that might have been given, and neither have we; but the important thing, from the historian's point of view, is that Rossetti was left with horrible feelings of guilt and remorse. He believed, or half believed, that he had driven his wife to suicide.

It was surely the sense of guilt that led Rossetti, with one of those fine impulses which, at the time, seem so unquestionably right, to place his unpublished and uncopied poems in Lizzie's coffin. It was a magnificent and thoroughly romantic gesture, the supreme offering of an artist who sacrifices the most precious thing he has left in the world to that which was even more precious. The trouble about romantic gestures is, however, that although they may seem splendid in anticipation and glorious in action they can, if you have the complex and awkward character of Dante Gabriel, become a decided bore when once accomplished.

After a time Dante Gabriel wanted his poems back, and there was nothing at all romantic about the business of recovering them. It was a matter of finding the right authorities, receiving the necessary permissions, opening the seven-year-old coffin and retrieving a grey notebook. From this it was necessary to remove, in so far as it could be removed, the evidence of mortal decay. A horrid

business indeed and one which Rossetti, very understandably, left to another person: Charles Augustus Howell.

Howell was the Pre-Raphaelite bounder[23]. I think that is the right word for him, although I would have used a harsher word before I read Helen Rossetti Angeli's persuasive defence of that singular person. She finds many extenuating circumstances, and she deflates, almost destroys, the grandest of all the Howell legends – that of the circumstances of his death. It was said – and it is the most widely known story about him – that he was found lying in the gutter outside a public house, this throat cut and a half-sovereign fixed by the rigour of death between his teeth. The story seems to rest upon the unsupported evidence of Mr T J Wise, an informant who hardly inspires confidence. But although this and other stories may be untrue and unjust, there was something of the bounder about Howell, on the one hand a kind of resilience which enabled him to bound with inventive ease from even the most awkward situations, or invent a story that would meet almost any emergency, on the other a tendency to exceed the bounds of decency, to go beyond the proper boundaries of good conduct.

Again and again in the lives of Rossetti, of Ruskin, of Burne-Jones and of many of their friends, including Swinburne and Whistler, Howell comes swaggering upon the scene; charming, amusing, brilliant, handsome and ingenious, he appears bearing upon his manly bosom the red ribbon of some Portuguese order of chivalry (hereditary in my family, don't you know – not, to be sure, of the family of poor Howell, the drawing master who was washed up upon the Tagus, heaven knows why or where in the dim past, but of the Portuguese lady of ancient lineage whom he married: it was *she* who could trace her lineage back to Boabdil el Chico, the last saracen ruler on the Peninsula). Mrs Howell – but no, she must surely have kept some hereditary title – this lady, at all events, was maintained by her devoted son for many years. It was a feat which he accomplished by the simple expedient of diving into the ocean and bringing up long-lost treasure from a sunken galleon. Later he travelled in Morocco, where he became the chieftain of some important tribe. Later still he was a leader of brigands in the mountains of Portugal, a career which he relinquished in order to become Ruskin's secretary. He was, in early youth, an engineer, he was involved together with Orsini in the plot to blow up the Emperor Napoleon III. He became a picture dealer, running up the bidding at auctions on behalf of Rossetti, to whom indeed he made himself useful in a great variety of ways. Rossetti had a weakness for Howell and an appetite for his really staggering lies. He became a racehorse owner, he was a representative on the London School

Board, he was employed by the King of Portugal to buy horses, and he ended as a leader of the White Rose League, the object of which was to restore the Stuart monarchy.

There can be no doubt that Howell had great qualities and, on the face of it, he was friendly and helpful and resourceful in his dealings with the writers and painters who employed him in one way or another. But it is equally certain that somehow things always went wrong; there came a moment when his friends found him impossible and would have nothing more to do with him. William Michael and Dante Gabriel Rossetti, Swinburne, Ruskin, Whistler – in the end they all found it necessary to close their doors against Howell. Why, seems uncertain: usually there were faults on both sides, but in the end they broke with him.

The sharpest and most bitter quarrel was with the Burne-Joneses. Again the circumstances are not clear, but at a time when Burne-Jones was being unfaithful to Georgiana, Howell in some manner intervened. His intervention was disastrous. It would appear that he introduced the mistress to the wife and left the husband to find the two of them together in his drawing room. It gave Burne-Jones a shock which – literally – sent him reeling, so that he struck his head upon the mantelpiece and fell senseless upon the domestic hearthrug. Why and how and when this happened is not clear, but what is very clear indeed is that when Mrs Burne-Jones had dressed and healed the wounds to her husband's head and her marriage, and all was peace again, husband and wife were perfectly united in their bitter resentment against Howell. Georgiana writes of him with a corrosive pen quite unlike her usual style, and they both tried to have him expelled not only from their own society but from that of all their friends. For me this is enough to damn Howell, or at least to make it seem very probable that he ought to be damned; but perhaps I attach too much value to Georgiana's opinion.

Any rate, damned or saved, there can be no doubt that Howell was just the man for a little bit of resurrection work, and we do owe him something – it is not perfectly clear how much manuscript would otherwise have been lost for ever – but something of Rossetti's poetry. This was published in 1870 after some very careful preparation.

For twenty years Gabriel had not appeared before the public as an artist. His works went to no public exhibitions, and in fact he had found it not unprofitable to sell from his studio. Thanks to Ruskin he had a considerable name. It was a socially commendable thing, a feather in one's aesthetic cap, actually to have visited the great man in his own house, to have seen his wombats and owls, his pictures and perhaps a stunner; and, having gained admission to

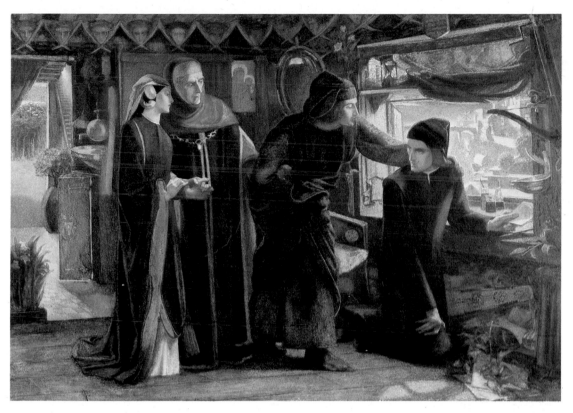

PLATE 13
DANTE GABRIEL
ROSSETTI *Dante Drawing
an Angel on the
Anniversary of the Death of
Beatrice* 1853.

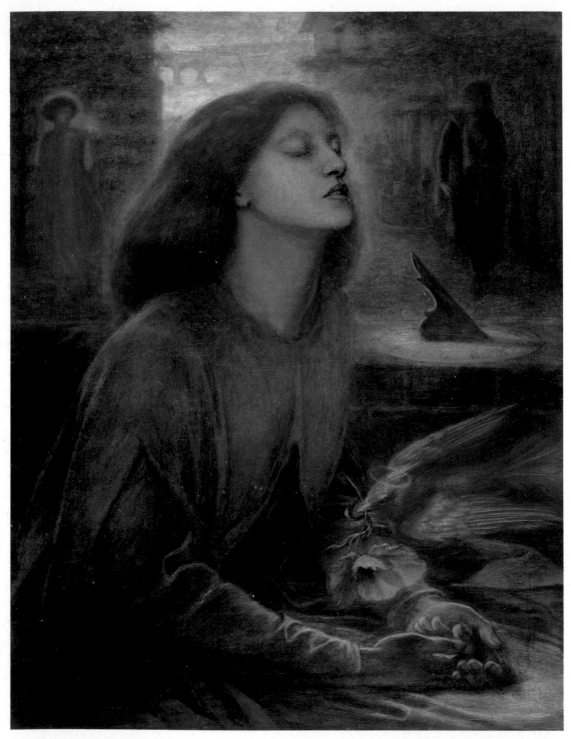

PLATE 14
DANTE GABRIEL ROSSETTI *Beata Beatrix*
c. 1863.

that haunt of the happy few, the artistically minded man from Leeds or Liverpool found himself in the presence of a real artist who had a rather disconcertingly sharp eye for business. But a volume of poetry could not be disposed of in this way. It had in the nature of things to be published, it had to be left to the judgement of the multitude; it would be assessed in newspapers and other periodicals, and the process could not but be frightening. Anyone who has published a book or reviewed one knows how easy it is to be hurt, how hard to praise and yet stay readable, and must sympathize with Dante Gabriel. And yet there is something a little shocking about the pains which he took to see that as far as possible the review copies should fall only into the hands of his friends. The poems were in fact very well received and went into many editions; the unfavourable notices were few and faint, and the publication of 1870 marks the beginning of Rossetti's great prosperity — not alas, of any great happiness.

The poems had been cast into Lizzie's coffin, one must suppose, because of a feeling of guilt. Their retrieval would have intensified the guilty feeling and that feeling would have been still further strengthened by the great success of the book. To the guilty mind good fortune is but the bringer of hubris; nemesis can never be far behind. In October 1872 the *Contemporary Review* carried an article over the signature Thomas Maitland (alias Buchanan), entitled 'The Fleshly School of Poetry', in which Rossetti was singled out as a sensualist, a worshipper of the body, in fact a pornographer. Rossetti was hideously upset; for a time he was almost mad with anger and despair.

It is an amazing thing that Maitland's criticism should have caused Rossetti so much agony. He must have realized that this was in fact but a part of the critics' war with Swinburne; here a puritanical critic could find ammunition, for Swinburne was vulnerable to such attacks. But an attack on Rossetti seems very wide of the mark.

Rossetti certainly is an amorous poet; he is also an amorous painter. Of the poet I would only say this: Imagine the libidinous Victorian paterfamilias with his private orgies of Zola and *Fanny Hill* reading Maitland and from him learning that Mr Rossetti dealt in 'the most secret mysteries of sexual connection, and that with so sickening a desire to reproduce the sensual mood, so careful a choice of epithet to convey mere animal sensations, that we merely shudder at the shameless nakedness. . . .'[24] And then imagine the naughty old gentleman going to the nearest bookseller in order to buy a really dirty bit of poetry. Surely, when he got home and in the privacy of his study opened the peccant volume, he must have felt uncommonly well sold?

Be that as it may, when we look at the paintings, they reveal a complete, perhaps even an obsessive interest in women. He is so much of a gynophile that, as is the case with Burne-Jones, even his men tend to become a trifle ladylike. And yet, unlike the great majority of those who have devoted their talents to the celebration of female beauty, Rossetti seems uninterested in the feminine body. Cranach, Correggio, Rubens, Ingres and Renoir rejoice in the arms and legs, the flanks and buttocks, the breasts and bellies of womankind: for Rossetti they hardly seem to exist.

> Not in the body is thy life at all,
> But in this lady's lips and hands and eyes;
> Through these she yields thee life that vivifies.
> (*The House of Life*: sonnet xxxvi)

Writing thus, Rossetti seems to summarize the vast majority of his paintings. He is a face painter; it is in the eyes, the mouth, the nose, even the hair and the hands of his models that he tries to discover the soul, it is in his painting of faces that he shows his strength. But for the rest his woman are but drapery — and not the kind of drapery which suggests the form and movement of a living body, but rather a kind of decorative arrangement of textiles, helpful to the competition as a whole, rather than a description of the body. In the very few pictures where he does attempt to go beyond the habitual and modest frontiers of his usual observation, Rossetti is awkward and ill at ease; here indeed there is a trace of lubricity, but it arises from a too conscious sense of audacity rather than from anything like a fluent rejoicing in the shapes of women.

From this point of view — and perhaps it is not the point of view of the true Rossettian — his best work lies in those earlier drawings and watercolours where, because the whole picture is heraldically flattened and patterned, there is a magisterial dismissal of all probability, all realism. The strongly designed element gives his work an immediacy, a freshness and a sensual quality (in the true sense of the word) which is lacking both in his attempt at realism and in the heavily laboured sentiment of his later 'stunners'. Jane Morris was one of those models who, like Augustus John's Dorelia, is almost too well suited to the easier purposes of the artist. She provided real live Rossettis which were too luscious, too sumptuous even for his sweet tooth, and he did better when he had to accommodate the corpulent Fanny Cornforth within those rich overdecorated confections.

But although there is so little that can fairly be called carnality in any of his paintings or possibly because there is too heavy a charge

of sentiment in his treatment of the more soulful aspects of his sitters, his is in the end a kind of hothouse art, overcharged with meaning and overelaborate in its accessories. In this it seems to express the decline of his later years, the recurrent illnesses, the too frequent potations of whisky and chloral, the persecution mania which led him to quarrel with nearly all his old friends.

His art had run to seed and he was already a broken man, much older than his years, when, in 1882, he died.

Morris

There must always have been a certain number of people in London – Ruskin and his friends, Patmore, and the coterie that revolved around Little Holland House – who bought Pre-Raphaelite pictures. But the group found its best clientele in the industrial North: men like McCracken of Belfast, Plint of Leeds, James Leathart and Leyland the shipping magnate were the best and most constant supporters of the movement in both its stages. Just as the new men with new money from the New World bought the Impressionists, so did these buy the Pre-Raphaelites, and I suppose that there was a resemblance between the two situations. Cultural standards in the metropolis were still to some extent dominated by men who had inherited both money and an aesthetic tradition; it was not very likely that these men would encourage artists who broke with tradition, and with the rules of good taste that had been handed down from past generations and were still exemplified by the family portraits or the spoils of the Grand Tour upon the walls of ducal palaces. It was left to the newcomers, those who were unaware of or uninterested in traditional aesthetic values, barbarians who in fact knew no better, to invest in Renoir or in Rossetti.

G F WATTS *William Morris* 1880

The new plutocracy in England had indeed begun by attempting to emulate the purchasing habits of their social superiors; one hears stories of rich men from Bradford or from Liverpool coming by railway to London and returning with a dozen Michelangelos. It was one of the tasks of the *Art Journal* to enlighten these imprudent men from the provinces. Then came a generation which invested, like Mr Sheepshanks, in native contemporary work, knowing at least what they were buying; and finally came those who may be said to have established a taste of their own, spending their new wealth on a new kind of art. So that today, when most of the important collections seem eventually to have found a home in London, great Pre-Raphaelite treasuries remain in the cities of the industrial North, and those who seek to study the Pre-Raphaelites must go, not only to the Tate, but to Manchester, Liverpool, Birmingham and Leeds.

There was perhaps something particularly congenial to the modern manufacturer about the work of the group. Millais and Hunt gave him, manifestly, his pennyworth for his penny; their pictures were so eminently an expression of hard labour and honest workmanship. Rossetti and his followers gave them something even better, they gave them poetry:

> Forget six counties overhung with smoke,
> Forget the snorting steam and piston stroke,
> Forget the spreading of the hideous town. . . .
> (Morris, *The Wanderers*, Prologue I. 1)

This was precisely what the second generation of Pre-Raphaelites invited you to do, and for the mill owner or the shipbuilder no proposal could, one imagines, have been more agreeable. His was a life deprived of beauty, as beauty was usually understood, and the Pre-Raphaelites of the 1860s and 1870s supplied that commodity in a palatable form, without sectarian religion, without too much paganism and without that reality in which, if a man was to make money, he must spend so much of his life.

But there was another potential market. Up and down the country there were clergymen who wanted to make their churches harmonize with the new Anglican beliefs – beliefs which allowed so much more scope for the decorative artist than had hitherto been the case. Ever since the 1830s the apostles of the new movement led by the Ecclesiological Society had been calling for new churches to serve the new parishes of the ever-growing towns – new churches built upon strict ecclesiological principles, or to have the old churches demolished and rebuilt in the English Decorated style. These buildings needed stained glass, ciboriums, fonts, lecterns, chasubles, thuribles, pattens, pyxes and heaven knows what else. To the puritan it must have seemed that Laud walked again. For the Firm of Morris, Marshall & Faulkner there was a market.

The Firm was founded in 1861, Morris, Marshall and Faulkner being joined by Burne-Jones, Rossetti, Ford Madox Brown and Webb. The active management was in the hands of Morris and of Faulkner, an Oxford friend who had become a civil engineer and who was clearly devoted to Morris. Morris himself, a man of great energy, made himself master of and undertook experiments in all the crafts of the workshop; he was not a good businessman but had the sense to realize this and to find assistants who were. Burne-Jones was extremely active, and in every way an admirable partner for Morris. Rossetti did comparatively little; nevertheless his influence was of capital importance to the whole enterprise. The professional

church furnishers had at first looked with a mixture of contempt and anger at these young amateurs who presumed to teach them their business. But soon there was public recognition, commissions began to pour in, and there was, at all events, much less contempt. The Firm was teaching its competitors a great deal.

Just what it was teaching is less certain. From a glance at the catalogue for the International Exhibition of 1862 it would seem that the prevailing idea amongst decorators at that time was that any object should be covered with the greatest possible number of adornments. Flowers, foliage, arabesques in prodigious quantities were fastened to any available projection, there was an abundance of nymphs and putti, birds, beasts and fishes, a vast accumulation of patterning and a very large range of styles. Some of the most immediately likeable designs are for carriages where a certain tradition of athletic form and scientific balance chastens the exuberance of the age; at the opposite end of the spectrum, is the lace-work, where the infinitely delicate elaboration of florid detail which seems natural to the material also seems congenial to the spirit of the age. It has to be remembered that at an International Exhibition nations may show their most extravagant, rather than their most judiciously designed products, and also that unless we can go from the catalogue to the museum exhibit we are forced to accept the interpretations of the draughtsman and the engraver. If we can find actual specimens or can consult *The Journal of Design* of ten years earlier, whose pages were illustrated with specimens of textiles and wallpaper, we shall gain a much livelier and happier impression of the manufactured goods of our ancestors.

It will be seen that in trying to assess the decorative art of the 1850s and '60s, a large task in which I can do no more than make tentative judgements from a few samples, I do not share the opinion of many reputable critics who see Morris as bringing something not only new but entirely desirable in the place of that which was fussy, conventional and stuffy. I do not think that the decorative arts of that period can so easily be dismissed, nor does it always seem to me that the products of the new Firm were so markedly superior. Nevertheless, it did do much good; at times it brought a healthy simplicity to such things as furniture and wallpaper, and it did find some pure and lively colours in its tapestry. It was in the main a healthy corrective, an inventive alternative to a kind of design which was often absurdly fussy, much too ready to rely upon the pattern book, and which, when it sought variety, found it only in a kind of desperate historicism that looked myopically to Egyptian, Pompeian, Chinese, Islamic and above all Mannerist originals.

It was in its stained glass that the Firm originally showed itself

to be outstandingly good. The productions of Burne-Jones contrast strikingly with those of Messrs Balantyne and Messrs Cox, as might be expected when the work of a vigorous modern artist is set against that of a firm of ecclesiastical furnishers attempting to reproduce the old masters in terms of painted glass. There is a pleasing irony in the fact that whereas the established firms seemed to try to make their products as much like painted windows – pictures which happened to be composed of glass – as they could, and where they could be pictorial, crowding the space with a mass of ugly decorative trivialities, Rossetti and Burne-Jones seem always conscious of the structural necessities of the design, using heavy window bars and leading to maintain a strong surface. I think that the Firm is at its best, and perhaps Burne-Jones is at his best, in this medium, and I would recommend anyone who wants to assess Burne-Jones to make a pilgrimage to the Cathedral Church in Birmingham. Here the exigencies of the medium impose a discipline which Burne-Jones in a very splendid way accepts; he is not able to indulge his penchant for agonized emotion, and his full strength as a designer and colourist is well displayed.

Observe that Birmingham Cathedral is a Baroque building and that Burne-Jones is perfectly happy in it. And, since I am uttering heresies, let me add that in the work of the Firm and in particular its later work, we seem much nearer at times to seventeenth-century than to Gothic originals.

Look, for instance, at the celebrated 'Strawberry Thief' pattern by Morris, and compare it, as I am sure he never consciously would

WILLIAM MORRIS *Design for chintz, 'Strawberry Thief'* 1883

have, with Grinling Gibbon's reredos in St James's, Piccadilly; the
conventions are of course quite different but they are used, so it
seems to me, in much the same way. In each case we get a bold,
fluent, unhesitating line forming a continuous and logical system of
curves, in each there is the same pleasurable ability to enrich and
load the field (one of Morris's great concerns) so that the whole
surface is enlivened by one joyous system of patterning, and yet
there is never a feeling of crowding.

Burne-Jones was never very far from Italian originals and always
distant from the Gothic North. Just as Morris did Burne-Jones a
power of good by inviting him to work within the discipline of a
craft, so Burne-Jones, in my opinion, kept Morris at a safe distance
from his original love, the Middle Ages. It was indeed a famous
partnership, and was perhaps enriched by the difference between the

two men, for whereas Burne-Jones was essentially an artist shy of the world and happiest within the territory of his own imagination, William Morris was, as everyone knows, a politician.

Morris, like Ruskin, is an art-historical phenomenon, in that his political beliefs resulted from his aesthetic feelings. Already we find something of this kind in the doctrines of Pugin who, although essentially religious in his architectural feeling, is drawn towards what is in effect a political attitude, one of extreme reaction, by his distaste for the industrial scene of his own day. For Pugin the Dissenting tabernacle, the factory, the railway and socialism are all equally unlovely products of his age. But in Ruskin, the study of architecture leads to the study of society and hence to what are in fact purely political polemics, and this was even more true of Morris.

The Pre-Raphaelites of the Brotherhood were, for the most part, indifferent to politics. And yet any kind of regenerative and reforming body, even one composed of painters, is likely to be accounted subversive, and perhaps in the end the Pre-Raphaelites were more dangerous to society than were the Realists or the Impressionists of France. The realism of Courbet was based, it would seem, on a manner of painting rather than upon the choice of didactic subjects. It never prevented him from painting still-lives, nudes or landscapes, many of which, from a strictly political point of view, were perfectly innocuous. The work of the Impressionists was still further from propaganda. They became increasingly concerned with a theory of vision which permitted a neutral and indeed an impersonal scrutiny of nature. The Pre-Raphaelites, on the other hand, were concerned not only with truth but with ideas concerning morality and religion.

An interest in religion, even so broad and non-sectarian an interest as that of Holman Hunt, might always hold subversive potentialities. For it is hard to divorce religion altogether from questions of social justice, and sometimes the solutions that are found are of a disquieting nature. Even on the continent of Europe where, by and large, established religion was the ally and companion of authority, the opinions of a Lamennais or a Montalembert could be very inconvenient. It was much more true in England where the Christian communities were not united in defence of the state but tended to divide upon party lines. Thus Holman Hunt, who clearly was a firm believer in Christianity of some kind, was much less clear when it came to finding some form of Christianity to which he could adhere; at the same time he was very positive in his rejection of any kind of hierarchy. His attitude exhibits in an extreme form that of Ruskin.

To Ruskin it seemed that the Catholic advocates of English Gothic had never played quite fair. Pugin and his followers confused the idea of the pointed arch with that of (Catholic) mediaeval piety. Canterbury had strayed from Rome, and in the same way and at the same time, it had strayed from the Gothic. But to foreigners this would have seemed an odd, indeed a very parochial view; to them it seemed that St Peter's was just as much a Catholic monument as Beauvais or Amiens. And even here there was an Italianizing school of thought amongst Catholics which, when Brompton Oratory was built, clad it in all the ornate Baroque splendour of seventeenth-century Rome. To Pugin's followers this must have seemed extremely painful – by Christian art and architecture they meant the art of the Middle Ages, the art of a united Christendom. If pressed they would no doubt have allowed that Borromini and Pietro da Cortona were eminently Catholic architects, but it was a form of Catholicism on which they would not have liked to dwell, exhibiting as it did something worldly, theatrical and decidedly un-English. It had surely then to be admitted that it was not Protestantism, or not Protestantism alone which had done the mischief; the Renaissance was also to blame and the Counter-Reformation had not made things any better.

Ruskin, in his aggressively Protestant youth, seized with delight on this contradiction: 'The Papists' temple', he declared, was 'eminently exhibitory; it is surface work throughout . . . tinsel and glitter . . . dingy robes and crowding of imitated gems'[25]. He was to regret these words and later on to excise them, but at the time he suggests very clearly the shocked feelings of the austere Protestant who is appalled by the gaudy theatre of Catholic worship he finds when travelling abroad. Indeed, with splendid audacity Ruskin persuades himself, and I imagine a quite large public, into the belief that Gothic ornament is essentially Protestant. The Gothic Church is regulated by an authority, but there is also a kind of spiritual freedom within the limits of that authority; the sculptor is free to invent, he creates images of his own, not of the Church's imagining; he is both disciplined and free, as becomes a good Protestant (this at all events was the popular idea of the Gothic craftsman). Decay comes, not with the change in religion, but with the foul paganism of the Renaissance and, above all, with the imposed regularity of Bramante and Palladio; for these are not only pagan but tyrannous: the ruler is their symbol and with its straight mechanical edge it rules the workman – the architect is everything now and the mason nothing. His freedom has been stolen from him and he must conform to the architect's cold exactitudes. Rome ends by imposing her pagan geometry on Christendom, hers is the servile

architecture of a servile religion.

Polite applause from the great Protestant public. Yes, indeed, the horrid Papists, just what one would have expected of them, corrupt despots and so vulgar. How different from the lovely blend of freedom and social loyalty which characterizes both the British crowned republic and English Decorated architecture, where a sturdy independence of spirit is united with a happy recognition that there is a place for everyone and everyone should know his place. Also, of course, it meant that Protestants could go on admiring Gothic architecture with a perfectly clear conscience.

The Seven Lamps of Architecture was then an entirely acceptable offering. But the trouble with Ruskin was that he pushed his otherwise admirable ideas to absurd extremes. Moreover he began to have his doubts about the nature of English Christianity. Unlike the Greeks in their decadence and the French in their folly, the British did not deny their God, only they put matters of religious belief in an entirely new light:

> There *is* a Supreme Ruler, no question of it, only He cannot rule. His orders won't work. He will be quite satisfied with euphonius and respectful repetition of them. Execution would be too dangerous under existing circumstances, which He certainly never contemplated. 26

It was typical of the general cussedness of the fellow. At a time when he himself was having serious doubts as to what he could or should believe, at a time when reaction had triumphed all over Europe and when Britain, sublimely confident in the teachings of her economists, was indeed prospering considerably, with the perils of Chartism forgotten, Ruskin, taking the Bible as his guide, began a bitter attack upon capitalism – and found in the engines of the industrial system all and more than all the brutal regulatory power of Bramante:

> And now, reader, look around this English room of yours, about which you have been proud so often, because the work of it was so good and strong, and the ornaments of it so finished. Examine again all those accurate mouldings, and perfect polishings, and unerring adjustments of the seasoned wood and tempered steel. Many a time you have exulted over them and thought how great England was, because her slightest work was done so thoroughly. Alas! if read rightly, those perfectnesses are signs of a slavery in our England a thousand times more bitter and more degrading than that of the scourged African, or helot Greek. Men may be beaten, chained,

tormented, yoked like cattle, slaughtered like summer flies, and yet remain in one sense, and the best sense, free. But to smother their souls within them, to blight and hew into rotten pollards the suckling branches of their human intelligence, to make the flesh and skin which, after the worm's work on it, is to see God, into leathern thongs to yoke machinery with, – this it is to be slave-masters indeed; and there might be more freedom in England, though her feudal lords' lightest words were worth men's lives, and though the blood of the vexed husbandman dropped in the furrows of her fields, than there is while the animation of her multitudes is sent like fuel to feed the factory smoke, and the strength of them is given daily to be wasted into the fineness of a web, or racked into the exactness of a line.[27]

'The Nature of Gothic', chapter VI of the second volume of *The Stones of Venice*, in which these words appear together with much else of a similar tendency, was later to be published (1892) by Morris at the Kelmscott Press. In the preface Morris, now an old man within sight of death, wrote:

To my mind, and I believe to some others, it is one of the most important things written by the author, and in future days will be considered one of the few necessary and inevitable utterances of the century. To some of us when we first read it, now many years ago, it seemed to point out the new road on which the world should travel. And in spite of all the disappointments of forty years, and although some of us, John Ruskin amongst others, have since learnt what the equipment for that journey must be, and how many things must be changed before we are equipped, yet we can still see no other way out of the folly and degradation of civilization.[28]

Ruskin and Morris start from more or less the same position. Both loved the art of the Middle Ages, both detested nearly all the art of their own period, both believed that art results from the society in which it grows; to both it seemed therefore that if art were to be rescued from its actual state of squalid ugliness society itself must be changed. Both I think would have agreed that the savage inhumanity of the prevailing system was part and parcel of the mean ugliness that it had created. But in truth they followed very different roads.

Ruskin came to socialism slowly and, it is probably true to say, unwillingly. There was so much in the teachings of the left, both in England and in Europe, which he found uncongenial. He

had lived through the great convulsions of 1848; he had, at first hand, seen the triumphant Austrians restored to Venice, and these experiences left him, unlike the majority of his compatriots, firmly on the side of the oppressor. He detested the 'mob', he trusted and respected their conquerors, he was deeply and immovably undemocratic; and it was because nearly all socialist party programmes were based upon a belief in Liberty, Equality and Fraternity, were in fact republican if not positively atheistical, that Ruskin could never have anything to do with any of them. In order to be a socialist he had to invent a party of his own, and a very strange party it was. In his programme the privileges of the gentry were no less important than the rights of the worker, and the idea of equality was to be jettisoned.

Nevertheless he was a socialist, and his socialist ideas provoked the English middle classes of his day to fury. *The Stones of Venice* (1853) gives a first indication of the direction of his thought. Seven years later he published *Unto This Last*, a polemic which caused the readers of the magazine in which it had begun to appear such intense agony that the editor had to stop its publication. Then, in 1871, he set up his Guild of St George, a society which was to establish Utopia, to transform the face and nature of England and, ultimately, to embrace the whole world in a happy, benevolent, autocratic and mainly agrarian society.

Like nearly all Ruskin's friends, Morris would have nothing to do with the Guild of St George. He had learned a great deal from Ruskin but he also had a good fund of common sense, and the Guild, he could see, was what he called 'gammon'. Morris began as a liberal; in fact he was a member of the Liberal Party and he came into politics not on social questions but on a matter of foreign policy, finding himself violently opposed to the imperial adventures of Disraeli and the possibility of a war with Russia. After that first political excursion he moved steadily to the left, discovering increasingly that his political ideas were in harmony with his aesthetic position, reading Karl Marx and, by the 1880s, becoming deeply engaged in extreme left-wing politics.

Like many others he found it a heart-breaking business. In England, after a long sleep, socialism was beginning to stir again. Old men who remembered Feargus O'Connor found the phrases of their youth once again on men's lips; but the revival was very slow and the socialists were to a large extent middle-class theorists. The business of propaganda was not easy and Morris found himself involved in that fearful and bitter faction-fighting which seems to tear left-wing groups into shreds everywhere and at all times. The high hopes of the earlier years faded, there were schisms and betrayals, and Morris himself (as Friedrich Engels saw) although an

honest and well disposed man, came as a novice to socialist theory and to the all-absorbing business of socialist in-fighting. At one time Morris's political career was seen as a kind of temporary aberration and something from which as an artist he soon withdrew in disgust and disillusion; more recent scholarship suggests that in truth it did remain an important part of his life until the end, that he never withdrew although with declining powers he inevitably became less active (and his activity could be prodigious). I think it is true that throughout his life he never doubted that socialism was a necessity if the horrors of our civilization were somehow to be mitigated.

Thirty or forty years ago the socialism of William Morris was widely regarded as something at once fine and pathetic. He had never come to terms with the machine age and remained, spiritually, a Luddite all his life, altogether too much attracted by the 'escapist' ideas of Ruskin and by a desire to retreat into the past. To us desirable progress was symbolized by the tractor and the hydro-electric station: there seemed altogether too many horses and hay wains in his life. Today the tractor has lost some of its enchantment and we are not so sure that Morris may not have been right after all when he insisted on a manner of life geared to cleaner instruments and healthier living.

At the same time a closer examination of *News from Nowhere*, Morris's most important propagandist book, does show very well that he realized that a socialist state would need to make use of modern techniques even though, like the 'power barge', they were more or less kept in the background. This is consistent with the techniques used in the Firm. On the whole it did make use of older methods and manual skills, but where power-driven machinery was necessary it was used. Because it did rely largely upon expensive methods, Morris & Co worked for the rich; in the social situation of his day Morris could not do otherwise. But there is not, as has sometimes been suggested, anything inconsistent about working for a wealthy clientele and holding advanced opinions.

A much more serious disability arose from Morris's education, which was the kind of education a rich man's son would naturally receive. When he addresses himself to an educated public he is effective, but when he tried to establish a sympathetic relationship with a working-class audience he was in difficulties. But we do not pay sufficient attention to his lectures. We still have much to learn from them, and sometimes they are superb essays in persuasion.

Look for instance, at his lecture to the London Institution, a body which, I surmise, was unused to socialist propaganda. He enters his main argument from an aesthetic point on which he was

almost certainly able to command general assent. He asks his audience to admire the scenery of the Cotswolds, and then:

> . . . a labourer's cottage built of Cotswold limestone . . .
> no line of it could ever have marred the Cotswold beauty,
> everything about it is so solid and well wrought; it is
> skilfully planned and well proportioned – there is a little
> delicate carving about an arched doorway . . .[29]

And from this anodyne beginning he comes gently enough to his first disquieting question: 'who built it then?' Did they employ a trained architect, did they get someone up from London, did they even employ a man from Worcester? They did not. It was built by the local mason, nor was there anything remarkable about it, that was how such dwellings were built in those days. 'This is simple harmless beauty' was the product of a culture, of a society which has been destroyed and destroyed by us. And then he turns upon his audience and asks it:

> Are you contented that we should lose all this? . . . you
> cannot be contented with it, all you can do is try and
> forget it and say such things are the necessary and
> inevitable consequences of civilization.

Ruskin, in one of his sudden appeals to the conscience of his audience, could not have been more savage or more penetrating. But Ruskin, through intemperance and dogmatism, would have lost the sympathy of his hearers. Morris persuades his hearers into agreeing with him before letting them discover the consequences of their assent.

As a performance it is superb; but also it is an impressive example of Morris's theoretical approach, and shows a more rational and a more impressive understanding of the relationship between art and society than that of Ruskin. For whereas Ruskin, viewing the matter in terms of spiritual events – of the Renaissance, paganism and Christianity – ends by having to make the facts correspond to his theories, so that the whole of Venetian history has to be readjusted in order to conform with his views on Venetian art, Morris approaches the matter in a far more scientific spirit, asking to examine the facts and then draw our own conclusions.

Later left-wing theorists, basing their practice upon that of the Marxists, tend continually to look at the work and achievements of a few individuals, so that we are left with ingenious theories which seek to show the impact of bourgeois ideology on the work of say, Chardin, or of agrarian unrest on the landscapes of Cotman. Morris, on the other hand – and I think he was almost alone in this – took

as his starting point the art of the masses. Noticing the aesthetic virtues of demotic art, the architecture of barns and cottages, the artistic probity of peasant pottery or weaving, noticing also the rapid extinction of these ancient and as he considers them valuable forms of creativity, he sees in the rise of capitalism the emergence of a force which has extinguished both the art and the perceptions of a people. It is a form of cultural genocide no less cruel and disastrous for being to such a large extent the product of blind undirected forces resulting naturally from the operation of the profit motive. The machine has taken the pleasure out of work: people make things not because they enjoy making things but because they can live in no other way. No one individual is responsible for this disastrous evolution of the productive process; it is the system which is at fault.

The corollary is, of course, that peoples — entire cultures and not merely a few exceptional individuals — are capable of producing aesthetically valuable work. It is a human trait which, until the advent of the capitalist system, we find everywhere. Since the time of Morris the whole current of public taste throughout the world has confirmed this view. The work, not only of European peasants, which is I suppose what he had chiefly in mind, but of primitive cultures everywhere and indeed of children everywhere has been revalued and allows us to suppose that the essential qualities which make for the production, and in some sense the contemplation, of art exist everywhere. That kind of plebeian art can, it is true, be ignored or despised by societies which have developed an 'elitist' culture, and can be completely extinguished — indeed must be completely extinguished — by the advent of modern techinques of manufacture. To this Morris adds, and one can only hope he is right, that given the right kind of social arrangements the act of creation can again be made to give pleasure, and art can be restored to those who originally created it, the masses.

Such a theory gains immensely in force if one accepts Morris's aesthetic, an enthusiasm for demotic art which does not preclude an admiration for the admittedly grander productions of the exceptional individual. But the theory will stand up as an explanation of the cultural behaviour of human beings even if one does not share the theorist's particular taste in art. It is because of this that we can I think accept it as an objective aesthetic theory, something which neither Plekhanov or Lunacharsky succeeded in creating.

This brief excursion in the direction of Marxist theory will I hope serve to illustrate the very extensive changes to which Pre-Raphaelite ideas were subject in this second flourishing. Politically Morris would have found a number of sympathizers amongst his elders and contemporaries; Ford Madox Brown, in his later years,

William Michael Rossetti, both the Burne-Joneses would have understood his general attitude; but Rossetti, we know, did not, and one wonders what Holman Hunt and Millais thought of this surprising disciple who in the popular imagination was linked with them. In a sense one may regard Morris's doctrines as being Ruskin qualified by materialism and common sense; but all the same — what a change there had been.

Burne-Jones

PHILIP BURNE-JONES *Sir Edward Coley Burne-Jones* 1898

I hope I may be forgiven if at this point I strike a personal note, and speak about my feelings. They are a part of the historical evidence and, inasmuch as they must have been shared by a good many other people, not uninteresting.

A few months ago I was in the nineteenth-century wing of the Metropolitan Museum and found myself in front of a screen on which some imaginative person had hung four pictures: there was a painting by Gustave Moreau, one of his many versions of *Oedipus and the Sphinx*, a female figure by Leighton, a portrait by Klimt — not at all a good example of his work, and Burne-Jones's *Chant d'Amour*. Together these works provide a nice illustration of the anti-realist poetical art of the second half of the nineteenth century and of the obsessive interest in women — women as emblems of beauty, gravity and delicious melancholy — which marks that period. But what struck me chiefly on this occasion was my feeling that Burne-Jones seemed to tower above his neighbours. Of him and him alone, given the particular examples that were before me, could I feel that here was a painter who knew his business: the rest look like poetically-minded amateurs.

To this was added the rather disturbing reflection that I certainly should not have felt this forty years ago; and even fifteen years ago when writing about him I hesitated: I found him admirable, but I also found him repulsive. I still know very well what I meant by that; but the more I look at his paintings the more important his admirable qualities seem to be. And yet there was a time when I could hardly admit that he had any.

Why has there been this change in me? It is a rather embarrassing question, but one which should be answered, for it leads us to a more complete understanding not only of Burne-Jones but of art.

Apart from the influence of fashion, a thing which I think few of us can avoid, I was repelled by the sentiment, or rather the sentimentality, of his painting. It is the great stumbling block which prevented us and to some extent still prevents us from liking

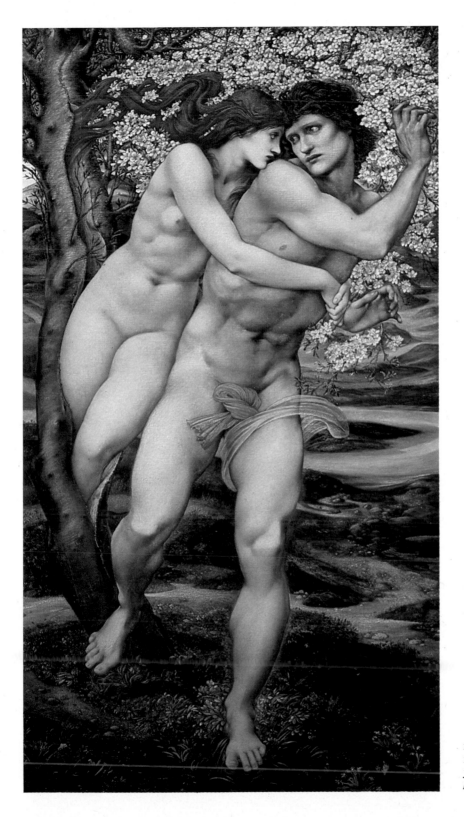

PLATE 15
EDWARD COLEY BURNE-
JONES *The Tree of
Forgiveness* 1882.

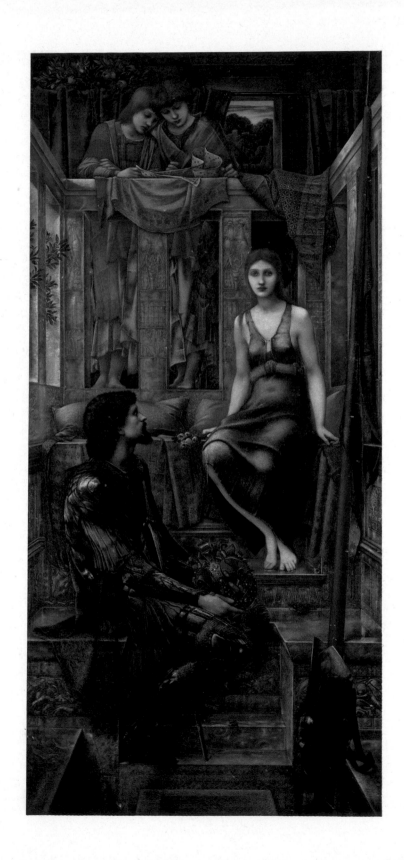

PLATE 16
EDWARD COLEY BURNE-
JONES *King Cophetua and
the Beggar Maid* 1884.

the Pre-Raphaelites. But when I think of the general aesthetic climate of my youth – say 1928–40 – it is odd that this should have been the case. Sentimentality was the quality in a work of art which we should have been able easily to set on one side; in our opinion it was the form that mattered – the 'story' was of little importance.

Indeed my father's generation tended to dismiss subject matter altogether and was ready, in theory at all events, to use just the same criteria in judging an illustration as it would have applied in judging a carpet or a teapot. That was the theory: find the 'significant form' and you have found all that Burne-Jones has to give. My own generation found such complete formalism impossible to sustain, and in fact we have run in the opposite direction, further and faster than we should, in my opinion; for although there seems no point in dismissing any part of an artist's intention, if we look at our own sensations a residual and universal formal quality must have its place in any aesthetic theory which does not forbid us to admire works coming from an alien and incomprehensible culture. The visual arts are something more universal and durable than literature.

Nevertheless the attitude of our parents was impossibly narrow, and when we dismissed Burne-Jones as being altogether too 'literary' we meant or we ought to have meant that his literature was not very good literature; in this there is I still think a great deal of truth, but the judgement has to be qualified.

In the '30s we were particularly hard on Burne-Jones because in his case there seemed to be, not only an element of sentimentality and perhaps of prurience in his 'literature', but an element of cowardice as well. His pursuit of the ideal seemed to us like a kind of flight. He was looking we felt, for a safe and cosy place in which to hide. Inevitably we compared the fortitude and audacity of William Morris struggling with the police on Bloody Sunday, or with Hyndman on committees, with the conduct of Burne-Jones who, holding opinions very similar to those of his friend, carefully kept out of trouble and tried to remain out of harm's way by painting pictures:

> I mean by a picture a beautiful romantic dream of something that never was, never will be – in a light better than any light that ever shone – in a land no one can remember, only desire – and from the forms divinely beautiful.[30]

And this we thought discreditable.

Perhaps it was; but it did not mean that he was, necessarily, a bad artist. After all the kind of picture Burne-Jones describes was painted by Giorgione, by Watteau and by Matisse. It is not a heroic

genre but it is not entirely despicable. It was of course in no sense realist; he was one of those painters who, like Blake and El Greco, had very little commerce with nature. His was an art which derived from art.

What seems to me more nearly descreditable, or at least severely damaging, to Burne-Jones's art is the fact that one suspects him of exhibiting emotions which are in part merely social, a kind of artistic courtesy in which only a part of his real feelings was allowed expression. All the Pre-Raphaelites suffered in some measure from the sense that art was something holy: in front of a painting you were in a manner in church, you took off your hat, you spoke in a hushed voice, in fact you were on your best behaviour. In private the Pre-Raphaelites compensated for this reverential attitude — an attitude which affected both the spectator and the artist — by a boisterous, an almost schoolboyish exuberance. They were slangy and jolly and a bit juvenile. *Ecce Ancilla Domini* becomes, in private, the 'blessed white eyesore', and even Miss Siddal becomes 'Guggums'.

In Burne-Jones's case the change is shown in his private drawings. Here the ethereal soulful ladies and yearning epicene gentlemen are replaced by funny sketches of 'Topsy' and comic fat women falling downstairs; the change is drastic between the poetical public artist and the private clown who finds fun in mere ugliness. I suspect that the need to change roles was bad for both personae. In an age which tended to exaggerate the courtesies of everyday life and which wore clothes that not only obscured but positively remodelled the human form, it must have been dangerous and difficult for an artist to appear always on his best behaviour before polite society.

There is something insincere and a little unreal about the idealities of Burne-Jones, as also about the passionate reticence of Rossetti's females, and this is an undeniable fault. It did not however prevent Burne-Jones from being, in his way, a very serious artist as well as being very gifted. Also, his concern for the dignity of art, although it may lead him to a kind of romanticism which, because it was intended to be socially acceptable, does not always strike a note of truth, led him also to a study of his great predecessors which is always sincere. As I have said, his art derived from art; he attempts always to remain within the great traditions of European, or at least of Italian, painting. He really had nothing to do with the Brethren, apart from Rossetti, but in another sense he is the first of the Pre-Raphaelites in that he looked and looked very carefully at the work of painters before the time of Raphael.

In 1862 Ruskin took the Burne-Joneses with him to Italy; he seems almost to have adopted them as his children. (At this time Burne-Jones was breaking away from the influence of Rossetti, which at first had been very great.) They saw Giotto at Padua and Mantegna at Verona. Mantegna exerted a permanent influence as did the later Venetians. The Brethren had admired, or wished to admire, the juvenile graces of Benozzo Gozzoli, of Pisanello and of Fra Angelico. Primitives such as these were accounted pure, pretty and devout. But in the 1860s and '70s such purism was found a good deal less interesting than the much more complicated agonies and ecstasies of Botticelli. The age was itself becoming more introspective and Botticelli suited it very much better. Burne-Jones, like Swinburne and Rossetti, followed or perhaps in part set this fashion. Even as a Pre-Raphaelite he was Pre-Raphaelite with a difference.

But in fact he was too catholic in his tastes to reject any of the great Italian schools and already, in the late '60s, we find him copying engravings by Marc Antonio Raimondi and drawings by Michelangelo. A curious occupation for a student of Rossetti's, but it has to be remembered that, although Burne-Jones went to life classes, he had never passed through the hands of Mr Sass or worked his way through the Academy cast room. He came to the study of the human figure, which obviously was as important to him as it could be to any Academician, without any educational disadvantages.

In a general way Burne-Jones marched with the classical revival of the time, which went with a lessening of religious or at least of sectarian feeling. The High Renaissance now was no longer dismissed as being 'pagan'; in fact the paganism both of the High Renaissance and of the Quattrocento was an added attraction. One might deplore the effect of Renaissance humanism upon the faith and *mores* of the age, but the moral conflict, which could be likened to the intellectual conflicts of modern times, was by no means uninteresting. Altogether the moral earnestness of the 1840s and 1850s which had made the idea of Christian art so attractive was being replaced by something rather different. Rossetti had produced an art for art's sake, and to this was added a notion that we have already discussed: a return to classical origins, not in the chaste and dignified manner of the Neo-classicists but with a kind of romantic fervour, seeking not archaism but refinement. Poynter and Leighton were the exponents of this revived academicism, while Alma-Tadema approached the same kind of subject matter albeit in a more archaeological — indeed a more realistic fashion.

The nineteenth century may be said to have found its own kind of Hellenic art in the terracotta statuettes which were discovered in

great quantities at Tanagra, Myrina and many other centres around the Eastern Mediterranean, and which soon became so popular that large businesses were set up to keep up with a demand which antiquity could not meet. Tiny in scale, made of cheap material, regarded in antiquity as an ephemeral and demotic genre, these 'Tanagra' figurines were more intimate and conversational in spirit, more approachable, than the bronze and marble of antiquity. Exquisite young ladies wearing absurd hats, draped but desirable matrons exchanging confidences (there were also actors, clowns and grotesques, but they were never so popular), the graceful figures seemed to have originated in the refined drawing rooms to which they now returned.

But they were accompanied by exquisite personages of another kind — willowy, graceful, elaborately coiffed, boldly patterned creatures from the Far East. The Japanese print was a more important innovation than the Tanagra figurine. It revealed a new way of painting, a new treatment of space, and it had a profound effect on the Post-Impressionists. To Whistler and his friends in England Japanese work seemed above all a wonderful exhibition of perfect taste. It is thus that it appears in the work of Joseph Albert Moore, whose pictures display a strong affection both for the grace of Hellas and the invention of Yedo.

The influence of Japanese forms can be discovered in the work of Burne-Jones but perhaps the Far East affected him in another, albeit a negative, way. Japanese pictorial art spoke to European artists chiefly through its form — one could perceive easily that here was a bold, subtle and harmonious treatment of natural forms, one could perceive also that the Japanese were a tremendously cultivated and polite nation. But unless a print were clearly and explicitly erotic it was extremely hard for the Western critic to understand what it represented. Hitherto Western critics had been so much involved with the art of the Hellenic world and of Christianity that it had been natural enough to think of most painting in terms of narrative, and this was felt to be the highest form of art; but Japan, by presenting us in a striking way with an art whose 'literary' meaning was incomprehensible, must have immediately raised the question in painters' minds — just how important is that part of my message?

The results were immediate. They showed themselves in the decay of the long explanatory title. *A Converted British Family Sheltering a Christian Priest from the Persecution of the Druids* was replaced by *Harmony in Gold and Grey* where Holman Hunt was eager to tell a complex and edifying story, Whistler reduced his picture to a phrase of visual music and his follower Joseph Albert

Moore was content to offer his public titles which suggested no more than a mood, an atmosphere, embodied by a girl or girls quietly being beautiful. Something of the same process may I think be observed in the work of Rossetti, who passes from an art of incident to an art of mood.

In Burne-Jones's work the starting point is usually a myth. It makes very little difference to him whether the fiction that he chooses is Christian, Hellenic or Arthurian — any story will do as a pretext for what finally becomes a gracefully composed design. But from a very early stage of his career he seems to have been intrigued by the notion of a kind of non-sectarian sacred conversation. *The Wedding of Psyche* is an example. It is a collection of pensive figures; they process, they play on musical instruments, they scatter flowers in their refined way; the girls (and all but one are girls) look alike, wear the same sad, almost despairing, expression. None of them, one feels, ever has been or could be in a hurry. Perhaps it is this, the feeling of extreme repose which adds the final touch to the irritation of those critics who denounce Burne-Jones as 'escapist'. The 'beautiful romantic dream' was so very close to complete unqualified sleep.

It is a sense of living behind glazed walls that makes me hesitate to join those who throw stones at Burne-Jones on this account. It seems to me hardly fair that our generation should accuse the later Pre-Raphaelites of escaping from life when we ourselves have invented methods of escape which seem so much more complete than theirs. They after all did refer to conflict and death, to the nobler and baser passions of the real world, even if it was seen through a dim and rosy glass; we have invented forms of art in which there is practically no reference to society, morality, nature or indeed anything except other works of art of the same kind.

Interestingly, some recent critics have attempted to find a place for Burne-Jones amongst the abstractionists. There is some truth in the suggestion. If one takes a reproduction of Burne-Jones's *King Cophetua and the Beggar Maid* and turns it upside down, having thus obscured its literary meaning, one may indeed discover something not unlike the highly structured Cubist works of about the year 1913. I doubt whether this means much more than that Burne-Jones was an extremely strong and careful designer, very interested in the surface pattern of his pictures. The fact hardly makes him seem more or less of a dreamer. Indeed, unless one is wilfully blind to his qualities, one must see that in nearly all his work he aims at a synthesis between the architectonic arrangement of forms and a manifest desire to illustrate the legends that took his fancy. He wanted to be a poet in paint. His intentions are less clear when we consider that somewhat disconcerting quality of sentimental quietism

to which I have already alluded, for there certainly were occasions – notably in his paintings of the early 1870s – when he tried to animate his poesie and to give the pictures what they usually lack, a feeling of intense energy.

Any discussion of movement, or more strictly speaking of suggested movement, in painting is a difficlut and perilous business. It is so easy to see activity where there really is none, and vice versa. Still it does seem to me that all the Pre-Raphaelites were much concerned with this question and found it hard to tackle, Burne-Jones perhaps being particularly worried by the problem. The works of the Brotherhood had been very deficient in any convincing sense of movement because, as I have said, the hard-edge method lent itself precisely to the opposite effect – that is to say, to what is literally, still life. There is a certain tendency to look for the immobile and hence carefully observable subject, and where the subject demands activity – as for instance in Hunt's *Druids* – the minute hard-edge style arrests the action of the figures; when action is displayed in the drawings it will evaporate on canvas. Hunt, I think, never really did manage to get a move on, and Ford Madox Brown is almost equally static; Millais starts into motion – significantly – just when he is abandoning his early manner in *The Rescue*. Rossetti in the same way begins to convey movement when he is abandoning his first manner, particularly in his works of the early 1850s and '60s – as for instance in *How They Met Themselves* – and then in later years opts for the lethargic subject. He was always fond of it. Even the most energetic of saints, St George, is shown resting, his dragon safely disposed of, its head in a box, while the saint's attention is entirely engrossed – as well it might be – by the Princess Sabra who, in her quiet way, suffers from migraine. When Burne-Jones attacked the same legend, his *St George and the Dragon* does show the hero slaying the creature, but here St George is made to look almost like a sympathetic dentist who is carefully probing a tooth in the monster's mouth.

But Burne-Jones, a generalizing artist and one who modestly disclaimed any skill in portraiture, was imbued with the still hardy idea of painting grand 'histories' in the manner of the High Renaissance. *Love and the Pilgrim*, *The Wheel of Fortune*, *The Depths of the Sea*, *The Car of Love* all show, not only that he wanted to rise to the very heights of the grand manner, but also that there were occasions when he felt the necessity for giving his figures a highly energetic air. Where he ran into difficulties was, I think, in his efforts to combine the study of the human being in action with an intensely dramatic study of the human emotions. In this connection

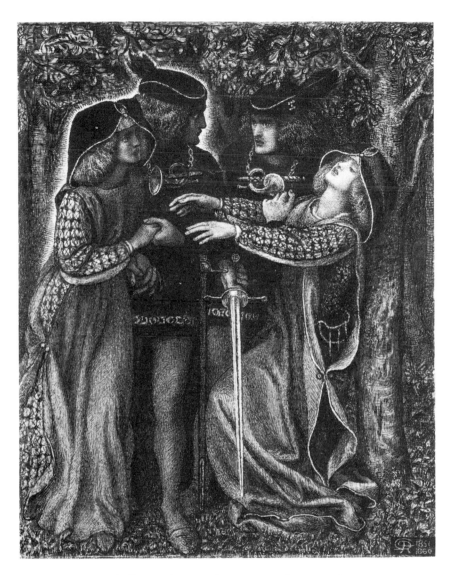

two pictures, *Phyllis and Demophoön* and *The Tree of Forgiveness*, are of particular interest.

DANTE GABRIEL
ROSSETTI *How They Met
Themselves* 1851–60

Phyllis and Demophoön is based upon a story in the *Heroides* of Ovid, telling how Demophoön the son to Theseus was kindly entertained by Phyllis in Thrace, how he forsook and forgot her, how she was changed into an almond tree from which – at least in Burne-Jones's version – she changed back again when he revisited her country. It seems probable that this story reflected a stormy passage in the painter's life, Burne-Jones having had a rather too desperate flirtation with a Greek lady who pursued him and attempted to engage him in a suicide pact.

In the picture a figure not unlike Miss Zambaco, the Greek

lady, bursts out of a tree to seize and hug the worried-looking hero
– who, it must be said, does not look at all like Ned Burne-Jones.
It has been suggested that the composition was inspired by
Pollaiuolo's *Apollo and Daphne*, now in the National Gallery. That is
an attractive and interesting idea, but unfortunately the Pollaiuolo
was not in the National Gallery until 1876, and there can be no
doubt that *Phyllis and Demophoön* was painted in 1870. But if Burne-
Jones had any other artist's work in mind – and after all there was
nothing to prevent him from inventing his own picture – I would
suggest that he might have found his source in Michelangelo's
sketches for *The Resurrection* which he would have seen in the British
Museum[31]. This is only a guess; but certainly there is something
very Michelangelesque about the painting of Demophoön. There
was indeed something not a little Michelangelesque about the man's
nudity, which like the Sistine wall, led to protests. Ten years later
Burne-Jones painted a second version in which Demophoön's genitals
were masked by a swag of drapery; it was Phyllis who was bare, and
there were no protests.

If we compare these two versions we shall find other differences.
In the second work the *Tree of Forgiveness* – from which this version
takes its title – has become more important; its blossoms fill nearly
all the background and are flattened out in a way that suggests both
Oriental and art nouveau influences. The figures are as Michelan-
gelesque as ever: but we are faced once again with the old Pre-
Raphaelite problem: undoubted vigour of the action conflicts with
the careful detail and in particular with the intensely observed facial
expressions. Demophoön is positively glaring at his importunate
mistress, and one regrets the calmer, less emphatic treatment of the
faces in the earlier painting. It is as if someone has been telling
Burne-Jones that he rejoiced too much in the actions of the human
body and should look with a more reverent interest at the soul.

Someone had.

One evening Ruskin had Burne-Jones to dinner at Denmark
Hill and read him the text of a lecture which he, Ruskin, had
written as a part of his course as Slade Professor at Oxford. Burne-
Jones had a deep admiration for Ruskin, who had been very kind
and who, in the painter's opinion, had done an enormous amount for
British art. He had also been exceptionally kind to Georgiana, he
had found patrons when patrons were few, and had been a very loyal
if at times a rather dictatorial friend. It was inevitable that Burne-
Jones should listen to what his mentor had to say about Michelangelo
who, as I believe, was all-important to him at this time. So far
Ruskin had not had very much to say about the great man. But now
he had plenty.

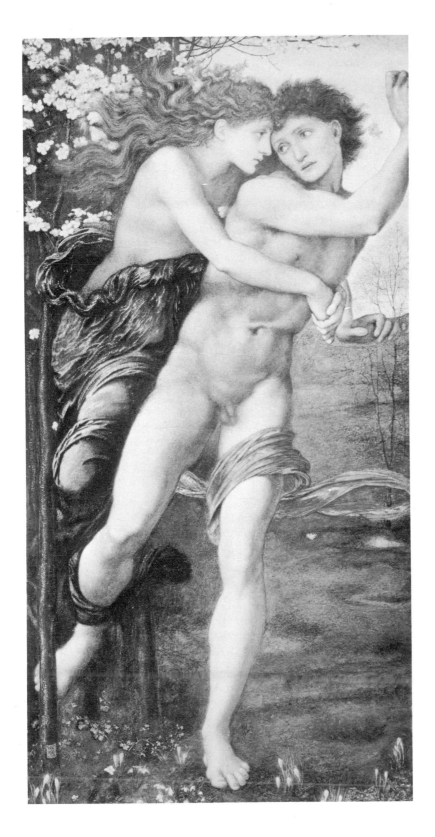

EDWARD COLEY BURNE-
JONES *Phyllis and
Demophoön* 1870.

And what he said was dreadful. Michelangelo it seemed was all wrong: he was not poetical, he was merely anatomical; he brought tumult for peace, the flesh of man for his spirit, ill for good. He followed the ancients in the most vicious of their practices in that he emphasized the body at the expense of the face; he was 'dishonest, insolent and artificial'.

The Burne-Jones of 1861 might have listened to such a diatribe with comparative equanimity, but not the Burne-Jones of 1871. Ruskin's words seemed addressed to him. Of *The Last Judgement* he said:

> It may have appalled, or impressed you for a time, as a thunder-cloud might: but has it ever taught you anything – chastised you in anything – confirmed a purpose – fortified a resistance – purified a passion? I know that, for you, it has done none of these things; and I know also that, for others, it has done very different things. In every vain and proud designer who has since lived, that dark carnality of Michael Angelo's has fostered insolent science, and fleshly imagination. Daubers and block heads think themselves painters and are received by the public as such, if they know how to foreshorten bones and decipher entrails; and men with a capacity of art either shrink away (the best of them always do) into petty felicities and innocencies of genre painting . . . or else if they have the full sensuous art-faculty that would have made true painters of them, being taught from their youth up, to look for and learn the body instead of the spirit, have learned it and taught it to such purpose, that at this hour, when I speak to you, the rooms of the Royal Academy of England . . . contain *not one* picture honourable to their age, and contain many which are shameful in their record of its manners. [32]

Ruskin was such an overwhelming fellow when he got on his high horse, and so very sure of himself, that poor Burne-Jones was entirely shattered: 'as I went home,' he said, 'I wanted to drown myself in the Surrey Canal or get drunk in a tavern – it didn't seem worth while to strive any more if he could think it and write it.' [33] And then Ruskin's attack upon the fleshly school of painting was echoed by Maitland's attack upon the fleshly school of poetry.

Under such an onslaught did Burne-Jones hesitate and reconsider his purpose? So far as I can see he remained faithful to Michelangelo, but he did falter a little. His great polyptych in the High Renaissance style, *The Story of Troy*, remained unfinished; in 'Pan and Psyche' he

looks rather to Piero di Cosimo than to Michelangelo, and devotes much attention to the facial expressions of his characters. In *Love Among the Ruins*, *The Golden Stairs* and more particularly in *Laus Veneris*, he seems to be retracing his steps, attempting to recapture the placid innocence of his earlier work; and in a series of panels, *The Days of Creation*, he seems almost to have been painting with the express idea of pleasing Ruskin. But in doing this he landed himself in trouble of another kind.

When *The Days of Creation* was newly painted, it was shown at the Grosvenor Gallery, opened in 1877 by Sir Coutts Lindsay as a home for new experiments in art, for things that would not easily find a place on the walls of the Royal Academy. (Also, it was a gallery in which, for the first time, the old principle of loading the walls with all the pictures they could bear was discarded in favour of a more enlightened method of display.)

The Days of Creation consisted of six panels, designed originally for stained glass and executed in watercolour, the theme being a series of angels, each of which holds a crystal sphere within which an act of creation is visible. There was nothing here of Michelangelo; Botticelli may have been a source, and Luca della Robbia's *Cantoria* was certainly in the painter's mind. The angels confront the spectator, their wings above and their multitudinous draperies below fill the picture space with a complex linear pattern and set off, to great advantage, the sweet staring wide-eyed faces of these very adolescent and decidedly feminine beings. No wonder Ruskin was delighted:

> His work, first, is simply the only art-work at present produced in England which will be received by the future as 'classic' in its kind — the best that has been, or could be . . . the action of imagination of the highest power in Burne-Jones, under conditions of scholarship, of social beauty, and of social distress, which necessarily aid, thwart and colour it, in the nineteenth century are alone in art — unrivalled in their kind; and I *know* that these will be immortal, as the best things that the mid nineteenth century in England could do, in such true relations as it had, through all confusion, retained with the paternal and everlasting Art of the world.[34]

Even in his eulogy Ruskin was a bit off balance; and when in the next room he found something that did not please him he was quite overcome by rage and toppled altoether in these much-quoted terms:

> For Mr Whistler's own sake no less than for the protection
> of the purchaser, Sir Coutts Lindsay ought not to have
> admitted works into the gallery in which the ill educated
> conceit on the artist so nearly approached the aspect of
> wilful imposture. I have seen and heard much of cockney
> impudence before now; but never expected to hear a
> coxcomb ask two hundred guineas for flinging a pot of
> paint in the public's face.

Burne-Jones cannot but have been elated by Ruskin's praise.
But his pleasure was brief. Whistler, a quarrelsome fellow and not
one to let his nose be tweaked by Ruskin or anyone else, brought an
action against the critic. Ruskin was delighted, he looked forward
to going into the witness box to defend his beliefs, for him it was all
'nuts and nectar'. But Ruskin was unwell and unable to be present
in court. This was, from every point of view, a pity: it would have
been splendid to have had the testimony of two such adversaries.
But for Burne-Jones it was dreadful. With an extraordinary lack of
consideration for his friend's feelings, Ruskin besought Burne-Jones
to give evidence on his behalf.

Poor Burne-Jones knew that he was not the man to do himself
justice in a court of law; but the thing was made far worse by the
fact that he would be defending a critic who had praised him
unrestrainedly and at the same time hurting a less fortunate brother
artist who was a friend, and whose work he liked. But how to refuse
Ruskin who had done so much for him and so much for the things
he believed in? It was not possible. Very sadly and reluctantly he
agreed to give evidence.

As far as Ruskin's interests were concerned Burne-Jones might
have saved himself the trouble. Confronted by Whistler's *Nocturne*,
he was asked by defendant's counsel:

> 'Do you see any art quality in that *Nocturne*, Mr Jones?'
> 'Yes . . . I must speak the truth, you know. . . .'[35]

No doubt he was trying to do so. But did he really mean what he
said when, in further examination, he declared that detail was
'essential to a work of art'? 'I think', he said,

> . . . that nothing but perfect finish ought to be allowed
> by artists; that they should not be content with anything
> that falls short of what the age acknowledges as essential
> to perfect work. I have seen the pictures by Mr Whistler
> which were produced yesterday in this court, and I think
> the *Nocturne in Blue Silver* is a work of art, but a very
> incomplete one; an admirable beginning, but that it in
> no sense whatever shews the finish of a complete work of

art. I am led to the conclusion because while I think the
picture has many good qualities – in colour, for instance,
it is beautiful – it is deficient in form, and form is as
essential as colour. 36

Might Burne-Jones not have reflected on these words, written
by Ruskin in his youth: 'A pencil scratch of Wilkie's on the back of
a letter is a great and a better picture – and I use the term picture
in its full sense – than the most laboured and luminous canvas that
ever left the easel of Gerard Dow.'37 Whistler only received a
farthing's damages and was ruined by the expense of the action, but
he gained all the glory of that day. Repeatedly he scored off the
Attorney-General, and although the victory might be pyrrhic it was
his, and even the ranks of Tuscany could scarce forbear to cheer:
'What a lark the Whistler case is!!', wrote Rossetti. 'I must say he
shone in the box, the fool of an Attorney-General was nowhere. I am
glad to see that Ruskin is not to be hauled out.'38

But Burne-Jones had been 'hauled out'. He had been forced
into a foolish and ungenerous role. It appeared that he was paying
for critical services received. 'Officially', as Lord David Cecil puts it,
'he and Ruskin remained on good terms.'39 But after this Burne-
Jones had no doubt that the friendship was more trouble than
pleasure to him. He had in fact lost both Ruskin and Whistler by
that day's work.

Worse still, as Whistler's fame and reputation increased Burne-
Jones became part of a legend, and his part was neither amiable nor
heroic. The trial took place in 1878. In the '80s Whistler was
becoming 'The Master' and Ruskin was becoming the enemy; the
Pre-Raphaelites, having once been denounced as dangerous revolu-
tionaries, were regarded as the old reactionaries of British art. Burne-
Jones, because of the part he had played in the Whistler–Ruskin
trial, was particularly offensive to the young.

The obsession with 'finish' was, indeed, a central belief of the
Pre-Raphaelites; Rossetti clung to it long after he had parted
company with the Brethren on all other points, and it was essentially
this which made it impossible for the Pre-Raphaelite painters of
either generation to look intelligently at the work of Impressionists
or Realists.

. . . this incredible new French school – people painted
with two eyes in one socket through merely being too
lazy to efface the first and what not. Fantin [Latour] took
me to see a man named Manet who has painted things of
the same kind. 40

Thus Rossetti, and Burne-Jones was equally dismayed by what was coming from Paris:

> The doctrine of the excellence of unfinished work was necessarily repugnant to Edward, who at first was incredulous as to its being seriously held by anyone; but as what is called the 'Impressionist' School gained ground it became one of the most disheartening thoughts of his life. The words which he had uttered publicly in 1878 [in court] – 'I think that nothing short of perfect finish ought to be allowed by artists' – did not express an opinion of the time merely, but a sure conviction to which the great art of the world bore witness; and the fulfilment of his warning 'if unfinished pictures become common we shall arrive at a stage of mere manufacture, and the art of the country will be degraded', seemed at hand.[41]

It was hardly to be expected that Holman Hunt would be less severe: 'childishly drawn and modelled, ignorantly coloured and handled, materialistic and soulless'[42] was his verdict. But for Holman Hunt, interestingly enough, the fault of the movement seems to have been moral rather than technical, and in the moral judgement Holman Hunt implied an aesthetic emotion:

> Instead of adorable pictures of nature's face, we are offered representations of scenes that none but those with blunted feelings could contemplate, not stopping short of the interiors of slaughter-houses. The degradation of art is nothing less than a sign of disease in Society.

Like Ruskin the Pre-Raphaelites seem, in their response to the art of the avant-garde, to have been oddly selective in their reading of art history. The wooden crudities of art before Raphael had indeed been more or less explained away; but were they never troubled by the recollection of Hogarth's *The Shrimp Girl* or the later landscapes of Turner? What had they to say before Rembrandt's flayed carcase? What indeed had Burne-Jones and Rossetti to say about some of their own less studied and highly polished works?

The Rediscovery of Europe

Thus the Pre-Raphaelites entered upon the period of reaction. The 'incredible new French School' made its converts and none was more highly regarded than Manet. For Burne-Jones it must have been very painful indeed.

And yet the picture was more complex and less clear than might be supposed. Look at an old number of the *Yellow Book*, which, in the mid-1890s was the organ of the avant-garde in

England. The illustrations are largely devoted, as might be expected, to Sickert, Whistler and Wilson Steer; but you will also find a good deal of space devoted to Burne-Jones and much to Rossetti.

One reason for this is that Rossetti's career as an artist was largely posthumous. For years he was a name and a very considerable name, he was purchased by private collectors and his works, until Liverpool purchased one, never got into public collections: he was the great unknown. When he died this partial obscurity ended suddenly and dramatically with a large retrospective at Burlington House. The public flocked to see what Rossetti was like – it stayed to rejoice and admire. Thus, from 1885 onwards, Rossetti became a great figure in the artistic world, not much to the satisfaction of his erstwhile Brethren, and Pre-Raphaelitism gathered a second, late and unexpected harvest.

But there is also this: the opposition between the Pre-Raphaelites and the avant-garde in France was by no means clear-cut. By the late '80s Impressionism was no longer the 'latest thing'; the French were returning to the idea of a highly literary form of painting, an art which would express all that welter of religious and erotic ideas – the one being not very clearly distinguished from the other – which goes under the name of Symbolism. Looking around, the French discovered a northern apostle of their creed in the person of Burne-Jones, and for a time he was 'taken up'.

Joséphin Péladan, high priest and organizer of the lunatic fringe of pictorial symbolism, announced in a manifesto of the Salon de la Rose-Croix that 'we will go to London and invite Burne-Jones, Watts and five other Pre-Raphaelites'. There is no record to show that M Péladan actually crossed the Channel, which is a pity. But he did write to Burne-Jones, who wrote to his fellow 'Pre-Raphaelite', Watts: 'I don't know about the Salon of the Rose-Cross – a funny high falutin sort of pamphlet has reached me – a letter asking me to exhibit there, but I feel suspicious of it . . . the pamphlet was disgracefully silly.'[43] No business was done.

But rather more serious people were also active, and Burne-Jones was shown and for a time considerably admired in Paris. After many years England and the Continent were getting in touch again, looking at each other with mutual interest and vast misunderstanding. England, as I have said, was becoming enthusiastic about Impressionism, an Impressionism from which the colour had been removed and to which a high moral tone had been added: the Impressionism of Bastien Lepage, which becomes the even less Impressionistic painting of the Newlyn school. France for her part was looking at Ruskin and seeing in him the founder of the Pre-Raphaelite movement. Central Europe was celebrating the virtues

of Walter Crane and William Morris; Pre-Raphaelitism was seen as something passionate, perverse, oversexed, and burdened by the sorrows of all the centuries; no one south of the Channel or east of the Rhine ever imagined that it could at one time have had something to do with realism.

At the same time the movement even in its native land gave some signs of continued life and vigour. Quite a number of young painters attempted to revive it in one form or another; men like Arthur Gaskin, Byam Shaw and Gerald Moira. It has even been claimed that Dicksee, who was later to be PRA in succession to Poynter, was the last of the line.

It must be confessed that these late followers and revivalists have not left names which resound loud or clear down 'the ringing groves of change'; but I dare say some Victorian revivalist will rediscover them presently and declare that we have been too hasty in dismissing them. As far as existing taste goes there is only one notable disciple of the Pre-Raphaelites who belongs to this final period. This was a follower who very consciously and earnestly took William Morris and Burne-Jones as his masters, together, it must be said, with the Japanese. He gained a European reputation and succeeded in shocking both his English masters and the public at large. Aubrey Beardsley adapted one of the later phenomena of Pre-Raphaelitism and used it as a vehicle for his very complex and at times very obscene imagination.

This manner of using later Pre-Raphaelitism had always been a possibility and it was in fact explored by a brilliant young man, Simeon Solomon, who was for a time greatly admired by Rossetti, by Swinburne and by Burne-Jones. He used Rossetti as an engine for the expression of ecstatic sentimentality; there was always, in his pictures, a kind of soft and flaccid sweetness which made the work almost unsupportable to those who like a little roughage in their pictorial diet. In his later works the sentiment becomes increasingly maudlin and the feeling increasingly epicene. Somehow it seems natural that eventually, suffering from an overdose of Swinburne, he fell foul of the law, served a prison sentence and was, I regret to say, dropped like a hot brick by all his Pre-Raphaelite friends. He died in a workhouse.

But whereas Simeon Solomon created an 'improper' form of Pre-Raphaelitism by emphasizing that which was slushy and sentimental in the work of Rossetti and Burne-Jones, Aubrey Beardsley, following in the footsteps of Morris, made his line harsher and stronger than theirs — or at least this is the tendency of his earliest works. It is through the influence of Oriental and above all of Japanese artists that he later combines strength with great fluidity

of line. The final result was an aggressively 'decadent' style, a naughty, weary sort of art full of strange, sweet, dirty suggestions. It was High Art in the sense in which a half-putrid pheasant or an overripe cheese is high.

Morris and Burne-Jones hated it heartily, just as they hated art nouveau, with which indeed it had much in common. To them Beardsley's work must have seemed a wicked deformation of everything for which they had striven, a twisted, diabolic kind of drawing where theirs was angelic and straight. It would have seemed all the more unpleasant by reason of its undoubted power.

By the end of the century Millais, Morris, Rossetti, Ford Madox Brown and Burne-Jones were all dead, and so was Beardsley. The movement seemed to be dying in a strange and complicated manner, partly as the result of new forces with which the Pre-Raphaelites could not come to terms and partly because, having already been changed almost beyond recognition, it had now suffered a final and radical deformation.

Chapter 4

Conclusions

How then and why did the Pre-Raphaelite movement come into existence, what made it what it was, and what was the reason for its sudden and vast success and for its equally sudden extinction? Finally, why was it that, having perished, it was to be reborn but with such a very different character?

The position of the Pre-Raphaelites in the history of ideas is somewhat vague. As we have seen, two quite different kinds of painting have been called Pre-Raphaelite and this could hardly have been the case if Pre-Raphaelitism had been securely attached to any definite idea or ideas. On the face of it the Pre-Raphaelites seem to have been much concerned with ideology, that is to say with subject matter, and their moral tone was high; nevertheless they found their themes not only in religion and poetry but in the incidents of daily life and sometimes in pure landscape, or portraiture. They are by turns political, sectarian, or simply romantic. What makes a picture instantly and readily classifiable as Pre-Raphaelite is the careful exactitude of the painter's technique and the purity of his colour.

The movement appears to have had its origins in notions or emotions of several kinds: in the desire to create a serious art capable of expressing the anxieties of the age in which it grew; in a new conception of art history; in the work of the great Flemings, of the Italian predecessors of Raphael, of the Nazarenes and of John Ruskin. But surely the most important factor in its growth and efflorescence was the actual work of Millais, a painter whose precocious mastery was almost bound to attract attention, and that of Holman Hunt, a less accomplished but in some ways more arresting artist. Imagine what effect the work of these two must have

had, shining out in pure, brilliant, precise areas of colour upon walls dark and gravy-hued with bituminous pastiches of C R Leslie, Frith and Etty. Here was nature, or at least one very convincingly rendered aspect of nature. Nothing is more delightful, more intoxicating and — I would say — healthful, for a young artist to be directed away from the conventions of the schools, whatever they may be, towards the eternally new and splendid world of facts. This was the secret of Caravaggio and of Courbet; these could set men of genius ablaze. The Pre-Raphaelites were not so fortunate and not, perhaps, so incendiary, but for a moment they did teach the Englishmen to look at the world of natural appearances with a new affection and a new humility.

But only for a moment. Why did that early conflagration die so soon? Perhaps because there was no coherent ideological drive to carry the movement forward, perhaps because Holman Hunt chose exile and an incoherent symbolism from which he alone could profit, or perhaps because Millais chose Academic safety. The naturalism of high exactitude was a technical experiment and little more; almost anyone might repeat the experiment but, having done so, they were left with no greater purpose than to repeat it again.

The reason for the continued existence of something which could be called a Pre-Raphaelite movement at a time when Millais had turned to easier ways of painting and Holman Hunt, having chosen a sort of voluntary exile, continued alone to follow the original path of the Brethren, may be given in one word: Rossetti.

Of Rossetti's place in the original Brotherhood I have said a good deal and could have said much more. It was a subject which engaged Holman Hunt and to which he constantly returns, proving again and again to his own satisfaction, and not without a fair show of reason that Dante Gabriel was but a pupil sitting at the feet of his Brethren and in no sense a leader amongst them. But Hunt's constant vehemence on this subject makes one suspect that the often repeated statement — and we have it from nearly all the earliest historians of the movement — that Rossetti was indeed the originator, animator and leader of the group was not so far from the truth.

It is true that Dante Gabriel was still a tyro, still technically unhandy, still needing the help of his Brethren until after the movement was started; nor can one easily suppose that he played a substantial part in that magnificent outburst of energetic imagination which transformed the work of Millais and Hunt in the years 1848 and 1849. But it is also true that Rossetti had such a fund of enthusiasm and was, socially, so irresistible a force that he would naturally have gravitated towards a leading role in any such group. Even though his talent was still unformed, his mind was in that

society pre-eminent; culturally and in point of education he stood higher than his friends. When he himself writes that he was hardly a Pre-Raphaelite, in the sense of being what he called an emotional realist, it was no more than the truth; but when he added that it was friendship – *camaraderie* – which joined his name to that of Millais and Hunt in the enthusiastic days of their youth, he was saying a good deal – the Brotherhood was in large measure a social, fraternal thing; it was after all Dante Gabriel who enlisted the Brethren and it was he, one supposes, who kept them together for some years.

An indication of Rossetti's natural claims to leadership is the unquestioning manner in which that leadership was accepted as a matter of course by Ruskin, and by the second generation of Pre-Raphaelites. Ruskin declares, without qualification, that Rossetti was 'the founder, and for some years the vital force, of the Pre-Raphaelite school'[1] – and yet Ruskin must have known how matters stood in 1851, and how vital had been the contribution of Millais. William Morris and Edward Burne-Jones seem almost as a matter of course to have looked to Rossetti for leadership. It is true that by then he stood almost alone in the field; but they could have paid, yet apparently did not, some attention to the methods of Hunt and the achievements of Millais, who when they came to London was still producing some very remarkable paintings. Morris perhaps could not have learnt very much from the other Brethren; but Burne-Jones seems unquestioningly to have turned to Rossetti, and in his earliest years was under his influence. It was later that he had recourse to those historic sources which a reviving classicism made acceptable.

Certainly it was the dominant position of Rossetti, the teacher of the new generation, which gave that generation its misleading label of Pre-Raphaelite. (So complete indeed was the confusion between the two epochs that it can be argued that Ruskin, in speaking as he did [in 1875], was in fact thinking of Rossetti as the founder and vital force not of the Brotherhood but of this later school.)

It is hardly adventurous to suggest as I have done that Pre-Raphaelitism was essentially a technical innovation and that it owes its name in the second avatar almost entirely to the influence of Rossetti. But let me in conclusion add one more glimpse of the obvious: Pre-Raphaelitism was essentially insular, it was eminently a national school and, for better or worse, it was Holman Hunt who made it so. With him this was a matter of principle: he believed passionately that the work of a painter was or should be patriotic.

Remember his statement, that with which he ends his book, that 'the purpose of art is . . . to lead men to distinguish between that which, being clean in spirit, is productive of virtue, and that

which is flaunting and meretricious and productive of ruin to a Nation'.[2] It is a point to which he adverts more than once. 'The eternal test of good art is the influence it is calculated to have on the world, and, actuated by patriotism, all propagandists will consider first the influence of their teaching upon their own nation.'[2] This insistence upon the public utility of good art, on the supreme value of painting as a moral engine at the service of the state, is, for us, a hard saying. We do not easily view aesthetic questions in this manner; but it is something with which we must reckon if we are to understand what Hunt achieved and sought to achieve.

As a young man he tried very hard to separate the English movement of reform and regeneration from its German origins; in his old age he tried to defend English painting from the still more pernicious influence of France. In this he failed, but for nearly half a century he did succeed in isolating the movement in England from all foreign influences. Politically a protectionist from his earliest youth, he would, I think, have liked to prevent Englishmen from even seeing what was being done abroad; that was not quite possible, although for long they saw very little, but he did drive out the German invaders until the very name of the Nazerenes was half-forgotten, and for many decades Englishmen painted as though the continent did not exist.

This was so much the case that, towards the end of the century, a French observer was able to remark that at any international exhibition of paintings there were in fact two groups: the French and their followers, and the English, who stood alone. Today with the revival and revaluation of the Pre-Raphaelite movement, and also of British salon painting, it would seem that these two parties, taken at their best, might almost have stood upon something like an equal footing. But such a statement would I think betray a certain loss of critical equilibrium, and really I doubt whether many of us, however enthusiastic about the Pre-Raphaelites we may be, would on mature consideration set even the greatest of them on a level of quality with Courbet, Degas or Seurat — let alone Cézanne.

For my part I feel that the avant-garde in France produced artists who belong to an order of magnitude different from that of our English rebels. Nevertheless these were in their way very remarkable, and they cannot now be neglected or overlooked; it is this which makes the study of Pre-Raphaelitism so exciting and so enjoyable. That extraordinary phenomenon, nineteenth-century civilization never ceases to perplex and astonish us: that it should have produced a Holman Hunt and a Renoir, a Millais and a Gauguin, makes it in my view the richest, the most fascinating and the most peculiar period in the entire history of art.

Notes and Sources

The following abbreviations have been used for works cited frequently:

GB-J Georgiana Burne-Jones, *Memorials of Edward Burne-Jones*, 2 vols (London, 1904)

WHH W Holman Hunt, *Pre-Raphaelitism and the Pre-Raphaelite Brotherhood*, 2 vols (London, 1905)

JGM John Guille Millais, *The Life and Letters of Sir John Everett Millais*, 2 vols (London, 1899)

LDGR *The Letters of Dante Gabriel Rossetti*, ed O Doughty and J R Wahl, 5 vols (Oxford, 1953–67)

WJR *The Works of John Ruskin*, ed E T Cook and A Wedderburn, 39 vols (London, 1903–12)

CHAPTER 1

1 'that this present age may vie . . .' Reynolds, First Discourse.

2 Hunt's 'all too complete memory . . .' Ford Madox Hueffer (Ford), *The Pre-Raphaelite Brotherhood, a critical monograph* (London, 1908), 55; see also 65, 76–7.

3 public exhibitions which they may or may not have seen . . . See Robyn Cooper, *British Attitudes Towards the Italian Primitives*, Ph.D. thesis, Sussex University, 1976, vol 1, 313–14.

4 'return to the gilt ground inanity . . .' *The Diary of Benjamin Robert Haydon*, ed W B Pope, vol V (Cambridge, Mass, 1963), 79; entry for 11 August 1841.

5 'Of the German art . . .' *Sublime and Instructive: Letters from John Ruskin to Louisa, Marchioness of Waterford, Anna Blunden and Ellen Heaton*, ed V Surtees (London, 1972), 32. See also *WJR*, XXXVI. 309.

6 the great man's violence . . . insanely anti-Catholic prejudice . . . See Keith Andrews, *The Nazarenes, a Brotherhood of German Painters in Rome* (Oxford, 1964), 77.

7 'I never speak of German art . . .' *WJR*, V. 424.

8 'The idea that Ruskin . . .' From a letter to Ernest Chesnau, 7 November 1868, *LDGR*, II. 672. The surviving portion of the original reads:

Les qualités de réalisme émotionnel mais extrêmement minutieux qui donnent le cachet au style nommé préraphaélite se

trouvent principalement dans tous les tableaux de Holman Hunt, dans la plupart de ceux de Madox Brown, dans quelques morceaux de Hughes et dans l'oeuvre admirable de la jeunesse de Millais. C'est la camaraderie plutôt que la collaboration réelle du style qui a uni mon nom au leurs dans les jours d'enthousiasme d'il y a vingt ans.

L'idée que Ruskin a fondé pars ses écrits l'école préraphaélite est une méprise que j'ai trouvé être presque universelle, mais qui n'en est pas moins pour cela une méprise absolue. Je crois en vérité que, parmi les peintres producteurs de l'école, pas un n'avait jusque-là lu un seul des admirables livres de M. Ruskin, et certainement pas un parmi eux ne lui était personellement connu. Ce n'est qu'après deux ou trois expositions annuelles de ces tableaux que ce grand écrivain s'est généreusement constitué leur défenseur contre les attaques acharnées de la presse.

See also JGM, I. 61, and *WJR*, XIII. xlv.

9 'I returned it . . .' Holman Hunt, 'The Pre-Raphaelite Brotherhood: a Fight for Art', *Contemporary Review*, XLIX (April 1886), 478. See also WHH, I. 73, 90–1, and II. 260; *WJR*, IV. 262–3 and XII. xliii.

10 the method which was to make . . . explosive emotion. While rewriting this chapter I have read Professor G P Landow's thoughtful and learned book, *William Holman Hunt and Typological Symbolism* (New Haven, Conn, 1979). With greater erudition than I command it reinforces my argument.

11 'The picture was painted . . .' Ford Madox Brown, diary, 16 August 1854, in *Pre-Raphaelite Diaries and Letters*, ed W M Rossetti (London, 1900), 110.

12 'They were all very simple . . .' Derek Patmore, *The Life and Times of Coventry Patmore* (London, 1949), 74.

CHAPTER 2

1 'Did other men have such a sacred friendship . . .' WHH, I. 365; see also Diana Holman Hunt, *My Grandfather, His Wives and Loves* (London, 1969), 38.

2 his 'conversation and personality were not striking . . .' Patmore, op cit, 76.

3 'The papers are good enough . . .' JGM, I. 52–5.

4 'You shall see in my next . . .' WHH, I. 91.

5 'The most wonderful painting . . .' Hunt in *Contemporary Review*, loc cit, quoted by Mary Bennett in catalogue of the Arts Council exhibition, *Millais* (1967), 25.

6 'It was Hunt – not Rossetti – whom I habitually consulted . . .' JGM, I. 55.

7 'If we look at Rossetti's crowded . . .' Timothy Hilton, *The Pre-Raphaelites* (London, 1970), 41.

8 '*Sunday 11th*. Having sat up at Hannay's . . .' William Michael Rossetti, *The PRB Journal*, ed W E Fredeman (Oxford, 1975), 93. (The passages will not be found in W M Rossetti's own edition of the Journal.)

9 '. . . the lowest depths of what is mean . . .' Charles Dickens in *Household Words*, 15 June 1850.

10 'They intend to return to the early days . . .' Ruskin, letter to *The Times*, 13 May 1851, *WJR*, XII. 322.

11 'In early times art was employed . . .' Ruskin, *Modern Painters*, vol III, *WJR*, V. 77.

12 'They sit down on the shore . . .' ibid, 80–1.

13 'Note their convenient dresses . . .' ibid, 81–2.

14 'With a surprising power of imitation . . .' *The Times*, 9 May 1850.

15 'I'm about half-way through . . .' letter to Robert Browning, 6 February 1856, *LDGR*, I. 286.

16 'Do you ever suppose that Jesus . . .' WHH, I. 355; see also Diana Holman Hunt, op cit, 106.

17 '. . . a type far inferior . . .' Ruskin, letter to *The Times*, 30 May 1851, *WJR*, XII. 325.

18 'We can extend no toleration . . .' *The Times*, 7 May 1851.

19 '. . . lay in our England the foundations . . .' Ruskin, letter to *The Times*, 30 May 1851, *WJR*, XII. 327.

20 'The "magna est veritas" . . .' Ruskin, 'Pre-Raphaelitism' (1853), *WJR*, XII. 160.

21 '. . . the battle is completely and confessedly . . .' Ruskin, *Academy Notes* (1856), *WJR*, XIV. 47.

22 'And he at last the champion . . .' Christina Rossetti, 'The P.R.B.', 10 November 1853, in *The P.R.B. Journal*, ed Fredeman, op cit, 103–4; see also WHH, II. 87 and 441.

23 '. . . threw away their old time-worn canvases . . .' Ford Madox Hueffer, op cit, 166.

24 Martineau, who was Hunt's pupil . . . WHH II. 309.

25 '. . . the only *great* picture exhibited this year . . .' Ruskin, *Academy Notes* (1855), *WJR*, XIV. 22.

26 'The change in his manner . . .' ibid (1857), *WJR*, XIV. 107.

27 'For Millais there is no hope . . .' ibid, 111.

28 ' "What! Mr Whistler! . . ." ' Roy MacMullen, *Victorian Outsider: A Biography of J. A. M. Whistler* (New York, 1973; London, 1974), 87; see also 93, 103 and 104.

29 'Mrs Grundy was shocked . . .' JGM, II. 24.

30 ' "You see me unmanned . . ." ' WHH, II. 392.

CHAPTER 3

1 'Not one [of the Pre-Raphaelites] . . .' W M Rossetti, *Some Reminiscences*, 2 vols (London, 1906), 71.

2 'I now wish that there were . . .' O Doughty, *A Victorian Romantic: Dante Gabriel Rossetti* (London and New Haven, Conn, 1949), 29.

3 Prosper Mérimée . . . likened them . . . Mérimée, *Oeuvres complètes* (Paris, 1930), VIII. 161.

4 'The evidence of Dr Wallinger . . .' W M Rossetti, 'Mrs Holmes Grey' in *The P.R.B. Journal*, op cit, 130–54.

5 'The informing idea of the poem . . .' ibid, 130.

6 'People gaze at it in a blank wonder . . .' Ruskin, letter to *The Times*, 25 May 1854, *WJR*, XII. 333.

7 'Innocent and unenlightened spectators . . .' *The Athenaeum*, quoted by Mary Bennett in catalogue of the Arts Council exhibition, *Holman Hunt* (1969), 36.

8 'There is not a single object . . .' Ruskin, *The Times*, 25 May 1854, loc cit.

9 '. . . the purpose of art is, in love . . .' WHH, II. 439.

10 'I can easily understand . . .' Ruskin, *The Times*, 25 May 1854, loc cit.

11 'What I meant is this: . . .' W M Rossetti, Introduction to facsimile repr of *The Germ* (London, 1901), 16.

12 'But now (being at length . . .' D G Rossetti, 'Hand and Soul' in *The Germ*, No 1 (1849), 26.

13 'Where I write Peace, in that spot . . .' ibid, 29.

14 'Give thou to God no more . . .' ibid, 31.

15 'The *Vanna* picture . . .', 'I have come to the conclusion . . .', 'It was very sweet of you . . .' *Dante Gabriel Rossetti and Jane Morris: Their Correspondence*, ed J Bryson and T C Troxell (Oxford, 1976), 153–5.

16 'She cries in her locked heart . . .' See *Poetical Works of Dante Gabriel Rossetti*, ed W M Rossetti (London, 1905), 363.

17 The long, confused and unhappy story . . . See Alistair Grieve, *The Art of Dante Gabriel Rossetti* (Norwich, 1976), Part I, *Found*, passim.

18 refute 'the charge that a painter adopts . . .' letter to William Graham, 5 May 1879, *LDGR*, IV. 1635.

19 'the qualities of emotional but extremely remote realism . . .' letter to Ernest Chesnau, 7 November 1868, ibid, II. 672 (and cf note on p 54).

20 'But our greatest wonder and delight . . .' GB-J, I. 110.

21 'The characteristic in which they strike us . . .' Patmore, op cit, 73.

22 'Morris, young, rich, talented . . .' Hilton, op cit, 169.

23 Howell the bounder. See Helen Rossetti Angeli, *Pre-Raphaelite Twilight: The Story of Charles Augustus Howell* (London, 1954).

24 'the most secret mysteries of sexual connection . . .' T Maitland, 'The Fleshly School of Poetry', *Contemporary Review*, October 1872, quoted in B and J Dobbs, *Dante Gabriel Rossetti: An Alien Victorian* (London, 1977), 181.

25 'The Papists' temple . . .' Ruskin, *The Seven Lamps of Architecture* (original version), *WJR*, VIII. 41n.

26 'There *is* a Supreme Ruler . . .' Ruskin, *Modern Painters*, vol V, *WJR*, VII. 448.

27 'And now, reader, look around . . .' Ruskin, *The Stones of Venice*, vol II, 'The Nature of Gothic', *WJR*, X. 193.

28 'To my mind, and I believe . . .' Morris, preface to *The Nature of Gothic* (Kelmscott, 1892), repr in *WJR*, X, Appendix 14, 460.

29 '. . . a labourer's cottage . . . Are you contented that . . .' Morris, 'The Prospects of Architecture in Civilisation', lecture to the London Institution, 10 March 1880, repr in *Hopes and Fears for Art* (London, 1903), 181–2.

30 'I mean by a picture . . .' Burne-Jones, as quoted in catalogue of the Arts Council exhibition, *Burne-Jones*.

31 Michelangelo's sketches for *The Resurrection* . . . See Johannes Wilde, *Italian Drawings in the Department of Prints and Drawings in the British Museum* (1953), plate LXXX and frontis no 52, p 87. Burne-Jones was interested in Michelangelo's drawings or at least in Michelangelesque drawings; see M Harrison and B Waters, *Burne-Jones* (London, 1973), where plate 191 shows a Burne-Jones copy of Pontormo attributed to Michelangelo (see Ludwig Goldscheider, *Michelangelo Drawings* [London, 1966], Appendix VIIb, p 207 and plate). According to Wilde a painting by Venusti, based upon Michelangelo's drawing and now in the Fogg Art Museum, Cambridge Mass, was in the collection of Charles Fairfax Murray. Fairfax Murray was a friend of Burne-Jones who could, therefore, have been familiar with this version.

32 'It may have appalled, or impressed you . . .' Ruskin, 'The Relation between Michael Angelo and Tintoret', *WJR*, XXII. 104.

33 '. . . as I went home . . .' GB-J, II. 18.

34 'His work, firstly, is simply . . .', 'For Mr Whistler's own sake . . .' Ruskin, *Fors Clavigera*, 79, *WJR*, XXIX. 159–60.

35 'Do you see any art quality . . .' Whistler, *The Gentle Art of Making Enemies* (London, 1909), 14.

36 'I think that nothing but perfect finish . . .' GB-J, II. 57.

37 'A pencil scratch of Wilkie's . . .' Ruskin, *Modern Painters*, vol I, *WJR*, III. 91.

38 'What a lark . . .' letter to F J Shields, November 1878, *LDGR*, IV. 1609.

39 'Officially he and Ruskin remained . . .' D Cecil, *Visionary and Dreamer. Two Poetic Painters: Samuel Palmer and Edward Burne-Jones* (London, 1969), 173.

40 '. . . this incredible new French school . . .' letter to W M Rossetti, 8 November 1864, *LDGR*, II. 526.

41 'The doctrine of excellence . . .' GB-J, II. 187–8.

42 '. . . childishly drawn and modelled. . . . Instead of adorable pictures . . .' WHH, II. 490, 488.

43 'I don't know about the Salon . . .' Harrison and Waters, op cit, 173–4.

CHAPTER 4

1 '. . . the founder and for some years the vital force . . .' Ruskin, *Academy Notes* (1875), *WJR*, XIV. 267.

2 'The purpose of art . . .', 'The eternal test of good art . . .' WHH, II. 493, 482.

Select Bibliography

Amongst more recent authors and editions I have made use of I am grateful to the following:

ARTS COUNCIL catalogues of the following exhibitions: *Ford Madox Brown* (1964), *Millais* (1967), *Holman Hunt* (1969) – Mary Bennett contributed to these; *Rossetti* (1973) – John Gere contributed; *Burne-Jones*

John Bryson and Janet Camp Troxell, eds, *Dante Gabriel Rossetti and Jane Morris: Their Correspondence* (Oxford, 1976)

David Cecil, *Visionary and Dreamer. Two Poetic Painters: Samuel Palmer and Edward Burne-Jones* (London, 1969)

Brian and Judy Dobbs, *Dante Gabriel Rossetti: An Alien Victorian* (London, 1977)

Gordon H Fleming, *Rossetti and the Pre-Raphaelite Brotherhood* (London, 1967)

William E Fredeman, *Pre-Raphaelitism: A Bibliocritical Study* (Cambridge, Mass and London, 1965)

–, ed, *William Michael Rossetti: The P.R.B. Journal* (Oxford, 1975)

Alistair Grieve, *The Art of Dante Gabriel Rossetti* (London, 1975) in progress

Martin Harrison and Bill Waters, *Burne-Jones* (London, 1973)

Francis Haskell, *Rediscoveries in Art* (London, 1976)

Timothy Hilton, *The Pre-Raphaelites* (London, 1970)

Diana Holman Hunt, *My Grandfather, His Wives and Loves* (London, 1969)

George P Landow, *William Holman Hunt and Typological Symbolism* (New Haven, Conn, 1979)

Jack Lindsay, *William Morris: His Life and Work* (London, 1975)

John Nicoll, *The Pre-Raphaelites* (London, 1970)

–, *Dante Gabriel Rossetti* (London, 1975)

Marcia Pointon, *William Dyce* (Oxford, 1973)

Allen Staley, *The Pre-Raphaelite Landscape* (Oxford, 1973)

Virginia Surtees, ed, *Sublime and Instructive, Letters from John Ruskin to Louisa, Marchioness of Waterford, Anna Blunden and Ellen Heaton* (London, 1972)

Raleigh Trevelyan, *A Pre-Raphaelite Circle* (London, 1978)

Ray Watkinson, *Pre-Raphaelite Art and Design* (London, 1970)

–, *William Morris as a Designer* (London, 1967)

Stanley Weintraub, *Four Rossettis* (London, 1978)

List of Illustrations

Index